Icons of Graphic Design

Steven Heller and Mirko Ilić

 Thames & Hudson

Acknowledgments

This book was a phenomenally difficult undertaking for
many conceptual and logistical reasons. Not only was the
editing and organization of materials difficult, but obtaining
the work was something of a career in itself. Since there is no
single clearing house for the major artifacts of graphic
design, we had to contact hundreds of original sources and
resources. For any historian or researcher, the detective work
alone is daunting. Perhaps someday an inclusive online data-
base will concentrate the study and analysis of this work, but
for now it is a time- and mind-consuming process. Therefore,
we must thank, indeed genuflect, before Heath Hinegardner,
our chief researcher, and Ringo Takahashi, both of Mirko
Ilić Corp. for their tireless, loyal and continually good-
natured efforts on behalf of this project. Without them this
would have been impossible.

We also want to thank the following for generously respond-
ing to continued requests for materials, information and
referrals. We cannot overstate their importance: Merrill C.
Berman and Jim Frank of the Merrill C. Berman Collection;
Crzysztof Dydo of Poster Gallery/Cracow, Poland; Remy
Squires of the Hoover Institution/Stanford; Sheila Taylor of
the London Transport Museum; David Burnhauser of the
Wolfsonian Institution of Decorative and Propaganda
Art/Miami; Jack Mellow, Jeff Roth, Roger Remington, Kari
Horowicz at the Wallace Library, Rochester Institute of
Technology; Michael Dooley, Rudy VanderLans at Émigré;
Maira Kalman and Meaghan Kombol at M & Co.; the
Chisholm-Larsson Gallery/New York; Ludger Saintelien at
the National Film Board of Canada; George Theofiles at
Miscellaneous Man; Rich West at Periodessy; Elaine Lustig
Cohen, Rick Poynor, John Walters at *EYE* magazine; Jack
Rennert at Posters International/New York; Jim Lapidus at
International Poster Gallery/Boston; Christopher Mount at
the Museum of Modern Art/New York; Neville Brody and
Sandra Steinebrunner at Research Studios; Gert Dumbar and
Gaby Schalk at Studio Dumbar; Gail Andersen at *Rolling
Stone*; David Batterham at David Batterham Books/London;
Irving Oaklander at Oaklander Books; Nicola Saunders at
Frederick Warne & Co.; Sally Waterman at Pentagram
London; Jim Brown at Pentagram New York; Andre Mathis at
AGI; Mark Armstrong at the Monarch Company; Philip B.
Meggs, Max Bruinsma, Joyce Kaye, *Print* magazine, Barbara
Kruger, Ellen Cober, Seymour Chwast, Lucille Tenazas,
Galie Jean-Louis, Louise Fili, Nicky Lindeman, Solenn
LeGrand, Laurie Haycock Makela, Cedomir Kostović, Robert
Massin, Luka Mjeda, Walter Bernard, Davor Vrankić,
Jonathan Rosen, Clement Mok and Lewis Blackwell.

A book is a collection of pages without its editor to help
shape them. Deep appreciation goes to Lynn Haller, who
acquired this book, understood its value to the design field
and continued to shepherd it through to completion. Thanks
to Linda Hwang, editor at North Light Books, for her con-
tinued support. And finally to James Victore for his impec-
cable design.

Steven Heller and Mirko Ilić

Dedication

To my wife Nicky
—MI

To my wife Louise
—SH

Table of Contents

Introduction: On the Shoulders of Genius (et al.)

"There is nothing new under the sun"—how often we hear that saying, uttered perhaps to console those who have no gift for discovery, or more likely to discourage the search for truths that might upset our complacency. —Herbert Read, *The Origins of Form in Art*, 1965

Pure art may be immaculately conceived; graphic design is not. Pure art inhabits almost any form and defines the forms that it takes. Graphic design is proscribed, communicating within delineated realms. While the sky is not the limit in graphic design, there are many ways to work within its confines. The history of graphic design is the legacy of attempts to expand the universe of visual communication.

This book is about the expanding universe. It is also about the consequent relationships between art and design, culture and design, and design and design. It is, therefore, about the interplay between fine and applied artists and how their collective innovations and derivations have influenced graphic design since the field took shape in the late nineteenth century. It is, in turn, about the impact of one hundred years of aesthetics, form and content on the look, feel and function of graphic communications, and how our antecedents shaped graphic design into an interdependent art form. Ultimately, it is about finding clues that reveal how the design language has evolved over time.

Through a survey of known and lesser-known affinities, this book follows the roots and routes of graphic design. Graphic design can either be ahead of or behind major artistic developments depending, of course, on the individual designers practicing at any particular time. Occasionally, pure art embraces commercial art as a means to an end. Such was the case with the early twentieth-century movements of Futurism and de Stijl, as well as the 1960s Fluxus group, where both pure and applied art forms were advanced simultaneously and complementarily. But on the whole, graphic design's progress ultimately depends on a client's tolerance for and the market's acceptance of original ideas. Furthermore, the clients (or patrons) are influenced by unpredictable social and economic conditions that may affect how designers address the problems they are asked to solve.

Yet it takes only one rogue to start a stampede. One designer with vision can inextricably change the direction of graphic design. Committees do not create innovative work, they strangle untested promise with consensus. Singular efforts make the difference. Sure, the casual audience may view graphic design (if they see it at all) as the ebbs and flows of discernable stylistic waves, but in truth even the most dominant styles are mélanges of idiosyncratic attributes.

In the final analysis, however, each of the constituent pieces comprises a whole. Individuals deposit ideas into a bank, yet every designer can make withdrawals. The original creator invariably bequeaths her discovery to everyone. Once it enters the public domain,

few characteristics of one's unique design, even the most proprietary, remain the sole ownership of an individual for long. Popularity is the great equalizer. Imitation is the ultimate response. Assimilation is the final outcome.

Graphic design, like all art, is built on the shoulders of genius and perpetuated by many others. The origin of the world's major graphic design styles, mannerisms and fashions, therefore, cannot always be pinpointed with precise accuracy. Innovations that develop here can turn up there without proper attribution simply because the elements that comprise graphic design are filtered and refined as the number of proponents increases. Early twentieth-century Modernism, for example, was not solely based on the uniform visual traits that today characterize its distinctive look (like black and red bars and sans serif gothic type). It began as an amalgam of various shared design decisions (i.e., preferences for mechanical instead of hand-drawn art, asymmetrical instead of symmetrical composition, etc.) that were initiated by individuals but were absorbed into an overall aesthetic and political philosophy. Likewise, mid-1980s Post-Modernism was not typified by layered, kinetic typography alone, but rather by the repetition of various design substyles that together forged an overall period style.

Modernism may be celebrated today as a revolutionary blow against antiquated, "old guard" methods, but in fact, it was born in fits and starts over a period of time. Similarly, Post-Modernism may seem to have sprung up overnight as a reaction against Modernism, but other alternative approaches (some with very similar decorative graphic attributes) had been percolating for years prior to the introduction of Post-Modernism as a full-blown international style.

As you can see, our roots and routes can be confusing. Yet it is necessary to address this confusion. And one way is to study past methods. Vintage graphic design tends to be classified in broad generalizations because stylistic or thematic generalizations are easier to comprehend than detailed taxonomies that address formal or theoretical complexity. But in fact, most designers only want a tertiary overview of design history. They are understandably more concerned with how their work will be judged by clients who pay the bills than by what phenomena came before them. In daily practice, knowing the origin of certain components of graphic design is usually of little consequence to a successful end-product.

And yet graphic design history *is* consequential because it separates the graphic designer's art and craft from mere client-driven service. And

with historical awareness, designers are a little less likely to regurgitate proscribed formulae that result in mediocre templates. "Graphic design is a language," wrote Philip Thompson in *The Dictionary of Visual Language* (Bergstrom & Boyle Books Limited, 1980). "Like other languages it has a vocabulary, grammar, syntax, rhetoric. It also has its cliché, but this is where the analogy ends."

The key to graphic design is knowing what to apply and how to revivify what is familiar. History provides insight for using the basic formal and stylistic tools. Yet this book is not a definitive history of form or style like Philip B. Meggs's *A History of Graphic Design* or Richard Hollis's *Graphic Design: A Concise History*. Since these historians track integral movements and individuals, repeating their respective findings would be redundant. So in this book, the standard chronology of accomplishments and litany of personae are replaced by an admittedly idiosyncratic visual survey of common recurring themes (such as ugliness, beauty, fantasy, etc.) and mechanisms (such as layering, blurring, handwriting, etc.).

Unearthing these traits (and relics) is something of an archeological dig. The slew of paper artifacts presented here reveal major, minor and speculative influences on the overall practice of graphic design. Showing that, over periods of time, many concepts and tools were reprised helps shed light on the evolution of our visual language. And it is fascinating to learn that various visual notions that might be considered unique to a particular time frame actually existed much earlier than previously accepted. For example, the use of the demonstrative pointing finger in patriotic political posters (see pages 38–39) was employed decades before the most familiar World War I-era American poster, "Uncle Sam Wants You." In fact, the poster artist, James Montgomery Flagg, borrowed this concept from three other nations' graphic arsenals, yet his reinvention tends to overshadow the originals. It is sobering to realize that even the most original piece of American iconography is rooted in precedent.

Patterns emerge from the aggregation of interconnected motifs and concepts that reveal both the truly unique and uniquely derivative ways that graphic designers have tackled a range of persistent problems. They highlight the continual reinvention of design elements within a finite realm. They also show the resourcefulness of designers as they attempt to unhinge the expectations of their audiences.

Examining these formal and fashionable traits—as well as the tics and quirks—of a century's worth of graphic design may sound a bit like speculating on the number of angels found on the head of a pin. You may ask: Other than the comparative girth of angels, does this exercise yield quantifiable data? What can we learn from a census of designers who used layered type, or outstretched hands or otherwise based their compositions on squares, triangles or circles? Admittedly, as an end in itself these findings are arcane. But assessing the influence

that these elements have had on design offers insight into how our shared visual language is applied over time.

Regardless of their genius (or lack thereof), graphic designers draw from the same sources of signs and symbols that date back to the turn of the century (if not antiquity). Even most of the extant typefaces are influenced by early archetypes, if not copies of the actual forms themselves. Until the onset of computer-aided design, for example, a mechanical produced in 1920 was constructed with the same materials and production methods as an editorial illustration using similar elements produced in 1980. When following old craft traditions, how can we not fail to be linked to the past?

Let's face it, graphic designers are cliché mongers. Yet don't be insulted (or embarrassed)—this is not as damning as it sounds. It is, however, the essential paradox. Although most designers' goal is to create work that is here and now, the majority of graphic communication is grounded in the tried and true. In *A Dictionary of Visual Language*, Philip Thompson explained that classic or "hackneyed" pieces of imagery "persist because they contain an essential truth that appeals to our collective sense of myth and form." The world understands these images at a glance. People don't necessarily relish learning a new language every time they open a magazine, read an advertisement or see a billboard. Yet neither do they want to be bored by what they read or see.

In printing jargon used during the late nineteenth- and mid-twentieth centuries, a cliché was a generic stock or clip art image that could be used to fill space or add visual interest to a page. In popular vernacular, however, a cliché is an overused word, phrase, metaphor or image. Eric Partridge wrote in *A Dictionary of Clichés*, "A cliché is a stereotyped expression—a phrase 'on tap' as it were." A cliché is, therefore, a formula. To use the word cliché in a critique about a work of art or graphic design is indeed the sharpest barb.

Yet visual clichés are also mnemonics, entry points and way-finders —both necessary and invaluable. The job of the contemporary designer is to somehow manipulate clichés by recasting their archetypal meaning. Mediocre designers use clichés without alteration, but clever designers invest timeworn veneers with new levels of meaning. Since graphic design is in large part a recycling of common imagery, then designers should squeeze out uncommon solutions. In *From Cliché to Archetype*, Marshall McLuhan offers a humorous anecdote about a teacher who challenged her students to use a familiar word in a new way. He writes, "One [student] read: 'The boy returned home with a cliché on his face.' Asked to explain his phrase, he said, 'The dictionary defines cliché as a worn-out expression.'" Like this young wiseguy, designers must also transform clichés from the expected to the unexpected. This is the most useful tool a design education can impart.

New thoughts, after all, rise from discarded old ones. Every designer builds on an existing premise or problem. And the majority of

design solutions derive from worn-out expressions. At best, these expressions are made totally new; at worst, they are derivative and formulaic. Although some designers would prefer to always answer the muse within, graphic design is the art of meeting challenges from without. "Today's archetype was yesterday's art form, day before yesterday's cliché, and the day before that, it was the last word," wrote Howard Gossage, an advertising executive. Only time determines the viability of a common design solution. So understanding how designers throughout history have solved basic conceptual problems validates the rationale that graphic design is a collection of familiar visual idioms and accents made new.

The old chestnut about there being nothing new under the sun is indeed just a poor excuse for idea-challenged designers. New ideas percolate all the time. The design annuals, not to mention the real world, are filled with posters, advertisements, CD packages, magazine covers, even Web sites that genuinely startle and surprise. Nonetheless, unique solutions are invariably derived from tested experience.

The word *new*, when applied to graphic design, does not mean "never before." The constraints imposed by clients, markets and technology demand that designers must invariably employ forms that the audience (or consumer) will easily comprehend. There is often little chance for total spontaneity. Of course, this does not mean that graphic designers are unable to be truly spontaneous or intuitive, but the limitations imposed by specific problems often demand predictable responses. What's more, spontaneity by itself does not ensure originality. Spontaneity often draws upon preconditioning, bringing forth semiconscious expressions of what is already known. Even the most vanguard graphic designer mediates rather than invents.

One can be a clever designer and still never once create something from whole cloth. But the clever designer knows how to marshal part or all of the extant design language to produce an unanticipated result.

Herbert Read wrote in *The Origins of Form in Art*, "We do not credit the midwife with the creation of the child she brings into the world…is there any more reason for crediting the artist with the creation of the work of art he spontaneously delivers?" The graphic designer is indeed something of a midwife who facilitates the birth of visual ideas from existing seminal forms. Moreover, just peruse the credits for any design competition or annual to find that other "midwives" were involved (art directors, typographers, illustrators, etc.). Perhaps a better synonym for *new* is *reborn*. One could argue that designers recombine the DNA of design into particular entities containing new ideas based on old forms. Graphic designers are, therefore, consummate re-creators. Yet for designers who want to create untested design, the perpetual link to the past offers a frustrating paradox.

Raymond Loewy, the industrial designer credited with significantly altering both the function and look of products and machines from the 1930s through the 1960s, recognized this paradox and developed a principle that he called "Most Advanced Yet Acceptable." In this "MAYA Principle" Loewy outlined the necessity for maintaining a balance between the unprecedented and the familiar. The pursuit of progress, he argued, must be gauged by the public's ability to understand, appreciate and ultimately accept change. In Loewy's calculus, few designs could function that did not meet this standard. Even if a prototype might be accepted at a later time and place, if it failed to work when introduced it was a failure. Originality is, therefore, linked to success, which is determined by its effect on an audience rather than on its inherent attributes. And with this premise in mind, Herbert Read questioned, "Is originality, then, merely a contrast to the typical style of any period, itself destined to sink to the level of the commonplace as it becomes acceptable to a wider public?" And answered thusly: "That might be an acceptable generalization if there were not this difference between the genius that retains its brightness, as Shakespeare's genius has done, and the genius that simply fades away."

What the authors of this book call the "genius dichotomy" is central to the pursuit of originality in graphic design. On one hand are form-giver-geniuses, who have contributed to the language of design by developing archetypes; on the other are stylist-geniuses, who exert momentary influence on the surface of form. Sometimes these traits are found in the same individual. Yet true form-givers are rarer than stylists, because new form is obviously rarer than transient surface modes. Our culture values the true inventor, but celebrates the decorator who alters surface while retaining familiar form.

Contemporary consumer society loves "new and improved"-ness. In the 1930s, advertising executive Earnest Elmo Calkins promoted a principle called "styling the goods" that evolved into "forced obsolescence" or the planned discontinuation of styles. The premise was that with changing veneers, consumers would desire new products even if the old ones still functioned. This consuming pressure made people yearn to be surprised—to expect the unexpected—but not to be shocked off their keesters. And this is true today. Consumers want novel, not radical. In the first half of the twentieth century, the principal shifts in graphic design took place within insular art movements and were filtered back into the commercial arena by interpreters and entrepreneurs. Although artists belonging to de Stijl, Dada and Futurism, for example, vociferously advocated the marriage of art and design, the mainstream manifestation of this union was popularized only after the sharp edges were dulled just enough to be acceptable to mass-market standards. Which is not to suggest that, say, The New Typography (and the other Modern design idioms of the 1920s that influenced commercial art) were not convention-busting. It does, however, suggest that by the time that mass-market advertising agencies began applying Modern motifs to magazine and billboard ads, the results were not so advanced that they were unacceptable.

Graphic designers have three primary responsibilities—to frame, to attract and to impart—from which emanates all other creative activity. Design must viably frame messages for optimum allure to attract the eye. Then it must impart an idea or deposit a "mental cookie" so that the audience receives and retains the message. Of course, there are many ways to accomplish these goals. Regardless of what forms are used, however, composition is paramount. How a work is composed and what elements are used ultimately determines whether meaning will be sent from the sender to the receiver without interference. It is in this context that the clichés we have been talking about are the brick and mortar of design. Once the structure is built, then all kinds of decoration, ornamentation, and style can be added.

So, in addition to its other claims, this book is also a building materials catalog. Each example herein has its own integrity and most are indeed valued for having contributed to the language of graphic design, as well as for impacting the social, political, or cultural environment. But when viewed as a catalog—of methods, manners, ideas—the works are component parts stored in a massive warehouse. Designers can reference them in the same way that one orders construction or plumbing supplies. Once installed, they can be used in designs with as many or few alterations as needed. As in an industrial catalog, these materials are grouped together according to shared formal references—i.e., structural, decorative, functional, contextual—as well as unconventional sets of criteria that address motivation and aesthetics.

The theory behind this book is simple: to examine as efficiently as possible the shared visual language, its various dialects and the many contributions that have been made to it over the past century. In order to accomplish this in an illuminating way we have designated one hundred single works, each representing one year of the twentieth century as a centerpiece around which other examples, which either influenced it or were influenced by it, revolve. Additionally, each of these main pieces represents a specific stylistic, thematic or conceptual genre or component of the language. Selection of the principal work was made based on its relative importance to other work produced at the same time in the same genre.

The selection is arguably arbitrary, for in some years multiple archetypes were clustered, while in others there were very few examples to choose from. We do not presume to have made a definitive historical decision and admit to using subjective criteria. This is not a book about the one hundred most significant graphic designs of the twentieth century (although some might be so considered). Admittedly, the chronological principal is simply an organizing tool that helps us arrive at our primary concern: to sample a variety of interrelationships.

In addition to the principal work, each year (each spread) includes at least four other works. Two were created before the principal and two afterward. The rationale for this juxtaposition is to show both precedence and influence, or how the principal work both drew upon existing ideas and impacted subsequent ones. Again, we are not definitively claiming that the featured piece is the Rosetta Stone or Holy Grail, but in our estimation it is a viable touchstone of a particular approach.

For the 1906 spread exploring flatness, for example, we selected Lucian Bernhard's Priester Match poster because it represents a major shift in design methodology from fussy and detailed to simplified or "objectified" execution. By using this example, we are able to illustrate how Bernhard was influenced by work that preceded his own, and how his work influenced others at the same time and decades later. Similarly, for the 1949 spread on title page constructions we selected Merle Armitage's book title spread for *Igor Stravinsky* because it exemplifies the practice of building typographic architecture over two pages. This example enables us to show the development of this key aspect of book design from the 1920s to the more recent past. For the 1940 spread on dimensional letters, we selected Norman Bel Geddes's book jacket for *Magic Motorways*, a treatise on "streamline" design, as the hub around which we show how other designers used mass, volume and shadow to give the illusion of three-dimensional letterforms on a two-dimensional surface.

Every spread in this book is designed to give the reader a visual overview of both direct and indirect influences in specific realms of application. We do not claim (and cannot prove) that in each case the designer actually referenced the earlier material. We acknowledge that comparable ideas are often in the air, or that the inherent function dictates a similar execution. Yet we do assert that the visual relationships are not entirely coincidental. The repetition of forms and themes underscores the communal nature of graphic design. And even the most original approaches employ and rely on elements from distant and recent pasts.

Graphic design routinely regenerates itself to meet the stylistic and conceptual needs of the market and the individual creator. Because it is rooted in a universal language, its innovators are often judged by a lesser standard than fine artists. Nonetheless, in the universe of mass culture, graphic designers push accepted norms and alter popular perceptions. Pure art may stimulate overall cultural change, often in unpredictable ways, but graphic design popularizes and quantifies these and other shifts in the visual environment on a popular stage. Graphic design filters the shocking into the acceptable, it transforms the cutting edge into the vernacular. But it also helps establish levels of acceptance that raise visual literacy. In conveying ordinary messages to the general public, designers often make unique ideas into visual clichés. But it takes a genius to make the prototype that, ultimately, everybody understands.

Expressive Hands

Expressive letterforms have long been a staple of graphic design. The pen and brush have always been as mighty as the printing press, camera and computer mouse. Throughout history, designers have developed idiosyncratic alphabets to serve as both illustration and decoration.

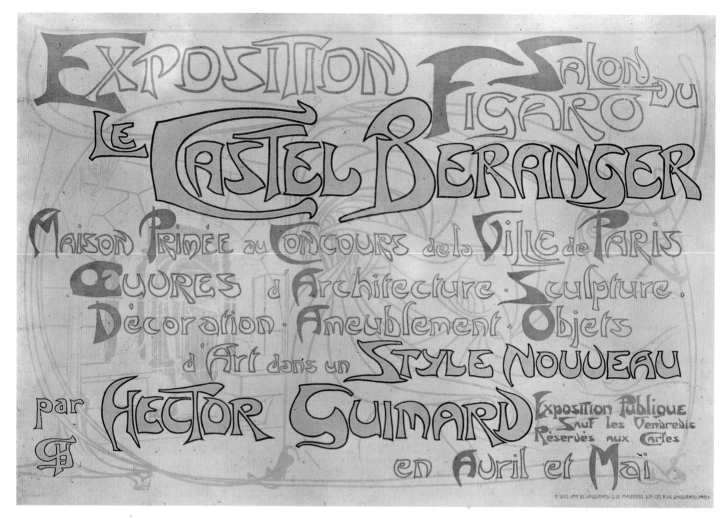

1900
Hector Guimard
Exposition Salon du Figaro le Castel Beranger
Lithograph, 35" x 49¼"
Collection, The Museum of Modern Art New York. Gift of Lillian Nassau.

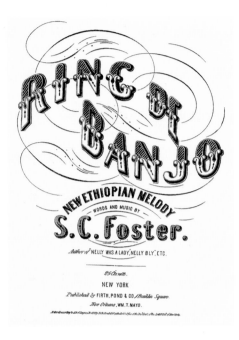

1851
Artist unknown
"Ring de Banjo"
Sheet music cover

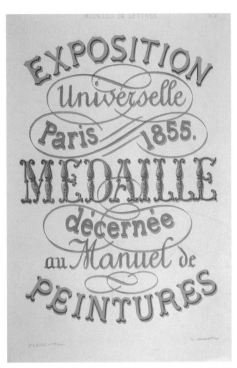

1855
Artist unknown
Exposition Universelle
Book title page

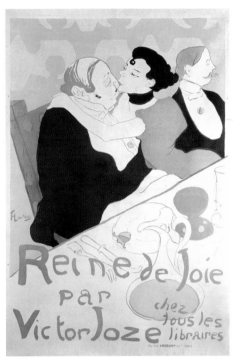

1892
Henri de Toulouse-Lautrec
Reine de Joie
Poster
Poster Photo Archives, Posters Please, Inc., New York City

After

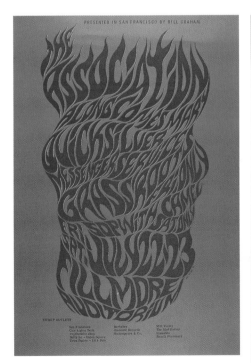

1966
Wes Wilson
The Association
Poster

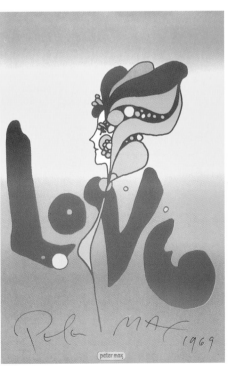

1969
Peter Max
Love
Poster
© Peter Max

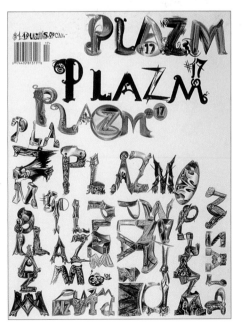

1998
Edward Fella, letterer
Josh Berger, art director
Plazm
Magazine cover

Kids' Stories

Children's book illustration defies the categories of Modernism, Postmodernism, et al. Children do not care a whit about -isms; for them the story reigns supreme. And narrative pictorial storytelling, wherein the images complement and supplement text, is as fundamental to this genre as the figure is to art.

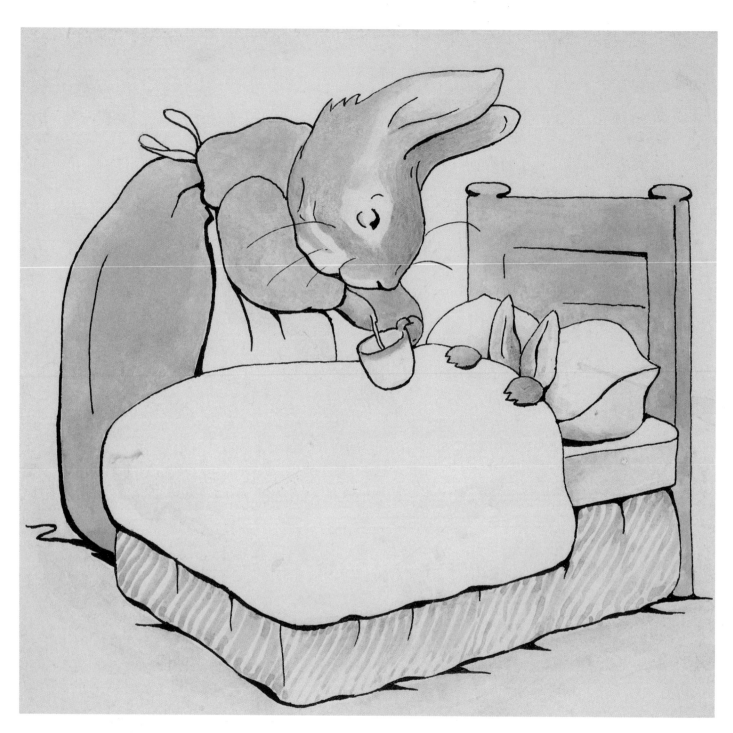

1901
Beatrix Potter
"First he ate some lettuces"
(from *The Adventures of Peter Rabbit*)
Watercolor illustration
© Frederick Warne & Co., 1902, 1987
Reproduced by kind permission of Frederick Warne & Co.

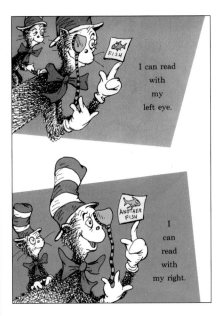

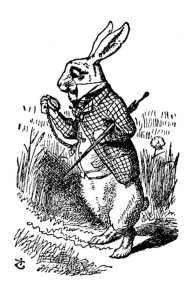

1956
Eve Titus
Paul Galdone, illustrator
Anatole
Book illustration
© 1956 by Eve Titus and Paul Galdone. Used by permission
of Bantam Books, a division of Random House, Inc.

1956
Dr. Seuss
I Can Read With My Eyes Shut
Book illustration
© Dr. Seuss Enterprises, L.P. 1978. Reprinted by permission of Random House
Children's Books, a division of Random House, Inc.

1865
John Tenniel
Alice's Adventures in Wonderland
Line drawing

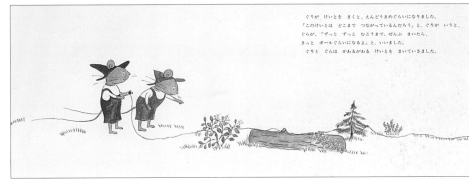

1979
Yamawaki Yuriko
Guri to Gura no Ensoku
Book illustration

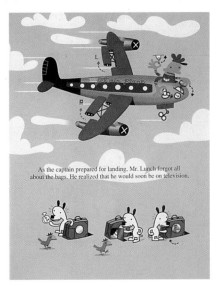

c. 1868
Gustave Doré
"The Wolf Turned Shepherd"
(from *Fables of La Fontaine*)
Line drawing

1991
Leo Lionni
Matthew's Dream
Book illustration

1993
J. Otto Seibold
Mr. Lunch Takes a Plane Ride
Book illustration

Patterns Personified

Posters must instantaneously attract the viewer's eye. The means, however, vary: Stark image, pithy headline and graphic pattern are among the most common. Repeated patterns are both hooks and mnemonics that can frame or underscore the textual message.

— 1902

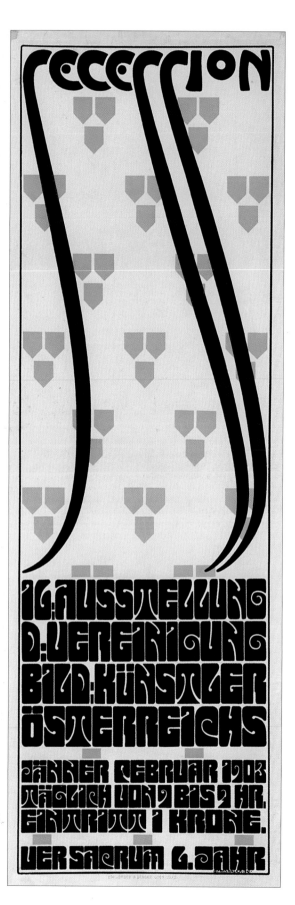

1902
Alfred Roller
Secession 16
Poster

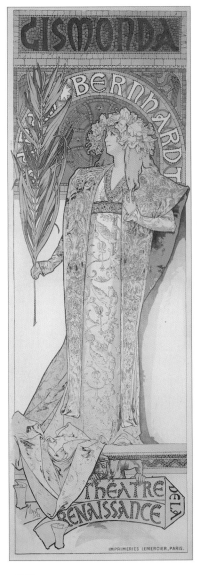

1894
Alphonse Mucha
Gismonda
Poster
Poster Photo Archives, Posters Please, Inc., New York City

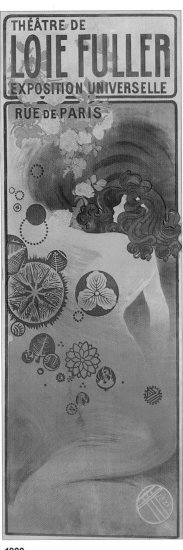

1900
Emmanuel Orazi
Théâtre de Loie Fuller, Exposition Universelle
Poster
Poster Photo Archives, Posters Please, Inc., New York City

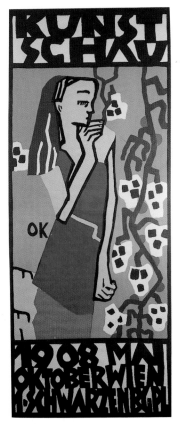

1908
Oskar Kokoschka
Kunst Schau
Poster

1967
Wes Wilson
The Byrds at the Fillmore
Poster
Courtesy of Wes Wilson

Political Polemics

Design in the service of politics, particularly the covers of polemic or propaganda magazines, has been fairly consistent throughout the twentieth century and before. Stark representational or allusive symbolic drawings, paintings, collage and montage are used as narratives of and signposts for a cause or issue.

Before

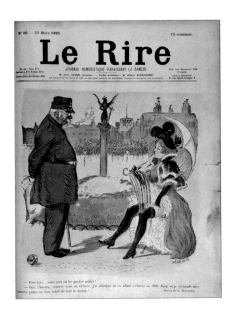

1895
Artist unknown
Le Rire
Magazine cover

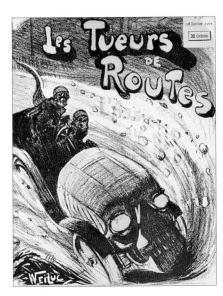

1902
Weiluc
"Les Tueurs de Routes"
L'Assiette au Beurre
Magazine cover

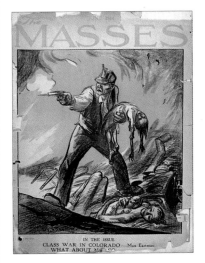

1914
John Sloan
Masses
Magazine cover

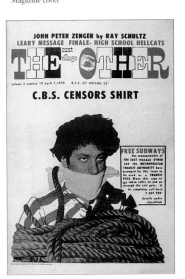

1969
Stephen Cohn, designer
The East Village Other
Magazine cover

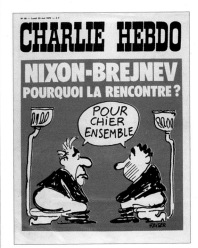

1972
Reiser
Charlie Hebdo
Magazine cover

After

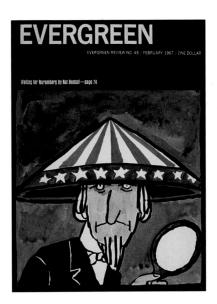

1967
Ken Deardorf, art director
Tom Ungerer, illustrator
Evergreen Review
Magazine cover

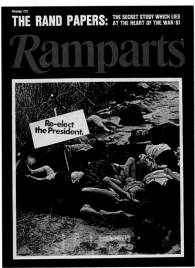

1972
Dugald Stermer, art director
Ramparts
Magazine cover

Facial Symmetry

The human face is not symmetrical at all—eyes, nose, mouth are routinely off-kilter. But the "typographic face," visages made by combining letters and typographic material, invariably reduces the human form to simplified component parts. While certain letters logically substitute for an eye (*O*) or nose (*L*), sometimes designers find unpredictable replacement parts to add personality.

Before

After

c. fifteenth century
Artist unknown
Mohommed, Hassan and Ali
Arabic text

1924
Wilhelm de Roos
Detors
Book cover

1924
Prof. Emil Preetorius
K & B
Logo

1514
Designer unknown
Heir of Octaviano Scotus de Modoetia
Symbol

1960
Paul Rand
Westinghouse
Logo

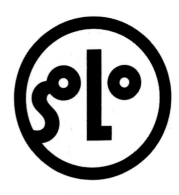

1991
Seymour Chwast
Solo
Logo

1850
Designer unknown
J.G. Schelter and Giesecke
Logo

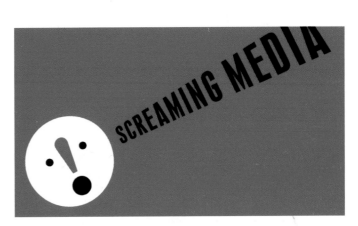

1999
Milton Glaser
Screaming Media
Logo

Squaring Off

Designers have long been obsessed with fitting type into geometrically prescribed areas on a page, such as squares, rectangles, even triangles. It is a challenge to do so without distorting or contorting the letters. In hot metal it was an excruciatingly difficult job; with contemporary digital media it is a keystroke away.

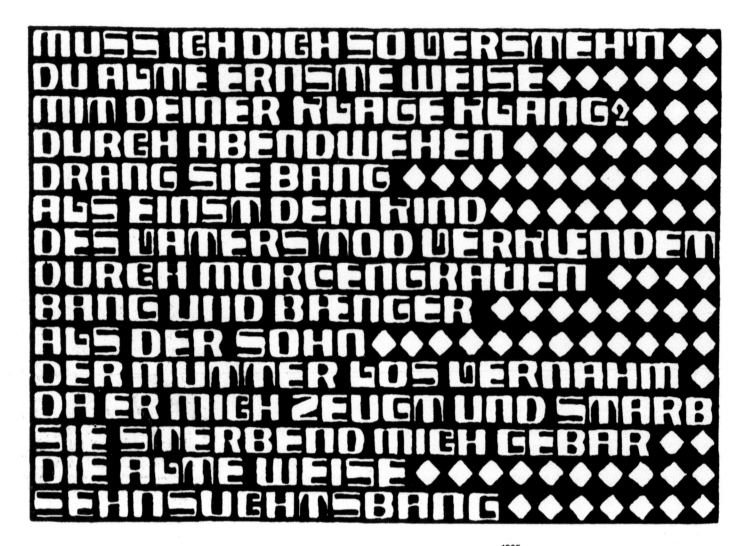

1905
Carl Otto Czeschka
Muss ich dich soversmeh'n
Typographic maquet

c. 1470
Artist unknown
Ars Memorandi per Figuras Evangelistarum
Manuscript page

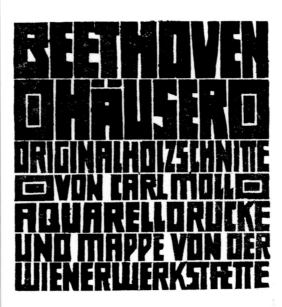

c. 1910
Carl Moll
Beethoven Häuser
Catalog cover

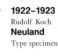

1922–1923
Rudolf Koch
Neuland
Type specimen

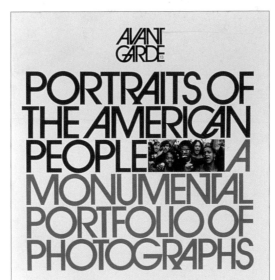

1478
Giovanni and Alberto Alvise
Ars Moriendi
Title page

1971
Herb Lubalin
Portraits of the American People
Magazine cover
Courtesy Herb Lubalin Study Center, New York

Objective Economy

Reduction was a radical concept back in 1896, when the British poster artists known as the Beggarstaff Brothers designed their earliest posters, which stripped away all but essential visual information. When German designer Lucian Bernhard designed the Priester poster in 1906, he further launched a major style of visual economy that focused exclusively on the object being advertised—hence the name "Object Poster" was affixed to the style.

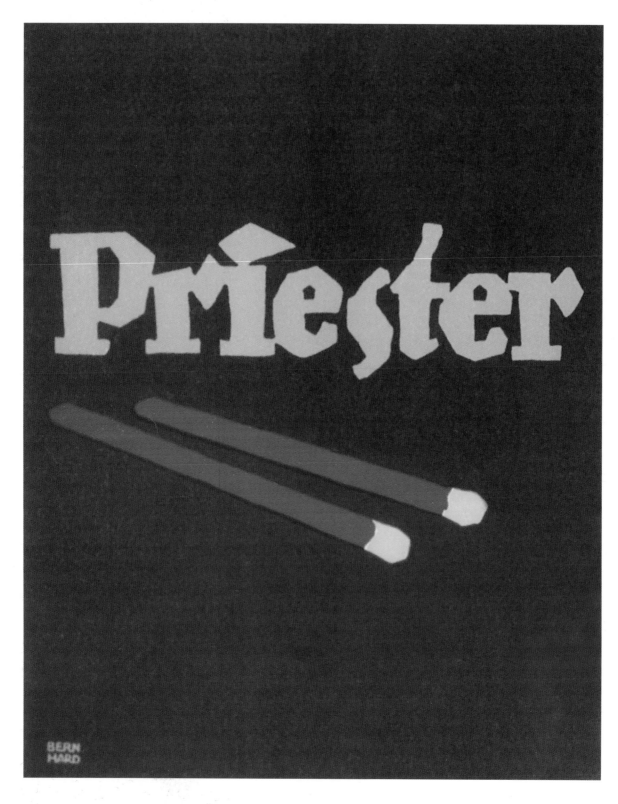

1906
Lucian Bernhard
Priester match company
Poster

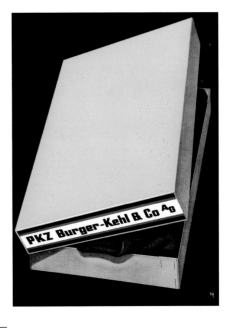

1935
Alex W. Diggelmann
PKZ: Burger-Kehl & Co.
Poster

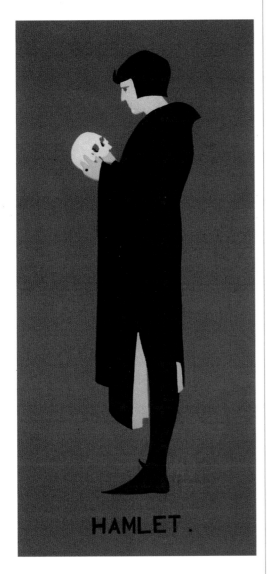

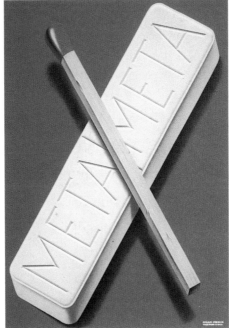

1894
The Beggarstaffs (William Nicholson and James Pryde)
Hamlet
Poster

1941
Niklaus Stoecklin
Meta-Meta
Poster

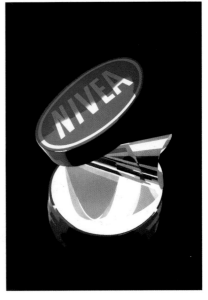

1948
Ruodi Barth and Fritz Bühler
Nivea
Advertisement

Flat Men

Removing extraneous decoration and detail was not only a
style but a mission. It meant simplifying objects and the
human form, not to mere lines and circles, but to flat, stylized
everymen who served as virtual mannequins on the printed
page. Color, pattern and geometry played the more important
graphic role.

—— 1907

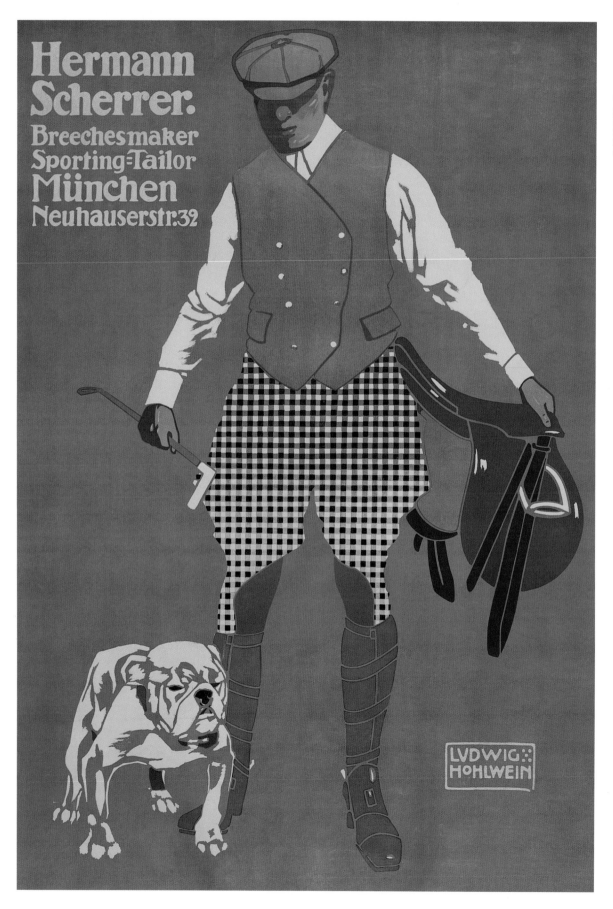

1907
Ludwig Holwein
Herman Scherrer
Breechesmaker
Sporting-Tailor
Poster

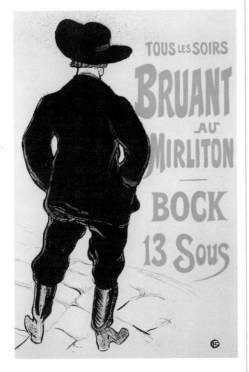

1894
Henri de Toulouse-Lautrec
Bruant au Mirliton
Poster

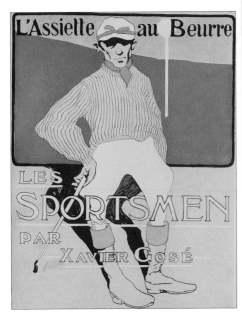

1902
Galantra
"Les Sportsmen"
L'Assiette au Beurre
Magazine cover

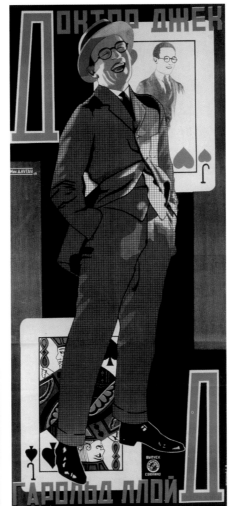

1928
Mikhail Dlugach
Doctor Jack
Poster

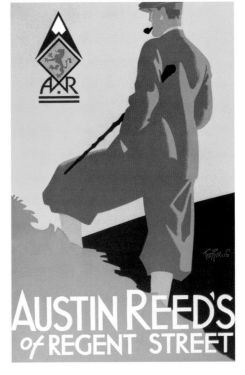

1928
Austin Cooper
Austin Reed's of Regent Street
Poster

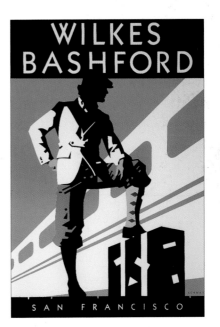

1989
Michael Schwab
Wilkes Bashford, San Francisco
Poster

Play Books

Tricky and clever printing techniques, such as die cuts, fold-outs and accordion folds, have been extant since the mid-nineteenth century (when many children's books were produced by hand). Today, the urge to transform a book into an interactive toy is common, yet continues to be influenced by the early (often primitive) attempts. For designers in this genre, the joy and wonder continues.

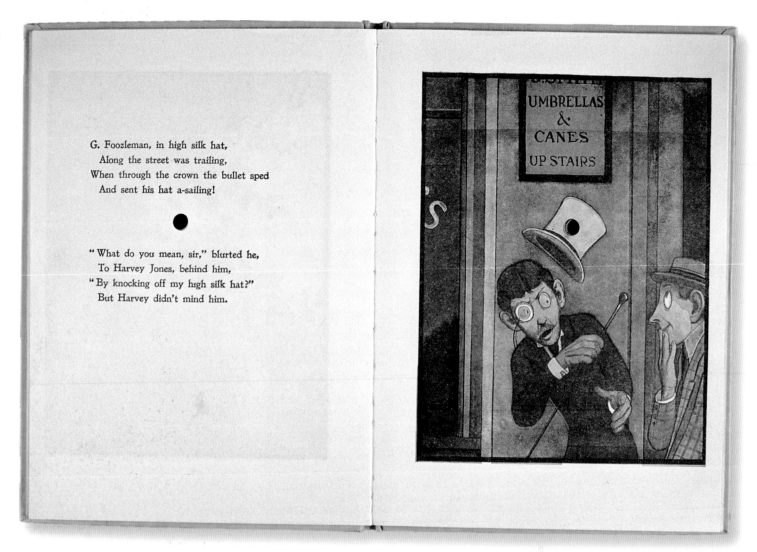

G. Foozleman, in high silk hat,
 Along the street was trailing,
When through the crown the bullet sped
 And sent his hat a-sailing!

"What do you mean, sir," blurted he,
 To Harvey Jones, behind him,
"By knocking off my high silk hat?"
 But Harvey didn't mind him.

1908
Peter Newell
The Hole Book
Children's book

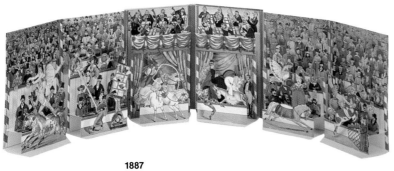

1887
Lothar Meggendorfer
International Circus
Children's book

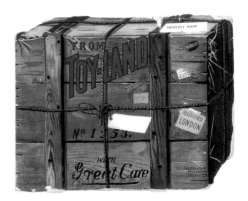

1880s
Designer unknown
(Publisher: Frederick Warne and Co., London)
Toyland
Children's book

1962
Bob Gill
A to Z
Children's book
© 1962 by Bob Gill

1968
Bruno Munari
The Circus in the Mist
Children's book

1972
Seymour Chwast
Limerickricks
Children's book

1981
Jan Pienkowski
Robot
Children's book

Long-legged Fantasy

Exaggeration is key to comic art and surreal fantasy—whether aimed at children or adults. And just as giants routinely capture one's imagination, the graphic elongation of human and animal body parts and commonplace inanimate objects is a principal way to express mystery and give life to absurdity.

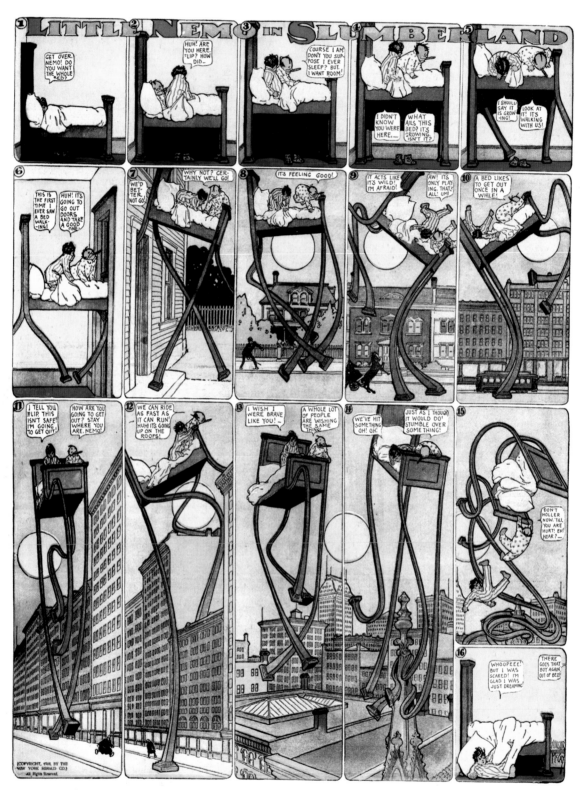

1909
Windsor McCay
Little Nemo in Slumberland
Comic page

c. 1850s–1860s
Edward Lear
There Was an Old Man of Coblenz…
Book illustration

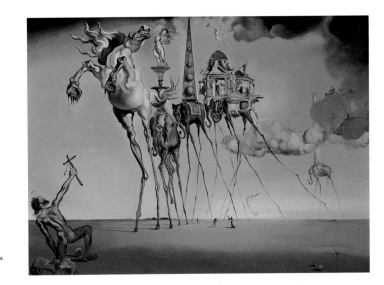

1947
Salvador Dali
***The Temptation of
St. Anthony***
Painting
Musées royaux des Beaux-Arts de
Belgique, Bruxelles Koninklijke Musea
voor Schone Kunsten van België,
Brussels

1968
Heinz Edelmann
**The Beatles:
*Yellow Submarine***
Animation
© Subafilms Ltd.

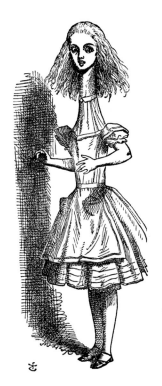

1856
John Tenniel
"She was now rather more than nine feet high"
(from *Alice in Wonderland*)
Book illustration

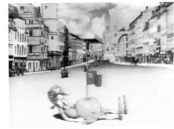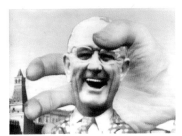

1971
Terry Gilliam
***Monty Python's
Flying Circus***
Animation
© Python (Monty) Pictures, Ltd.

Grid Locks

Whoever claimed that the grid was a Modernist invention born of Machine Age precision was mistaken. Sure, the grid was rigidly applied throughout the 1950s during the heyday of the Swiss International Style, but it started in antiquity and continued throughout the ensuing centuries in more or less the same rational way (occasionally, however, with decorative flourish).

1910

1910
Fritz Helmut (F.H.) Ehmke
Fr. Wilhelm Ruhfus-Dortmund
Billhead

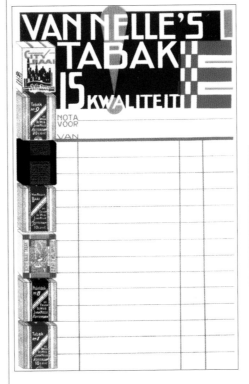

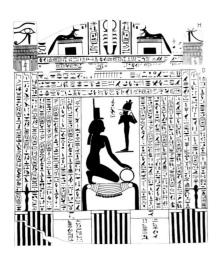

c. 593–568 B.C.
Artist unknown
**Egyptian Sarcophagus of
Aspalta, King of Ethiopia**

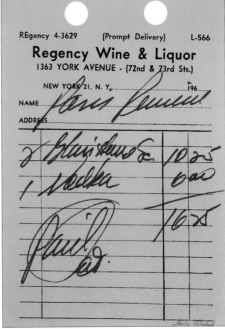

c. 1926
Jac. Jongert
Van Nelle's Tabak
Restaurant check

1967
Andy Warhol
Print for the *Paris Review*
Silk-screen
© 2000 Andy Warhol Foundation for the Visual Arts, ARS, New York

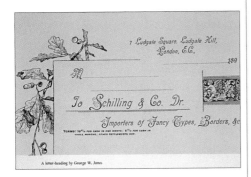

c. 1890
Designer unknown
Schilling & Co.
Billhead

1978
Dan Friedman
Chicken Little's
Order form

1995
Charles Spencer Anderson Design Company
Charles Spencer Anderson, art director
Joel Templin, designer
Paul Howalt, designer
CSA Archives
Stationery

Classic Man

Classic sculpture and painting doubtless influenced the graphic artist. The muscular form, as Leonardo might have rendered him in stone or on canvas, evokes an aura of heroic invincibility. But invincible or not, propriety as defined by the mores of the early twentieth century demanded that the figure be viewed from behind.

1911

1911
Artist unknown
Inchiostri da Scrivere
Poster

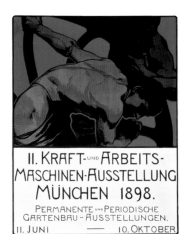

1898
Adolf Münzer, designer
Second Exhibition of Engines and Machinery…
Poster, commercial color lithograph
The Mitchell Wolfson Jr. Collection,
The Wolfsonian-Florida International University,
Miami Beach, Florida. Photo by Bruce White.

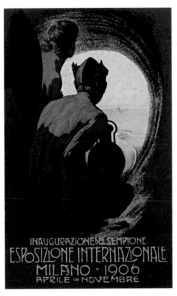

1906
Leopoldo Metlicovitz
Simplon Tunnels
Poster

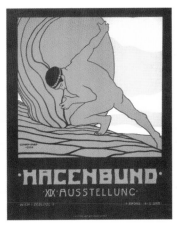

1906
Imre Simay
Association of artists of Hagen
Poster

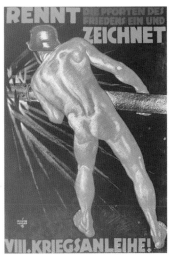

c. 1910
Mayer-Lukas
Rennt Zeichnet
Poster

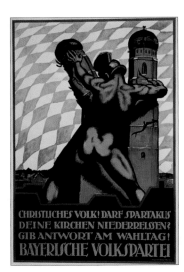

1919
Hermann Keimel
Bayerische Volkspartei
Poster
The Hoover Institution Archives, Stanford, California

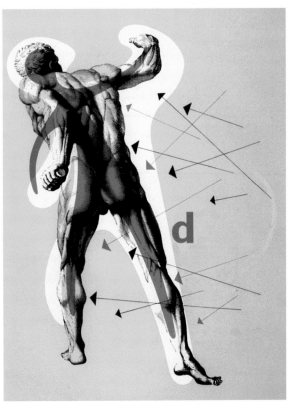

c. 1945
Matthew Leibowitz
Male torso
Brochure cover

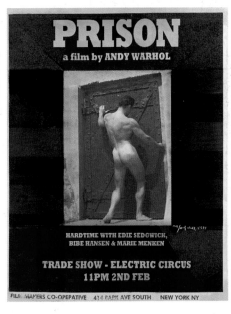

1965
Andy Warhol
***Prison*, a film by Andy Warhol**
Poster
Courtesy The Reel Poster Gallery
© 2000 Andy Warhol Foundation
for the Visual Arts, ARS, New York

Expressionist Truth

Expressing an inner truth is an artistic challenge and conceptual mandate for many artists. How to re-create the interior self on the exterior page is a problem solved only by the ability to assign a particular gesture to a certain feeling or make a distinct color represent a hidden emotion.

— 1912

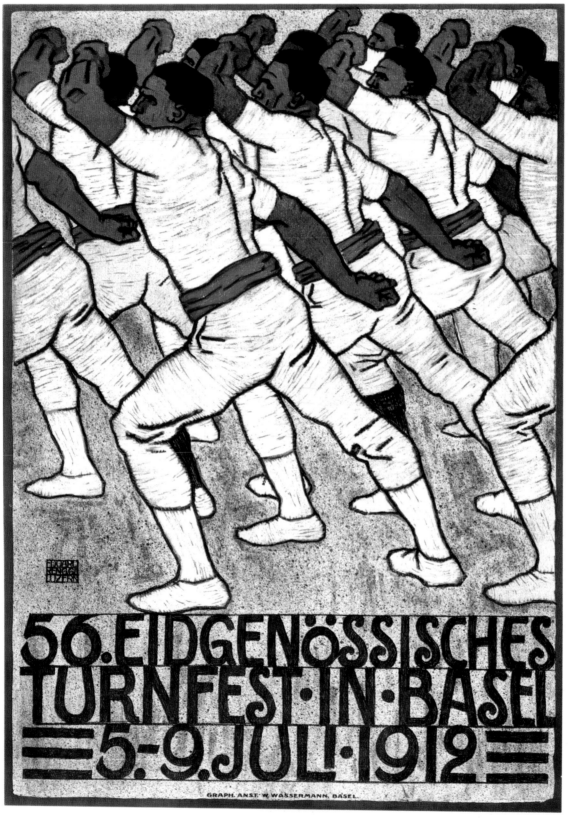

1912
Eduard Renggli
56th National Gymnastics Festival in Basel
Poster

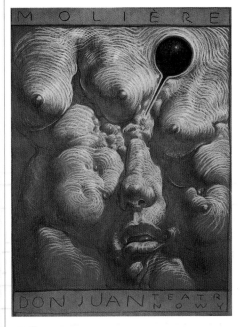

1983
Franciszek Starowieyski
Molière, *Don Juan*
Poster
Courtesy Dydo Poster Collection,
Crzysztof Dydo, Poster Gallery Cracow,
Ul. Stolarska 8–10, 31–043 Kraków, Poland

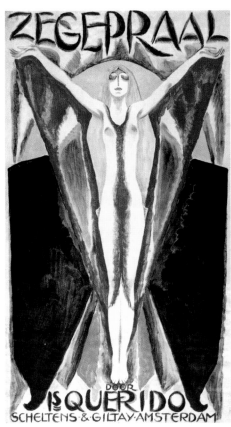

c. 1904
Jan Sluyters
Israel Querido's *Victory*
Poster

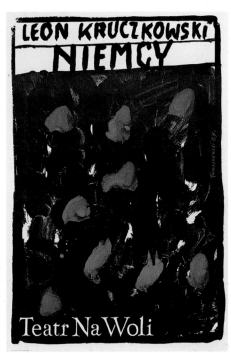

1984
Henryk Tomaszewski
Niemcy
Poster
Courtesy Dydo Poster Collection,
Crzysztof Dydo, Poster Gallery Cracow,
Ul. Stolarska 8–10, 31–043 Kraków, Poland

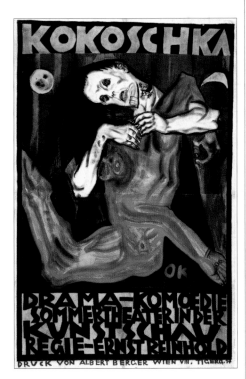

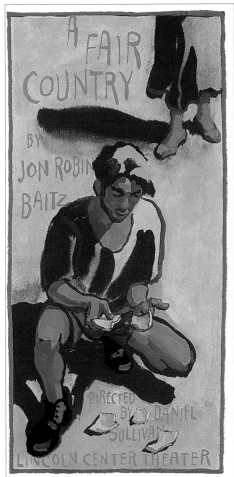

1907
Oskar Kokoschka
Drama-Komoedie
Poster

1996
James McMullan
A Fair Country
Poster

Hypnotic Meandering

Think of a roadmap: One follows a meandering line to a destination. Likewise, the meandering graphic pattern—whether curvilinear, rectilinear, whatever—can draw the viewer either into the core or far from a message. As a maze, it invites interactivity; as a border, it delineates space.

— 1913

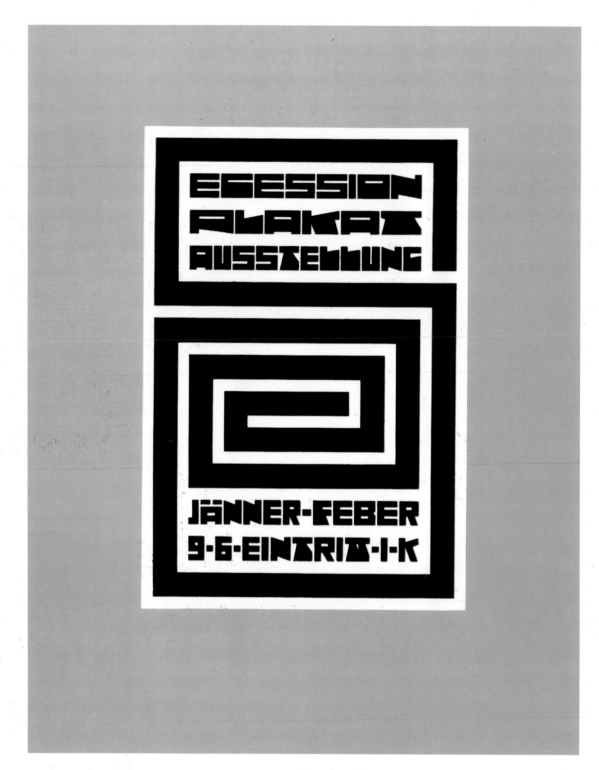

1913
Richard Harlfinger
Secession poster exhibition
Poster

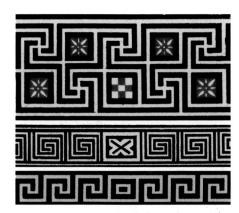

Date unknown
Ancient Greek patterns

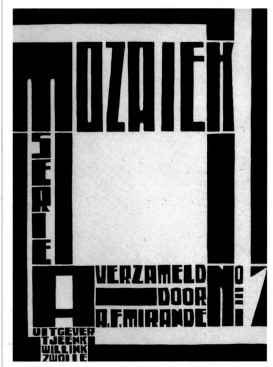

1925
Designer unknown
Mozaiek
Magazine cover

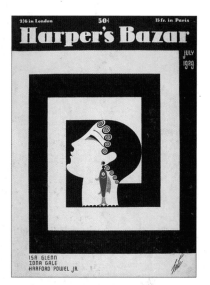

1929
Erté (Romain de Tirtoff)
Harper's Bazar
Magazine cover

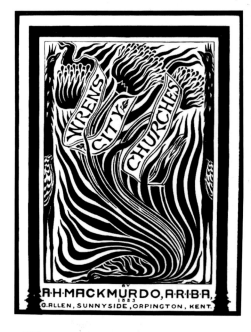

1883
A.H. Mackmurdo
Wrens City Churches
Book cover

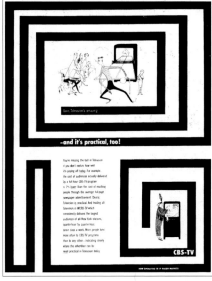

c. 1952
Jan Belt and Mort Rubenstein
"Sure, television's amazing…"
(CBS)
Advertisement

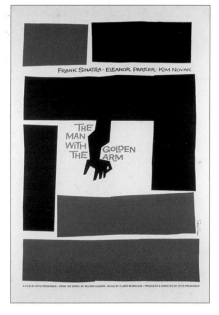

1955
Saul Bass
The Man With a Golden Arm
Poster

J'Accuse

What is it about an outstretched pointing finger that grabs us? Is it really the pointer who exerts the strength? Or is it the finger itself, like some disembodied icon, the potent force, indeed as powerful as the world's most graphic symbols? When the finger is aimed directly at the viewer, it is difficult not to be dragged into its magnetic field.

1914

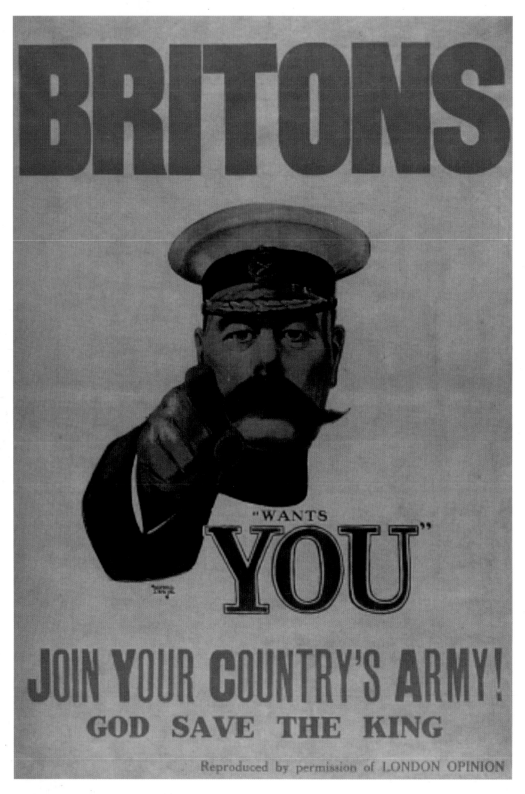

1914
Alfred Leete
Britons [Lord Kitchener] wants YOU
Poster

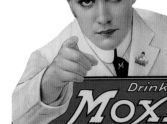

c. 1911
Artist unknown
Moxie Man
Countertop display

c. 1900
Printer's dingbat

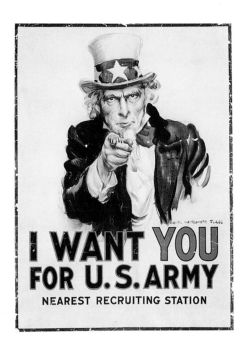

1917
James Montgomery Flagg
I want YOU for U.S. Army
Poster

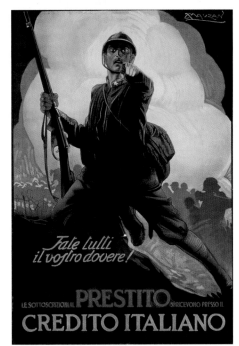

1917
Achille Luciano Mauzan
Do your duty!
Poster
The Hoover Institution Archives, Stanford, California

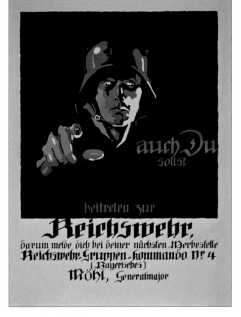

1919
Julius Ussy Engelhard
You too should join the Reichswehr
Poster
The Hoover Institution Archives, Stanford, California

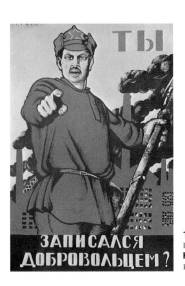

1920
Dimitri Moor
Have you volunteered for the Red Army?
Poster

1986
Shigeo Fukuda
Untitled
Poster

Chaos Principle

Random type is a Modern reaction to rigid, conventional, symmetrical composition—at least in part. It is also a means of expressing meaning in a nonlinear configuration. What began as a poetic alternative to linear text ultimately evolved with repeated use into a decorative mannerism.

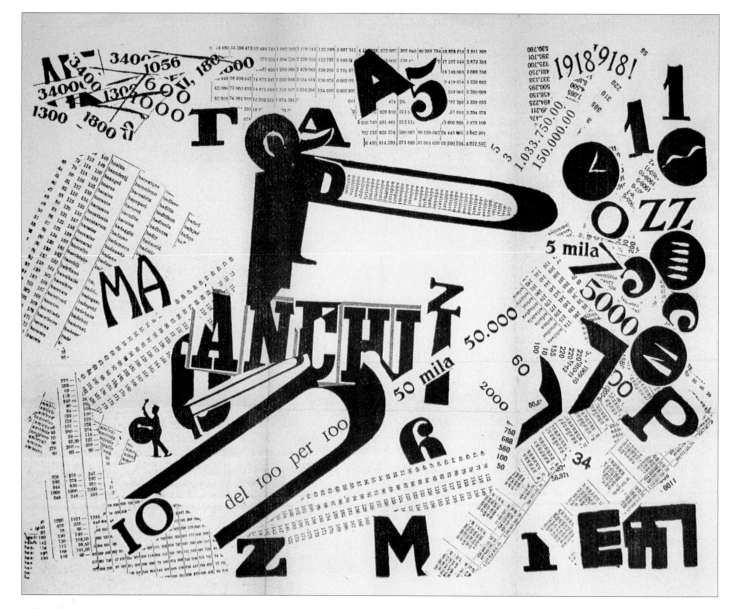

1915
F.T. Marinetti
Les Mots en Liberté Futuristes
Book cover

1914
Cangiullo
Grande Foul sur la Piazza
Aquarelle and ink

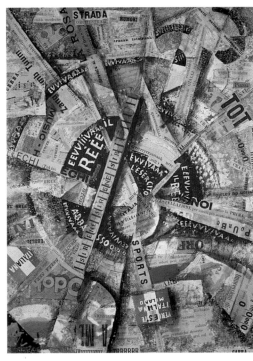

1914
Carlo Carré
*Manifestazione
Interventionniste ou
Peinture-Mots en Liberte*
Collage on cardboard
Giraudon/Art Resource, NY
© VAGA, NY Coll. Mattioli, Milan, Italy

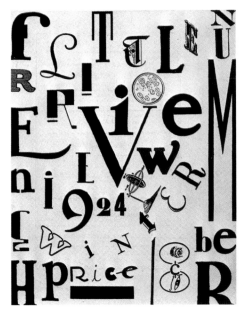

1924
Max Ernst
The Little Review
Magazine cover

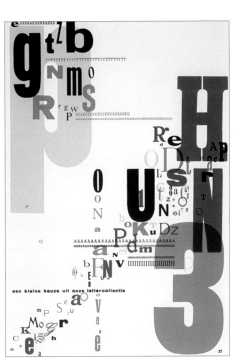

1928
Piet Zwart
Trio
Catalog page

1991
Neville Brody
F State, Fuse 1
Poster
Courtesy FontShop International

Metaphoric Type

Before sound recordings were invented, type approximated sound. Before film, type served the function of both word and picture. The application of type as metaphor has allowed designers to communicate two or more messages at one time, and in the bargain provide indelible *aides de memoire.*

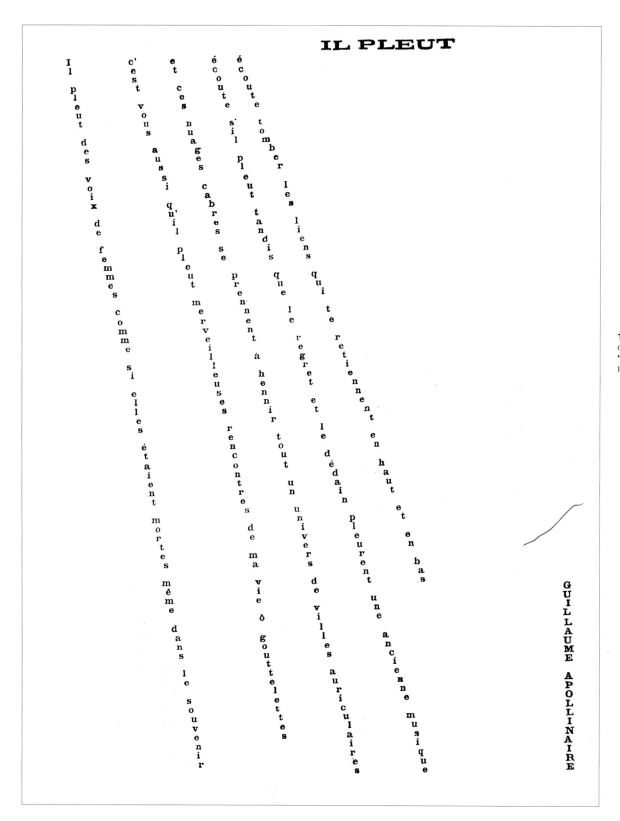

1916

Guillaume Apollinaire
"It Rains"
Page from *Calligrammes*

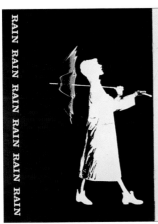

c. tenth century
Aratus manuscript

Bouteille,
Merveille
De mon cœur,
Ta liqueur
Vermeille
Me séduit,
M'enchaine,
M'entraine,
Agrandit
Mon esprit,
L'enflamme
Et produit
Sur mon ame
Le bien le plus doux!
Au bruit de tes glouglous
Quelle ame ne serait ravie !
Tu sais nous faire supporter
Les plus noirs chagrins de la vie,
Et des tourmens (plus affreux) de l'envie
Par des chemins de fleurs tu sais nous écarter.
Loin de toi qui pourrait encor trouver des charmes?
A tes coups séduisans qui pourrait résister ,
Quand le puissant Amour à tes pieds met ses armes,
Pour accroître sa force, et mieux blesser après
Les cœurs indifférens qui bravent ses succès
Et les heureux effets que produit ton génie ?...
Mais combien de mortels ont chanté mieux que moi,
Mieux que moi célébré ta puissance infinie,
Et fait de te chérir leur souverain loi !
Piron, Collé, Panard, Vadé, Favard, Sedaine,
En adorant ton culte, ont illustré la scène,
Et nous ont tous appris à n'oublier jamais
Que le feu des plaisirs qui circule en nos ames;
Besoin d'aimer, d'éteindre douces flammes,
Sont les moins grands de tes bienfaits.

1818
Pierre Capelle
"Chansons et Poésies Diverse de Capelle"
Poem

so that her idea of the tale was something like
this :——"Fury said to
a mouse, That
he met
in the
house,
' Let us
both go
to law :
I will
prosecute
you.—
Come, I'll
take no
denial ;
We must
have a
trial :
For
really
this
morning
I've
nothing
to do.'
Said the
mouse to
the cur,
' Such a
trial,
dear sir,
With no
jury or
judge,
would be
wasting
our breath.'
' I'll be
judge,
I'll be
jury,'
Said
cunning
old Fury :
' I'll
try the
whole
cause,
and
condemn
you
to death.'

1885
Lewis Carroll
"And a Long Tale"
(from *Alice's Adventures in Wonderland*)
Typography

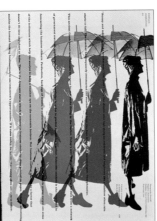

1958
Bradbury Thompson
"Rain, Rain, Rain"
(from *Westvaco Inspirations*)
Magazine spread

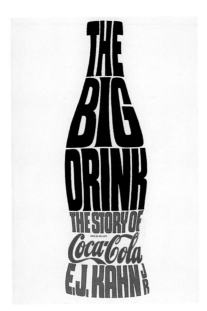

1965
Paul Bacon
The Big Drink
Book cover

1992
David Carson, designer
Andrew Christou and Erik Baker,
creative directors at BBDO
Be young, have fun, drink Pepsi
Advertisement

1999
Designer unknown
Burger King
Advertisement

Hip to Be Square

Schoolchildren make letters using graph paper grids, not unlike type designers who use the square (or rectangle) as the basis for rigidly geometric lettering. Modernism viewed the square (along with the circle and triangle) as the purest forms, and so are the letters based on them.

— 1917

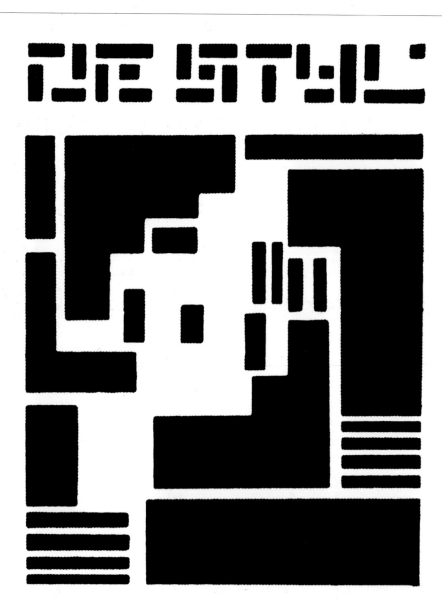

**ABCDEFGHIJKLM
NOPQRSTUVWXYZ**

1919
Theo van Doesburg
Alphabet
Typeface

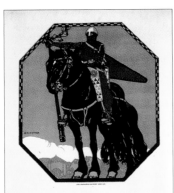

1904
Carl Czeschka
**The Thousand-Year Festival of the City
of Mödling**
Poster

1941
Bart van der Leck
de Stijl
Typeface

1970
Rudolph de Harak
Quadra
Typeface

1990
Tobias Frere-Jones
Rietveld
Typeface

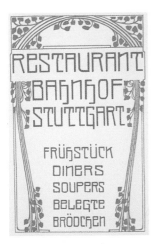

c. 1910
J.V. Cissarz
Restaurant Bahnhof
Advertisement

1993
Pierre di Sciullo
FF Minimum
Typeface

You Beast

Dehumanization is key to any negative propaganda, especially during wartime. Demonizing an enemy makes them easier to revile. For the artist, using monsters—flesh-eating, murderous beasts—in political posters effectively removes all traces of individual humanity from the subject as it ignites the atavistic fears of its audience.

— 1918

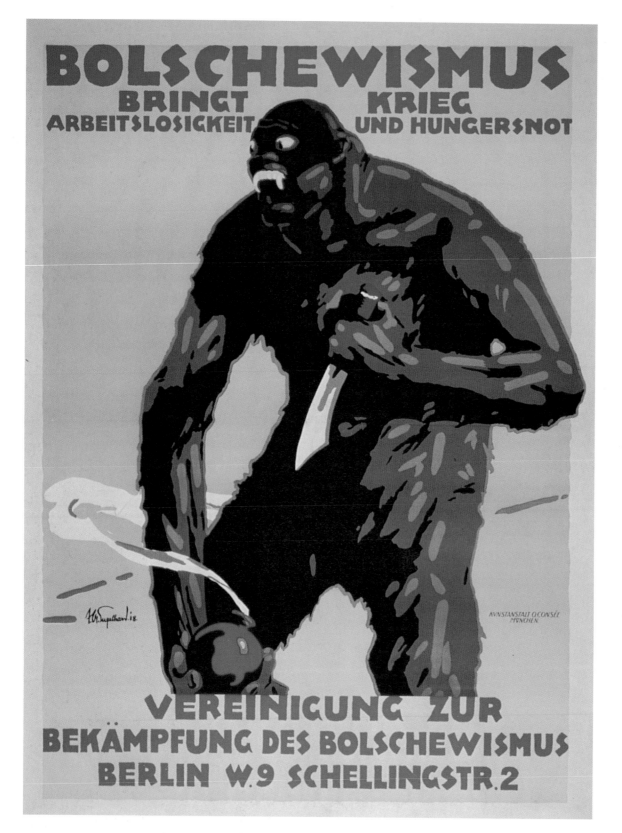

1918
Julius Ussy Engelhard
Bolshevism brings war, unemployment and famine
Poster
The Hoover Institution Archives, Stanford, California

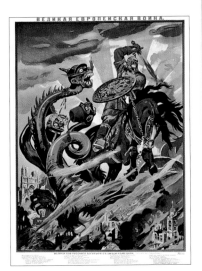

1915
Artist unknown
The Great War in Europe
Poster
The Hoover Institution Archives, Stanford, California

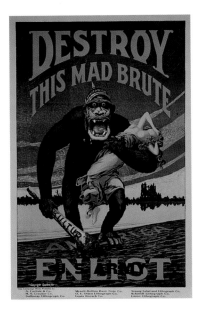

1917
H.R. Hopps
Destroy this mad brute: Enlist/U.S. Army
Poster
The Hoover Institution Archives, Stanford, California

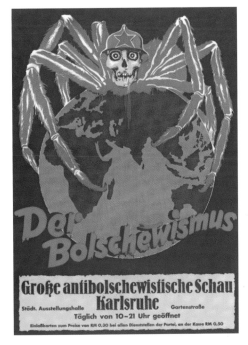

c. 1930
Artist unknown
Big antibolshevik exhibit
Poster

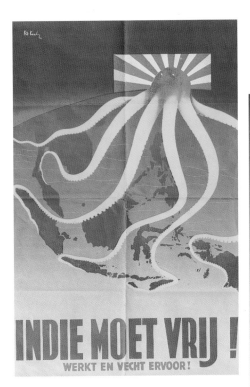

1944
Pat Keely
Work and fight to free the Indies
Poster
The Hoover Institution Archives, Stanford, California

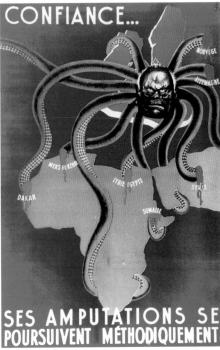

1941
SPK
His amputations continue systematically
Poster

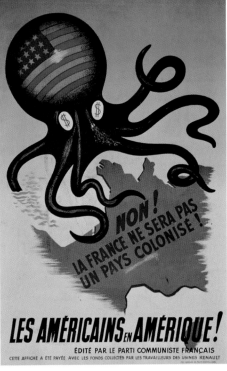

1952
Artist unknown
No! France will not become a colony!…
Poster
The Hoover Institution Archives, Stanford, California

Bars and Angles

Geometry rules. The strength of bars and power of angles has long been recognized. Rather than strain the senses, the bold forms enable the viewer to easily navigate typographic space. In some cases they proscribe; in others they expand the parameters of communication.

— 1919

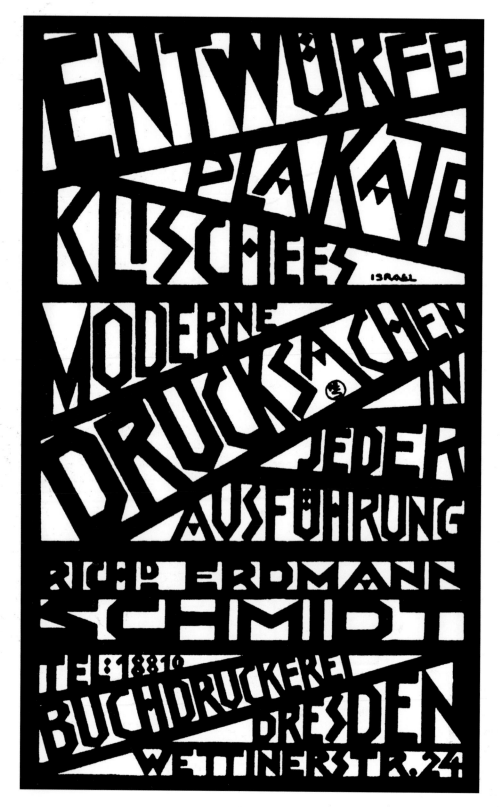

1919
Richard Erdmann Schmidt
Moderne Drucksachen
Advertisement

c. 1900
George Auriol
Otto Gotha
Advertisement

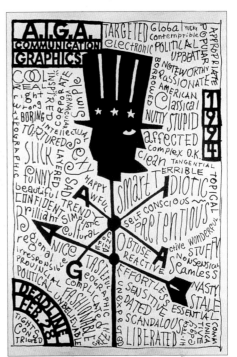

1994
Pentagram
Woody Pirtle, designer, illustrator
Ivette Montes de Oca, designer
AIGA Communciations Graphics 1994 Call for Entries
Poster

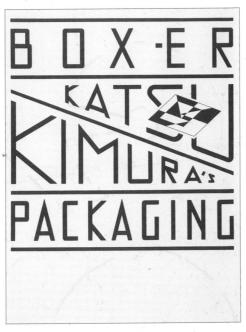

1980
Masayoshi Nakajo
Katsu Kimura's Packaging
Book cover

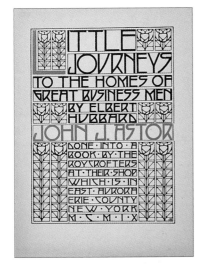

1904
Dard Hunter
Little Journeys
Book cover

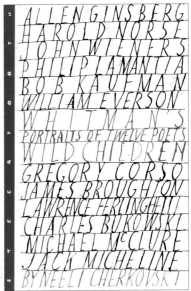

1999
Louise Fili, designer
Portraits of Twelve Poets
Book jacket

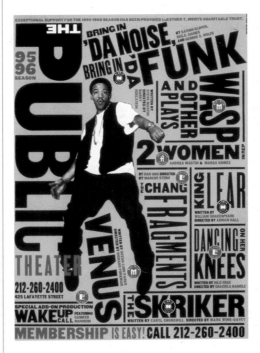

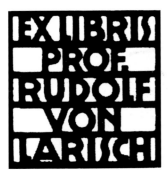

1905
Designer unknown
Ex Libris
Prof. Rudolf von Larisch
Bookplate

1995
Pentagram
Paula Scher, designer
Lisa Mazur, designer
Carol Rosegg, photographer
Public Theater Season 1995–1996
Poster

Circles and Wedges

Squares and rectangles can do only so much. Circles and wedges (triangles by any other name), however, serve the same function as an arrow and bullseye. Not coincidentally, advertising pundits of the 1920s and 1930s referred to hitting the target audience with precise (deadly) accuracy.

— 1920

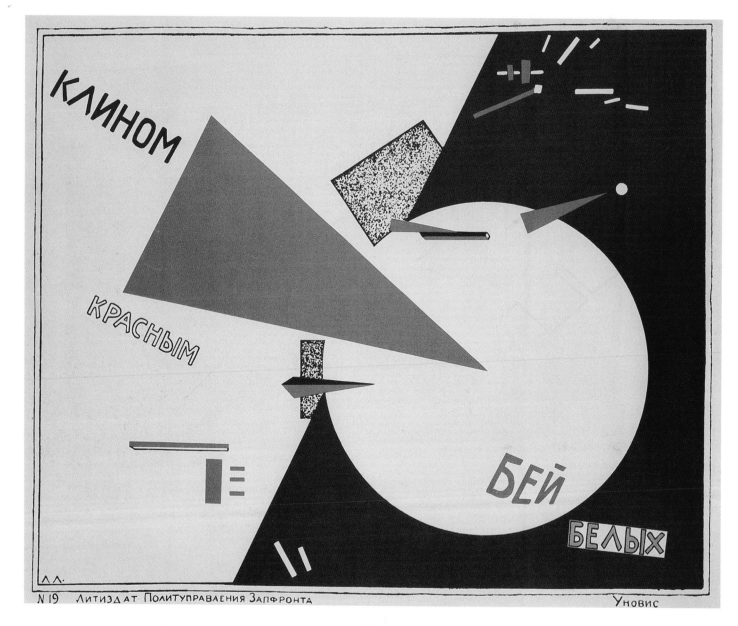

1920
L. Lissitzky
Beat the Whites with the Red Wedge
Poster

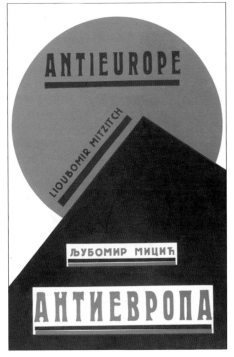

1926
Lioobomir Mitzitch
Anti-Europe
Magazine cover

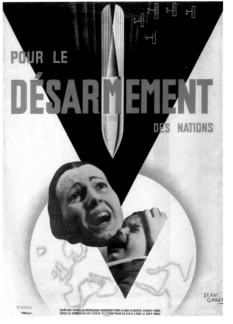

1932
Jean Carlu
**Pour le Désarmement
des Nations**
Poster

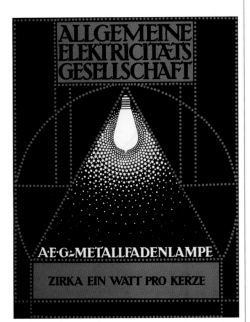

1907
Peter Behrens
AEG—Metallfadenlampe
Poster

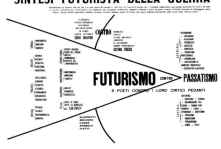

c. 1918
Designer unknown
Sintesi Futurista Della Guerra
Typography

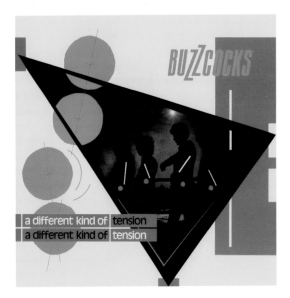

1979
Malcolm Garrett, designer
Jill Furmanovsky, photographer
A Different Kind of Tension, The Buzzcocks
Album cover

Type Characters

Design is play. So why shouldn't the tools of design, particularly typefaces, be used as toys? Letters are already symbols for sounds that combine to make words. It is, therefore, logical that letters arranged in pictorial compositions portray the words (and ideas) that they represent.

1921
Karl Schulpig
Chemischen Gabrik Oberschöneweide
Logo

c. 1840, c. 1856
Artists unknown
Metaphoric Rebus
Cartoons

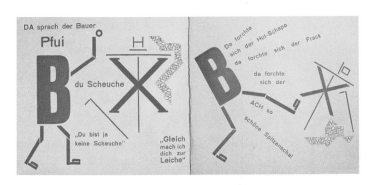

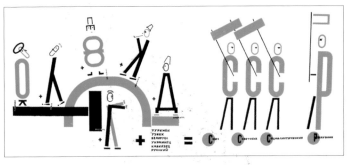

1925
Kathe Stienitz
Kurt Schwitters
Theo van Doesburg
The Scarecrow
Children's book

1928
L. Lissitzky
"4 Vanyas, take away 3, leaves 1 Vanya"
Children's book

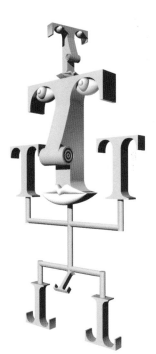

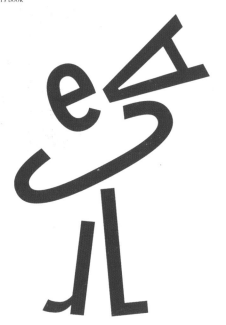

1997
Jun Takechi, art director
Kozue Takechi, designer
Untitled
Logo

1998
Imagine, Manchester
David Caunce, designer
Clare Simmons, conference director
Logo

Red Overprints

A sheet of paper is an obviously limited space on which to create; one might say, in current computer argot, that paper has limited memory. Hence derives the practice of overprinting layers of additional information using a second color. Red seems to be the most frequently overprinted color (against black) because it is indeed the most eye-catching.

1922

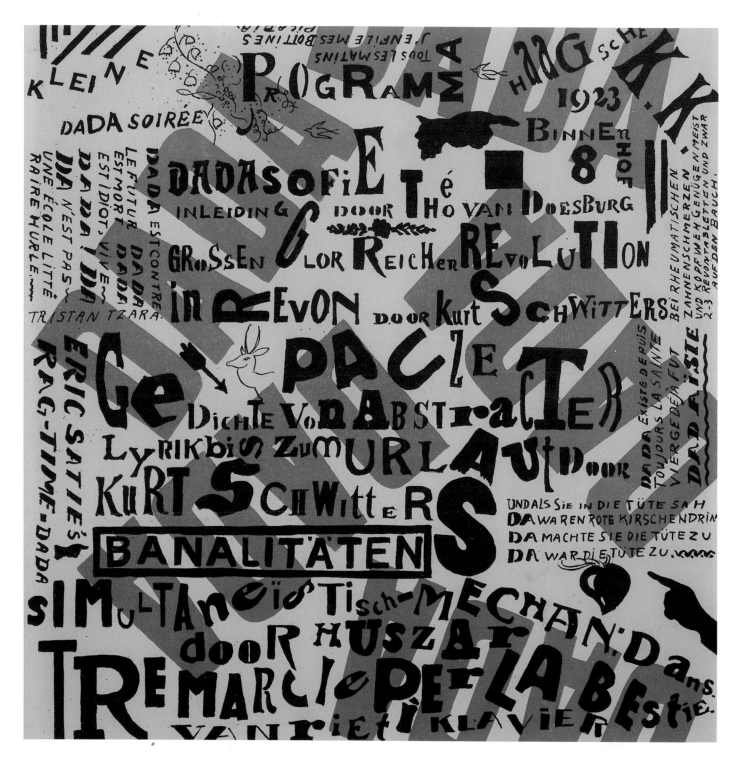

1922
Theo van Doesburg
Kurt Schwitters
Small Dada evening
Poster

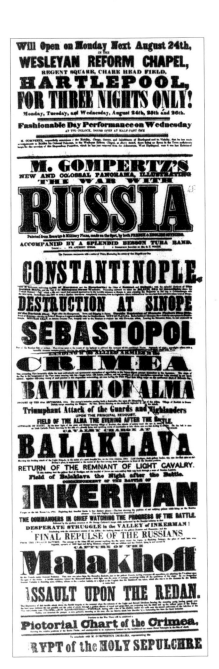

c. 1852
Designer unknown
"Russia…" etc.
Poster

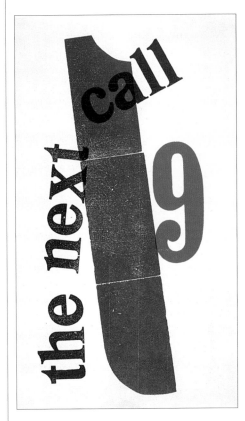

1925
H.N. Werkman
The Next Call
Magazine cover

1996
Charles Spencer Anderson Design
Hatch Show Print
Poster

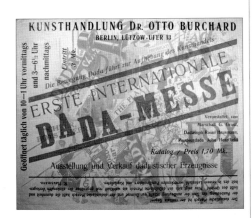

1919
Raoul Hausmann
Erste Internationale: Dada-Messe
Announcement

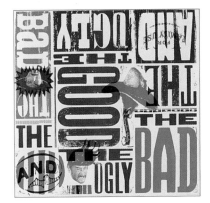

1998
Zeer Fijn
Anka Kammler, designer
Ludwig Spormann, designer
The Good, the Bad and the Ugly
Album cover

1998
Johnson & Wolverton
Hal Wolverton, designer
Heath Lowe, designer
Alicia Johnson, creative director
Hal Wolverton, creative director
Miller campaign
Poster

Icontact

The world's great religions have nurtured their respective icons because they serve as touchstones and embody the faith. Transforming the iconic concept into applied art, certain key, memorably charged images—sometimes abstract, but not logos or trademarks per se—serve to aid recognition.

— 1923

1923
L. Lissitzky, designer
Lutze & Vogt, Berlin, printer
Soviet Russian State Publishing House, Berlin, publisher
For the Voice
(by Vladimir Mayakovsky)
Book spread

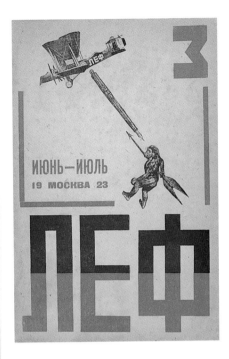

1923
Alexander Rodchenko
LEF
Magazine cover

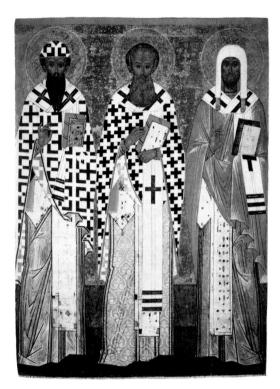

c. last quarter of the fifteenth century
Artist unknown
**Saints: Kirill and Afanasiy Alexandriyskiy,
Leontiy Rostovskiy**
Novogorodskaya icons

1992
Rudy VanderLans
Émigré
Magazine spread

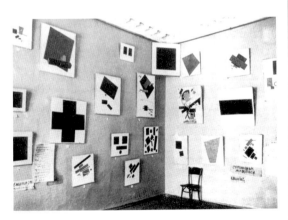

1922
Kasimir Malevich, artist
**View of the 0:10 exhibition showing Malevich's
Black Square in the "icon's place," center top**
Photograph

1998
Cahan & Associates
Bill Cahan, art director
Michael Braley, designer, illustrator
Thom Elkjer, copywriter
Xilinx 1998
Annual report

Systematic Clutter

The greatest affront to traditional typography was the seemingly ad hoc composition of various disparate typefaces in anarchic layouts. What began, however, as an assault on the classical rules ultimately became the basis for new systematic hierarchies.

1919
Raoul Hausmann
Der Dada
Magazine cover

1927
Bortnyik Sandor
**Bohémek
(from *UV Föld* magazine)**
Advertisements

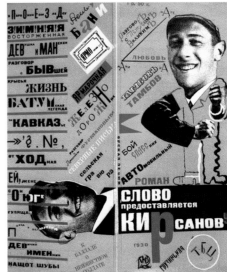

1930
S. Telingater
La Parole Est Kirsanov
Book cover

1921
Theo van Doesburg
de Stijl
Magazine cover

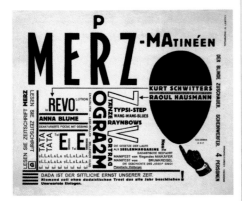

1923
L. Lissitzky
Merz-Matinéen
Invitation

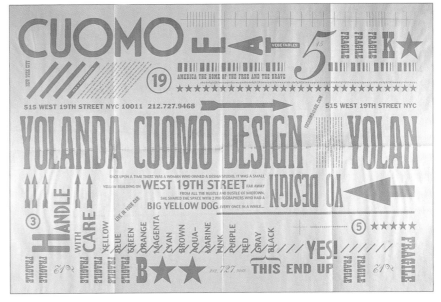

1998
Yolanda Cuomo
Yolanda Cuomo Design
Wrapping paper

Cover Girls and Guys

On few occasions illustrated magazine covers were totally abstract for reasons unique to the magazine. But for the most part, magazine illustrations, particularly in the early twentieth century, have been stylized representations that, in posterlike fashion, evoke a theme or identity of the magazine through the image—or the personality of the artist.

1925

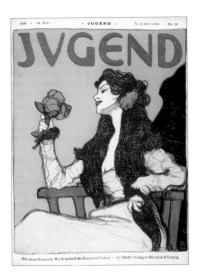

1900
Artist unknown
Jugend
Magazine cover

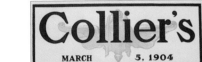

1904
Joseph Christian Leyendecker
Collier's
Magazine cover

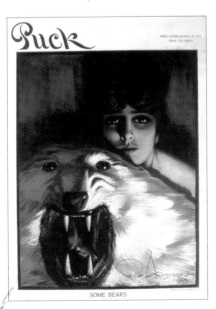

1915
Rolf Armstrong
Puck
Magazine cover

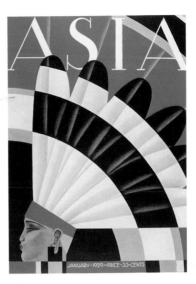

1929
Frank Macintosh
ASIA
Magazine cover

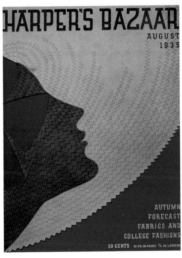

1935
Erté (Romain de Tirtoff)
Harper's Bazaar
Magazine cover

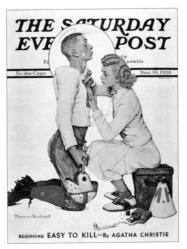

1938
Norman Rockwell
The Saturday Evening Post
Magazine cover

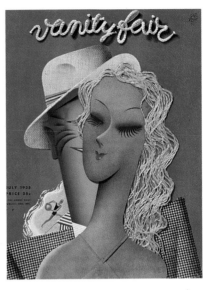

1935
Paolo Garetto
Vanity Fair
Magazine cover

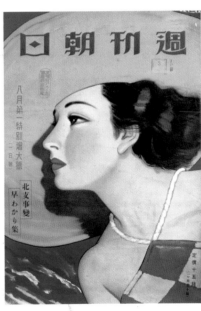

1937
Ken
Shukan Asahi
Magazine cover

Futuristic Fantasy

The Machine Age of the 1930s inspired artists and designers to project into the world of tomorrow. Although the graphic possibilities were limitless, the common trope was the robotic figure, quite often set against a prescient skyscraper landscape. These artists saw the future and it was their own time.

1926

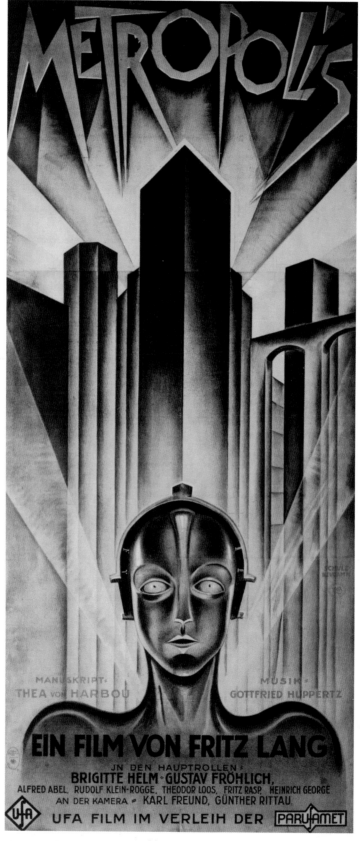

1926
Schulz-Neudamm
Metropolis
Poster

Before

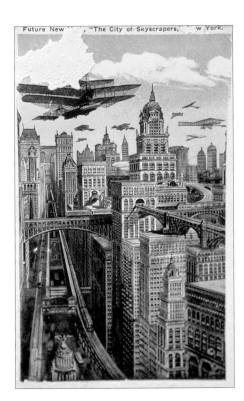

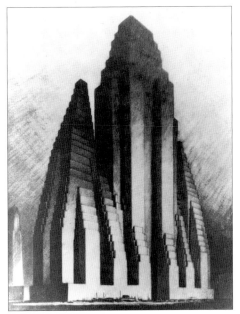

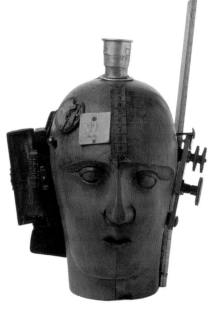

1916
Artist unknown
Future New York
Postcard

1916
Hugh Ferriss
Study for the maximum mass permitted by the 1916 New York zoning law
(for Helmle and Corbett, architects)
Architectural drawing

1921
Raoul Hausmann
The Spirit of Our Time
Sculpture
Collections Mnam/Cci–Centre Georges Pompidou
Photo: Photothèque des collections du Mnam/Cci

After

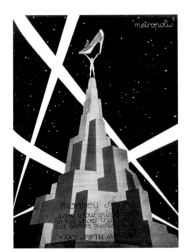

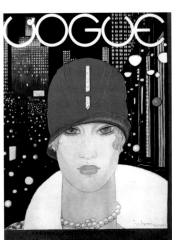

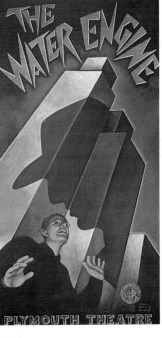

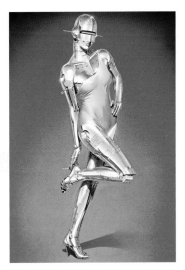

1927
Raymond Loewy
Metropolis
(for Saks 5th Avenue)
Advertisement

1927
Georges Lepape
Vogue
Magazine cover

1978
Paul David
The Water Engine
Poster

1985
Hajime Sorayama
Ford Laser
Acrylics on illustration board
© Hajime Sorayama, Artspace Company
K&Y, New York/Uptight Co., Ltd. Tokyo

Catalog Engineering

Art and design catalogs are more adventurous than trade books because they are not governed by market constraints. Throughout history, some of the more ambitious production feats—bolted bindings, plastic covers, Astro-turf jackets, etc.—were introduced through this significant genre.

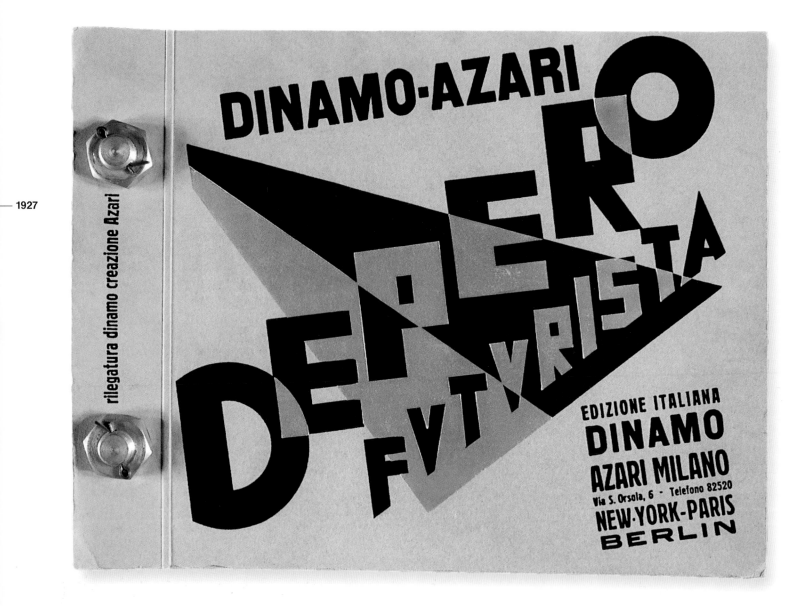

1927

1927
Fortunato Depero
Dinamo-Azari
Catalog cover

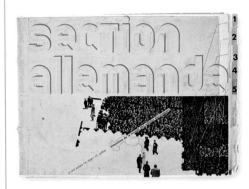

1930
Herbert Bayer
Section Allemand
Catalog cover
Courtesy Oaklander Books, New York

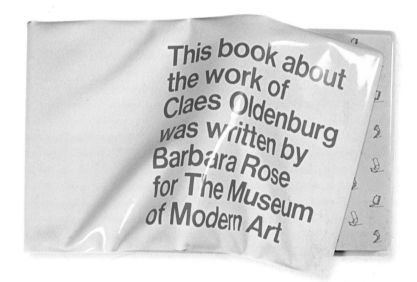

1970
Ivan Chermayeff: Chermayeff & Geismar Inc., New York
Claes Oldenburg
Exhibition catalog

1923
Herbert Bayer
Staatliches Bauhaus in Weimar, 1919–1923
Catalog cover

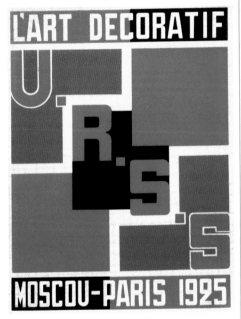

1925
Alexander Rodchenko
L'Art Décoratif U.R.S.S.: Moscou–Paris
Catalog cover

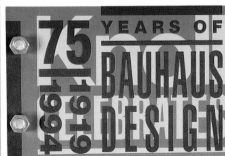

1994–1995
Chris Solwar, designer
Lucy Pope, designer
Chris Solwar, art director
75 Years of Bauhaus Design
Catalog cover

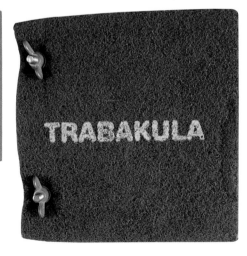

1996
Irene Wölle
Trabakula
Catalog cover

Show of Hands

After the face, there is nothing as graphically expressive as the outstretched hand. The fist, the salute, the grab and other such manifestations evoke senses of anger, might, longing, desperation, fealty, resistance and power. In the designer's hand, the graphic hand is indeed a weapon.

— 1928

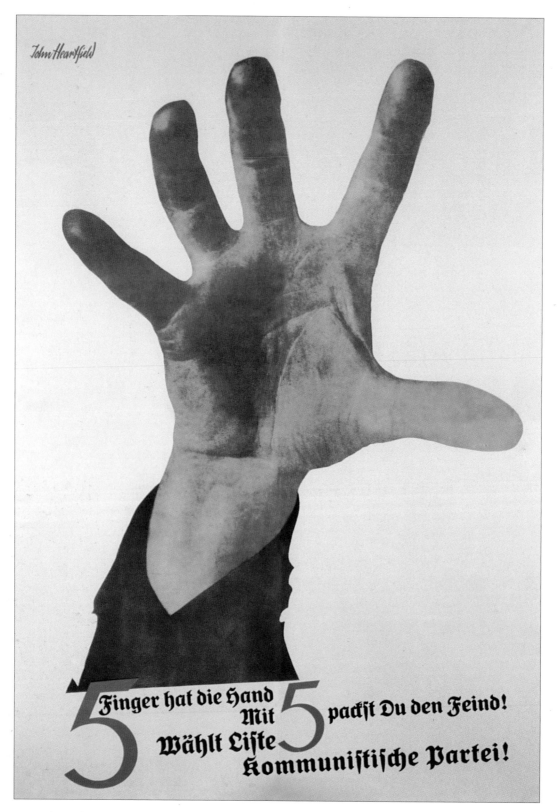

1928
John Heartfield
A hand has five fingers. With five you can repel the enemy! Vote List Five.
Poster

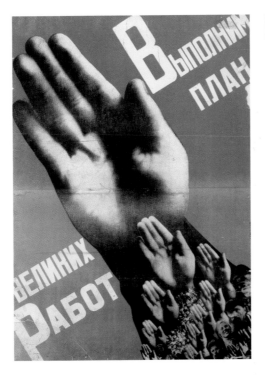

1930
Gustav Klutsis
Fulfilled plan, great work
Poster

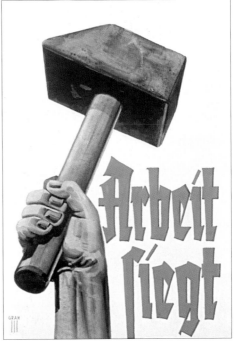

c. 1935
Hermann Grah
Work triumphs
Poster
The Mitchell Wolfson Jr. Collection,
The Wolfsonian-Florida International University,
Miami Beach, Florida. Photo by Bruce White.

c. 1917
Lucian Bernhard
That is the way to peace
Poster

1927
Yanase Masamu
**Shake hands with 50,000 readers,
Read the *Musansha Shimbun*
(proletarian newspaper)**
(for Musansha Shimbun Publishing Co.)
Advertisement

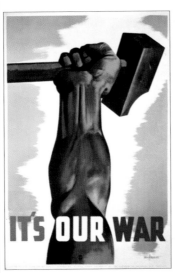

1941
Canadian
It's our war
Poster
Courtesy Chisholm-Larsson Gallery, New York

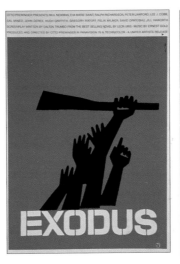

1965
Saul Bass
Exodus
Poster
Courtesy of the Academy Foundation/
Academy of Motion Pictures Arts & Sciences

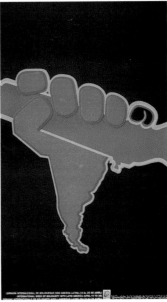

c. 1989
M. Perez
**International Week of Solidarity With
Latin America**
Poster

Covering Art

Often the only record of an art exhibition is the catalog produced to document its holdings. The covers of these documents must somehow embody the spirit of the exhibit (and the exhibitor) while serving the functional requirements of a book.

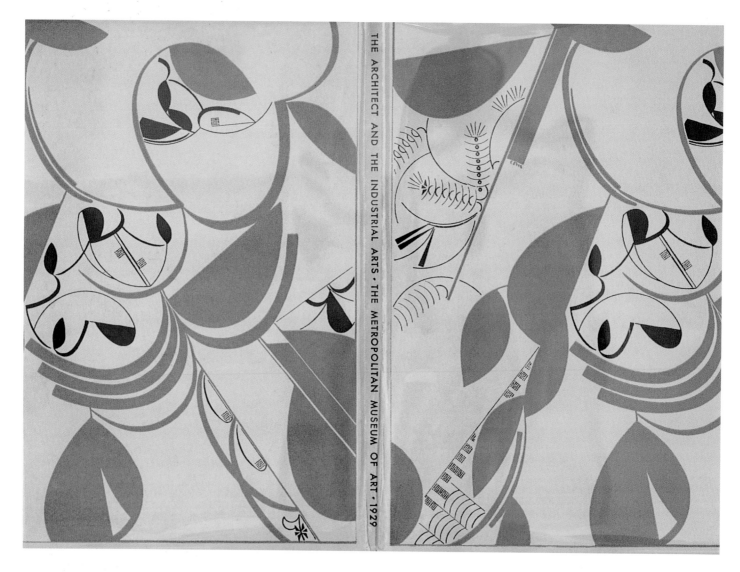

1929
William Addison Dwiggins
The Architect and the Industrial Arts
Catalog cover

THE ARCHITECT AND THE INDUSTRIAL ARTS · THE METROPOLITAN MUSEUM OF ART · 1929

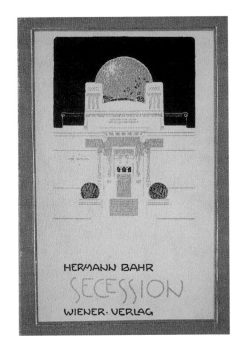

1898–1899
Joseph Maria Olbrich
Secession
Catalog cover

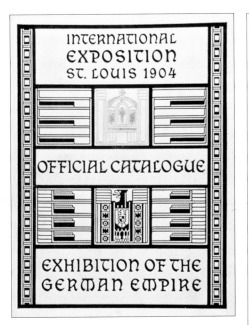

1904
Peter Behrens, designer
Georg Stilke, Berlin, publisher
***International Exposition, St. Louis, 1904: Official
Catalogue of the Exhibition of the German Empire***
Catalog cover
The Mitchell Wolfson Jr. Collection, The Wolfsonian-Florida International University,
Miami Beach, Florida. Photo by Bruce White.

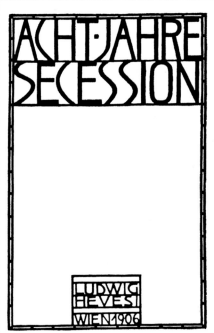

1906
Designer unknown
Acht Jahre Secession
Catalog cover

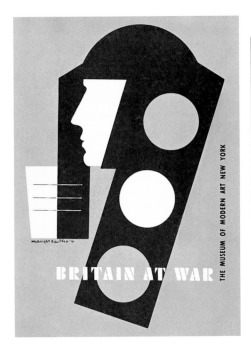

1941
E. McKnight Kauffer
Britain at War
The Museum of Modern Art
exhibition catalog
Catalog cover

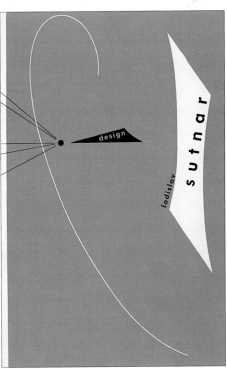

1947
Ladislav Sutnar
Sutnar Design
Catalog cover

1961
Willem Sandburg
***8 Argentinian Abstract
Artists***
Catalog cover

Portrait Charges

Distorted and exaggerated portraits, known as *portrait charges* (charged portraits) or caricatures, have been the bedrock of political, social and cultural graphic commentary. Curiously little about the art form, except for the personae, has changed since the early nineteenth century, when Daumier attacked the powerfully corrupt and corrupt power.

— **1930**

1930
Paolo Garetto
"Gandhi"
Caricature

Before

After

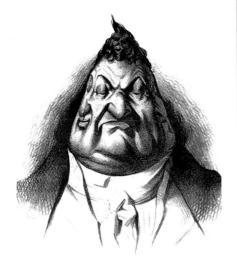

1832
Honoré Daumier
"King Louis Phillipe"
Caricature

1854
Gustave Doré
The North Star
(from *The History of
Holy Russia*)
Caricature

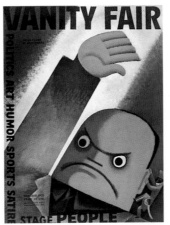

1933
Miguel Covarrubias, illustrator
M.F. Agha, art director
"Benito Mussolini"
Caricature

1967
Robert Grossman
"Ronald Rodent"
Caricature

1988
Spitting Image
"Margaret Thatcher, Dominatrix"
Caricature

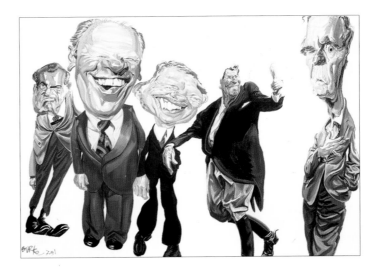

1991
Philip Burke
**"Richard Nixon, Gerald Ford, Jimmy Carter,
Ronald Reagan and George Bush"**
Caricature
Collection of Garry Trudeau

Post-its

Perhaps nothing is more difficult to design than a postage stamp. It is such a small space, yet must contain considerable information as well as a visual wallop. Designers have learned that it is not enough to simply reduce a poster to Lilliputian scale; the stamp must have its own integrity.

1931

1931
Piet Zwart
Goude stained glass
Postage stamps

1931
Gerard Kiljan
Printed by Joh. Enschedé &
Zonen, Haarlem, Netherlands
**Nederland 1.5 cent,
Nederland 5 cent,
Nederland 6 cent and
Nederland 12.5 cent
stamps**
Postage stamps

Before

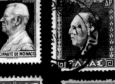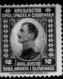

c. 1910
Various
Postage stamps

After

1984
Joost Swarte
Child Welfare Stamp
PTT (Post Office), The Hague
Postage stamp

1989
Wild Plakken
**Dutch Trade Union
Movement**
PTT (Post Office), The Hague
Postage stamp

1990
Brian Cronin
Irish 26
Postage stamp

1990
Nederland Februaristaking
Postage stamp

1992
István Orosz
**Hungarian: Columbus
Day**
Postage stamp

1995
Atelier de Création Graphique
60 + 30 Nederland
Postage stamp

1992
Neville Brody
Floriade Nederland
Postage stamp

1995
April Greiman
19th Amendment 1920–1995
Postage stamp

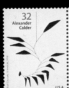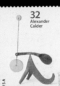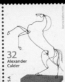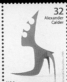

1997
Terry McCaffrey, creative director
Derry Noyes, designer, art director
Alexander Calder Series
Postage stamps

Speeding Trains

The diagonal line is one of the most powerful tools in the designer's repertoire. It evokes speed and power. Put a train, another evocation of velocity, on that same diagonal line, tilt it upwards towards the sky, and the viewer's vision is shot off the page.

1932

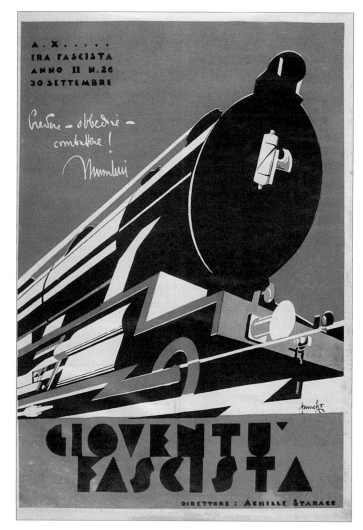

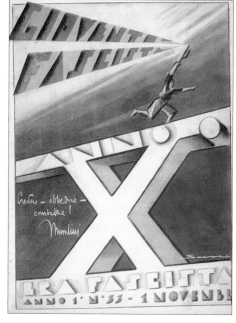

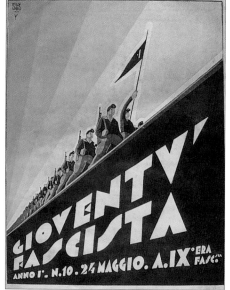

1931–1932
Cesare Gobbo
Gioventù Fascista
Magazine covers

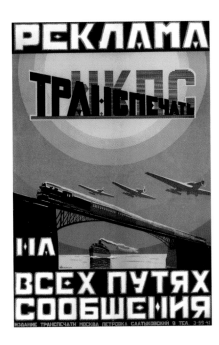

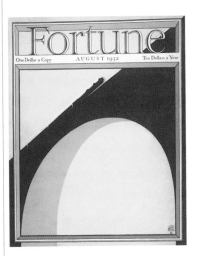

1925
A. Mikhailov
**People's Commissariat of
Paths of Communications**
Poster

1932
Paolo Garetto
Fortune
Magazine cover
© 1932 Time Inc. All rights reserved.

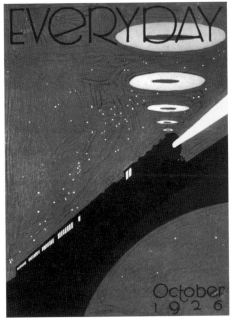

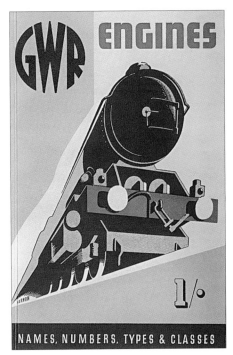

1926
C.E. Millard
Everyday
Calendar page

1935
Varnon
GWR Engines
Advertisement

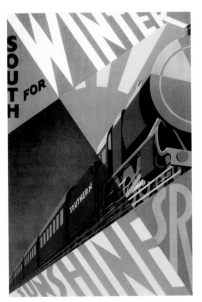

1929
Edmond Vaughn
**South for winter
sunshine**
Poster

1998
Mirko Ilić
Business Week
Magazine cover

News Overprint

The newspaper continues to serve as foreground and background for many messages signaling immediacy to a viewer. Overprinting the basic newspaper page with additional headlines or images is one way to bust through the confines of textual density.

— 1933

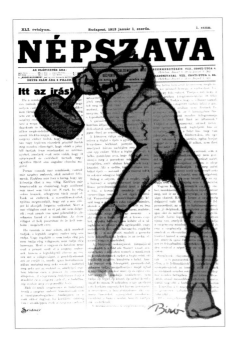

1913
Biró
Népszava
Newspaper cover

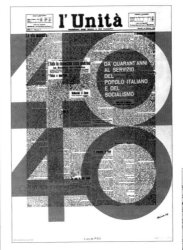

1964
Albe Steiner
L'Unitá
Poster

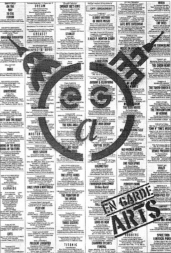

1995
Pentagram
Woody Pirtle, designer
En Garde Arts
Newsletter

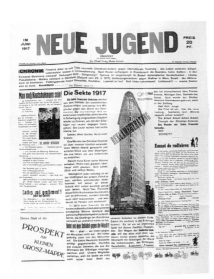

1917
John Heartfield
Neue Jugend
Newspaper cover

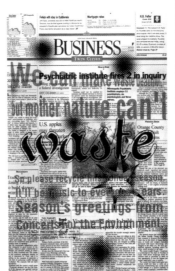

1993
Thorburn Design, Minneapolis, MN
Bill Thorburn, creative director
Chad Hagen, designer
Matt Elhart, copywriter
Season's Greetings
Mailer

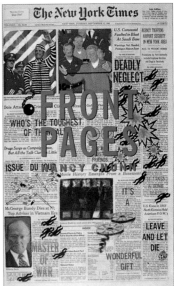

1997
Lisa Feldman Design
Front Pages: Nancy Chunn
Book cover
Courtesy of the artist

1932
Paul Schuitema
City
Book cover

Book of Days

The calendar poses a challenge to designers because its essential form—or its *raison d'être*—does not change from month to month, year to year. Moreover, a design concept must not obscure the essential service—a record of time. Nonetheless, the variations on this fundamental theme are varied.

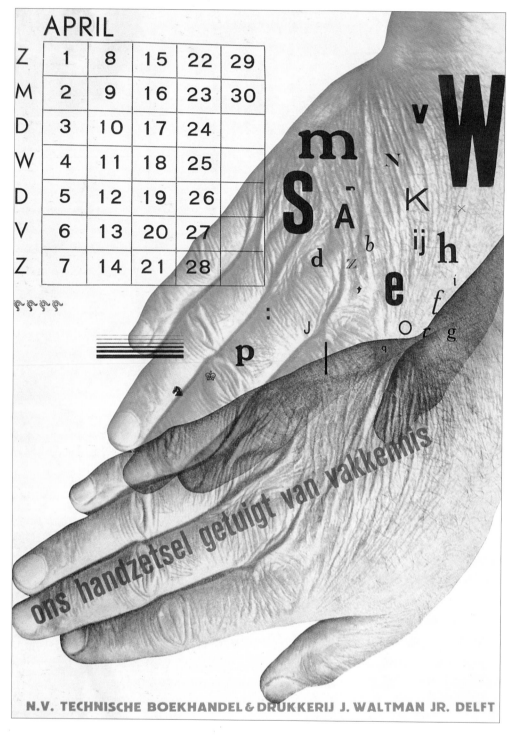

— 1934

1934
Dick Elffers
For the book dealer and printer, J. Waltham, Jr.
Calendar

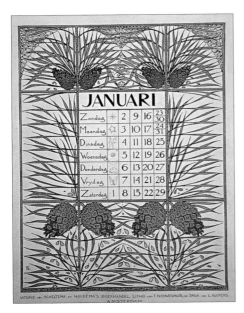

1898
Theodoor Willem Nieuwenhuis, designer
L. Kuipers, Amsterdam, printer
Scheltema en Holkema's Boekhandel, Amsterdam, publisher
January
Calendar
The Mitchell Wolfson Jr. Collection, The Wolfsonian–Florida International University,
Miami Beach, Florida. Photo by Bruce White.

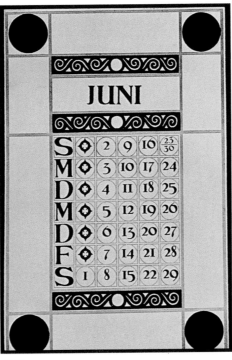

1908
Peter Behrens
Mitteilungen der Berliner Eledtricitaetswerke
Calendar

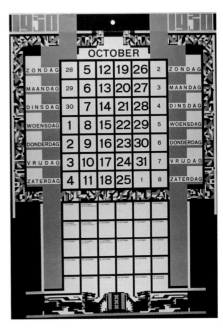

1930
H. Th. Wijdeveld
October
Calendar

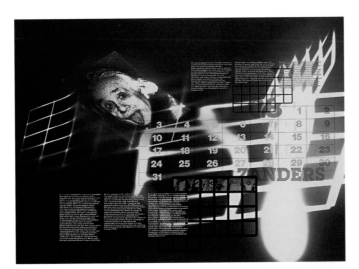

1991
8VO
Time Machine Future, August
(for Zanders Feinpapiere AG, Germany)
Calendar

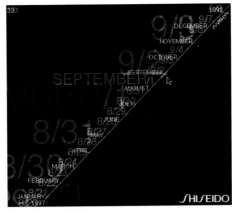

1997
John Maeda
**"Line" exploration of the
spatiotemporal nature of
time**
Digital calendar
© 1997, Shiseido Co., Ltd.

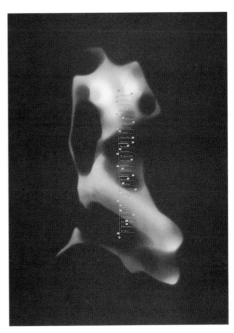

1992
Vaughn Oliver
1993 Anatomy, April
Calendar

Heads Up

The close-cropped, haughtily heroic head is a constant in graphic art. With emotionless facial features, this visage stares away from the viewer to give the impression of aloofness and total dedication to a greater power.

— 1935

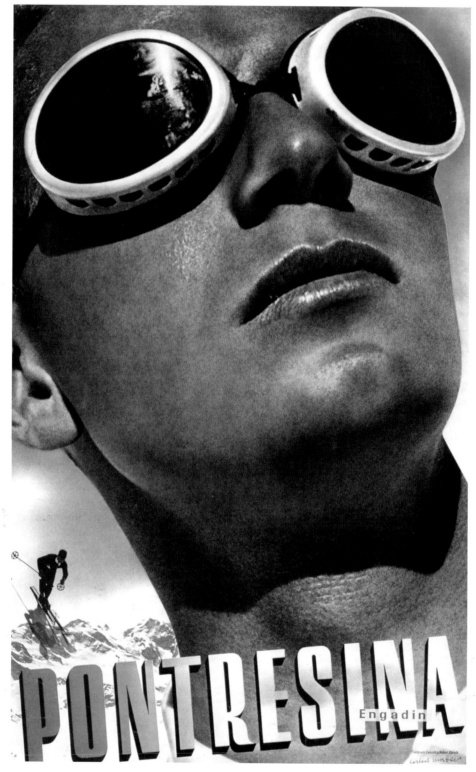

1935
Herbert Matter
Pontresina Engadin
Poster

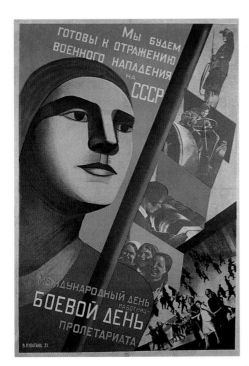

1931
Valentina Kulagina
International Day of the Women Workers
Poster

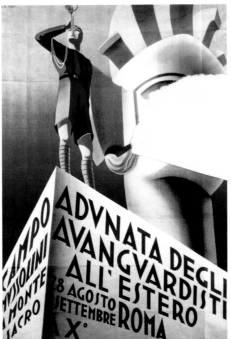

1932
C.V. Testi
Campo Mussolini
Exposition poster

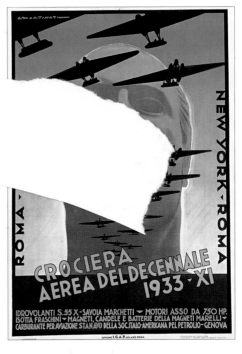

1933
Luigi Martinati
Cro Ciera Aera Deldecennale 1933–XI
Poster
Poster Photo Archives, Posters Please, Inc., New York City

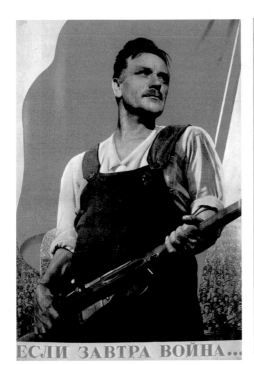

1938
Viktor Korestky
If war breaks out tomorrow…
Poster

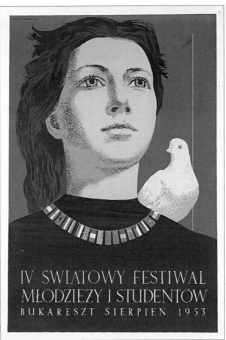

1953
Designer unknown
Fourth International Congress of Youth
Poster
Courtesy Chisholm-Larsson Gallery, New York

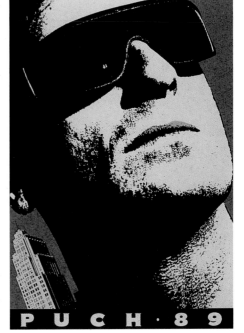

1989
BlackDog
Mark Fox, designer, illustrator, photographer
Tony Maniscalco, art director
Puch 89
Catalog cover

Photojournalistic Truth

LIFE was not the first exclusively photographic magazine ever published, but it certainly set the standard for how journalistic photographs would play a fundamental role in presenting "truth" (edited, that is) to the world. The photo magazine became a portal to common and extraordinary life.

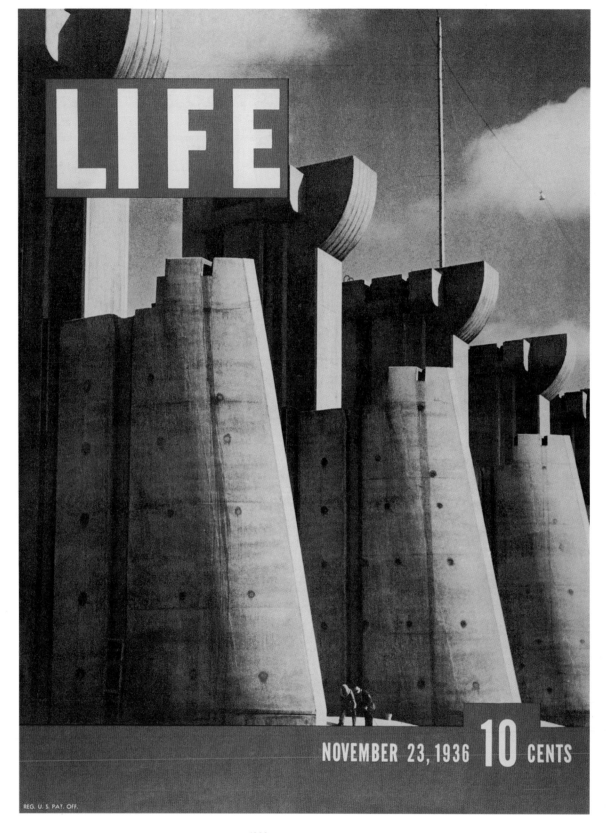

1936
Howard Richmond, art director
Margaret Bourke-White, photographer
LIFE
Magazine cover

Before

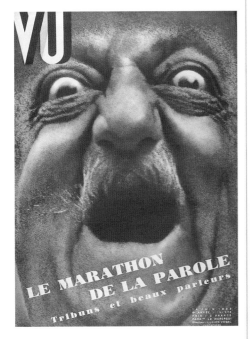

1933
Alexander Liberman, designer
VU
Magazine cover

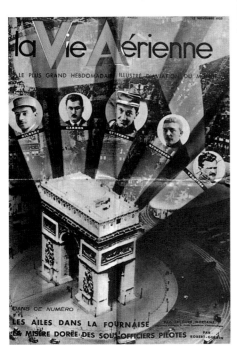

1935
Designer unknown
La Vie Aérienne
Newspaper

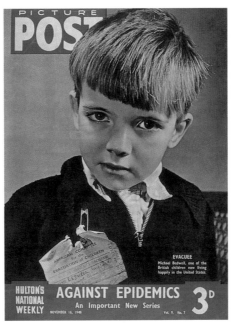

1940
Stefan Lorant, editor/designer
Picture Post
Magazine cover

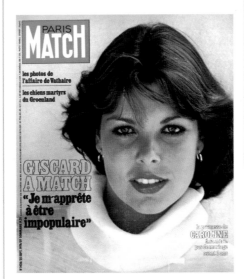

1976
Milton Glaser
Paris Match
Magazine cover

After

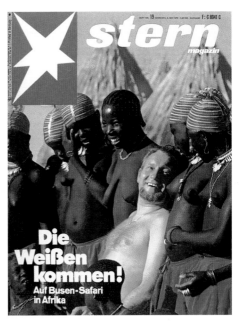

1973
Wollfang Benkhen, art director
Michael Friedel, photographer
Stern
Magazine cover
Courtesy Stern Syndication

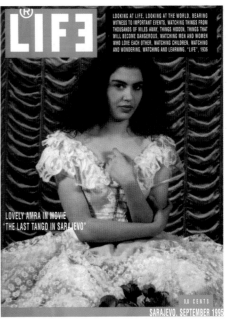

1995
Studio Dogan
Nenad Dogan, art director
Zrinka B. Penava, designer
LIF3
Magazine cover

Flat Color

Full process color can be purely exquisite, but the pristine nature of flat, limited color also has strength. Like most national flags, those poster images that employ flatness focus attention on the image rather than on extraneous visual noise.

1937

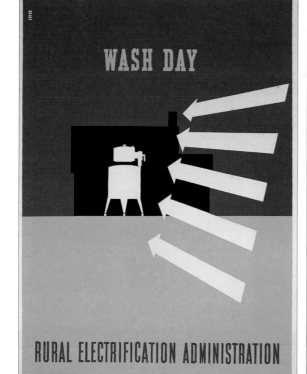

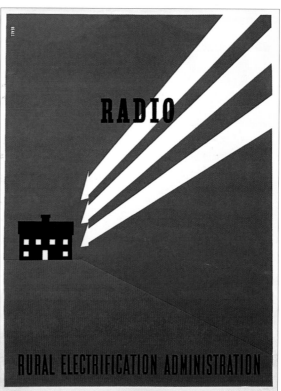

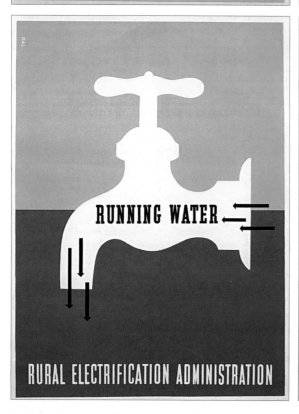

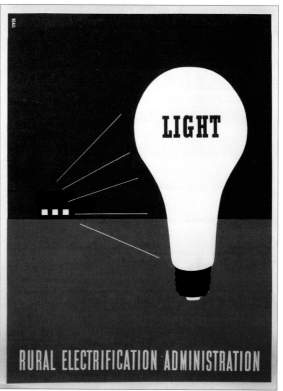

1937
Lester Beall
Wash Day, Rural Electrification Administration
Radio, Rural Electrification Administration
Running Water, Rural Electrification Administration
Light, Rural Electrification Administration
Posters
Lester Beall Collection, The Wallace Library, Rochester Institute of Technology

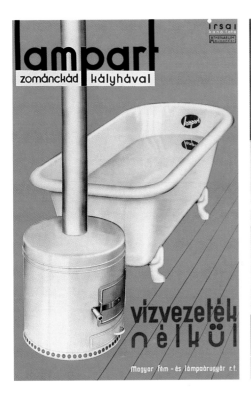

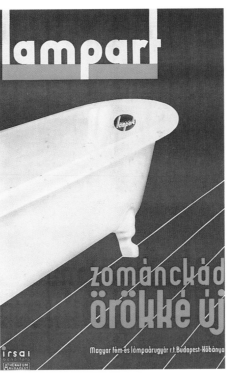

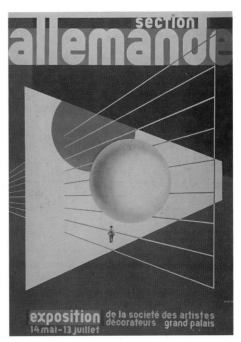

1924
István Irsai
Lampart: zománckád örökké új
Posters
Poster Photo Archives, Posters Please, Inc., New York City

1930
Herbert Bayer
**For the Exposition of
the Society of Decoration Artists, 1930**
Poster

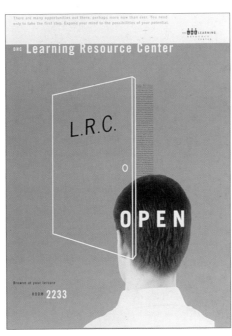

1955
George Tscherny, designer, photographer
Herman Miller Comes to Dallas
Advertisement

1997
Werner Design Werks, Inc.
Kim Aldrin/Target, creative director
Sharon Werner, art director, designer
Sarah Nelson, designer
Darrell Eager, photographer
Learning Resource Center: Open
Poster

1997
Design Machine
Alexander Gelman, designer
Poetry Readings
Poster

Playtime

If design elements are considered toys for the playful designer, then what are *toys* when used as design elements? The result is the same, really. When designers use objects with mischievous abandon, it is to add a level of surprise, as well as greater dimension, to the printed page.

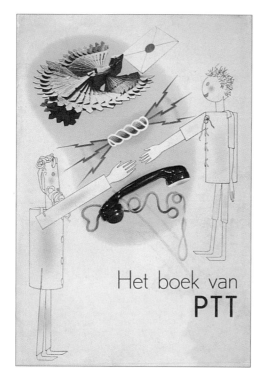

1938
Piet Zwart
The PTT Book
Cover and inside spread

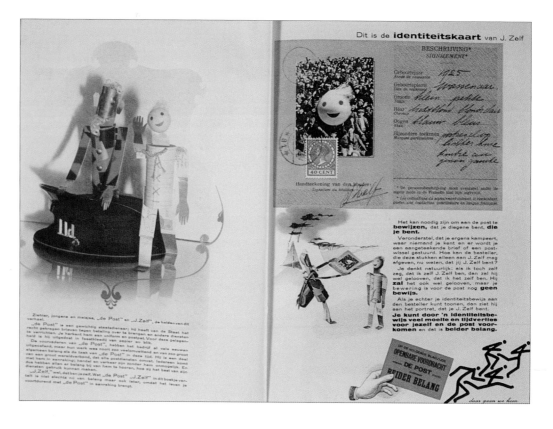

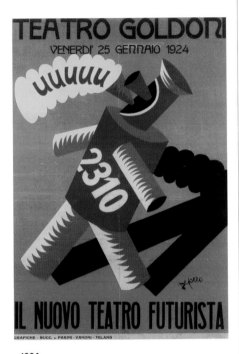

1924
Fortunato Depero
**Advertising billboard for
the New Futurist Theater**
Poster

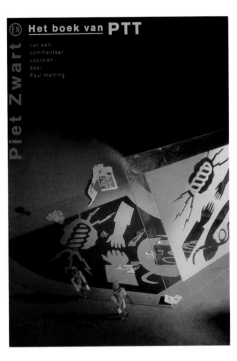

1985
Studio Dumbar
Lex van Pieterson, photographer
The PTT Book
Book cover

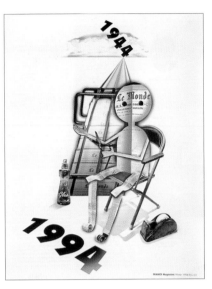

1995
Viva Dolan Communication and Design
Kelly Doe, art director
Teresa Fernandes, art director, designer
Frank Viva, illustrator
"The Paper 1944–1994"
(from *France* magazine)
Magazine spread

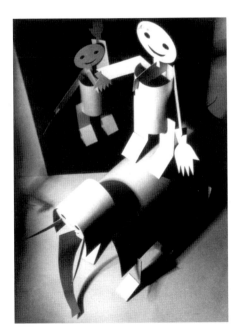

1926
Alexander Rodchenko
Elephant (Slon)
Photograph

1997
Cahan & Associates
Bill Cahan, art director
Kevin Roberson, designer, copywriter
Richard McGuire, illustrator
Lindsay Beaman, copywriter
Adaptec 1996
Annual report

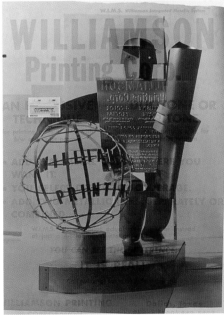

1998
Duffy Design Group
Sharon Werner, art director, designer
Todd Waterbury, designer
Geof Kern, photographer
Tim Duffy, production coordinator
Williamson Printing
Poster

Attendance Required

The ways in which designers have promoted world's fairs and Olympic events have not changed significantly over the years. These spectacles require spectacular imagery, both drawing on and transforming the common heroic, iconic and revered symbolic idioms into understandable icons.

— 1939

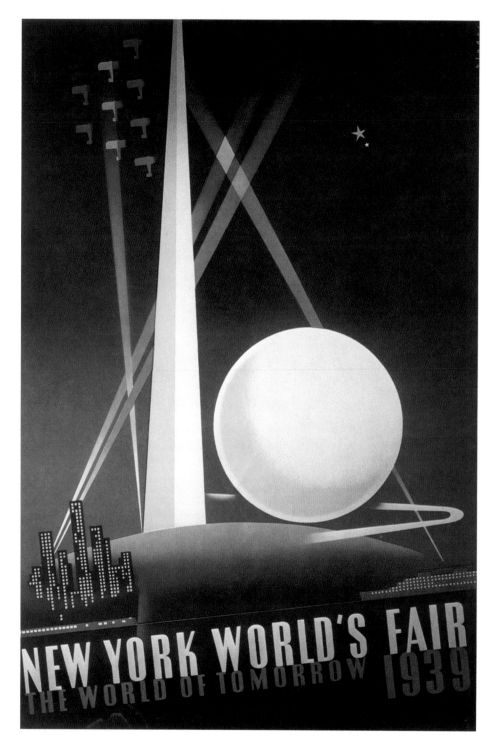

1939
Joseph Binder
New York World's Fair
Poster

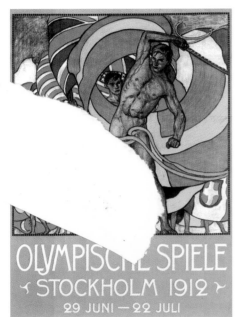

1912
Olle Hjörtzberg
1912 Olympic Games, Stockholm
Poster

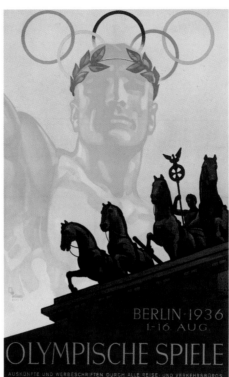

1936
Franz Würbel
1936 Olympic Games, Berlin
Poster

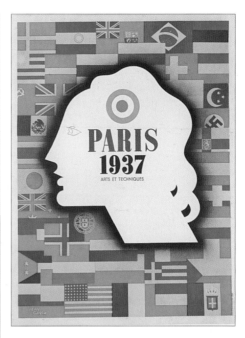

1937
Jean Carlu
**Exposition Internationale: Paris 1937,
Arts et Techniques**
Poster
Courtesy Chisholm-Larsson Gallery, New York

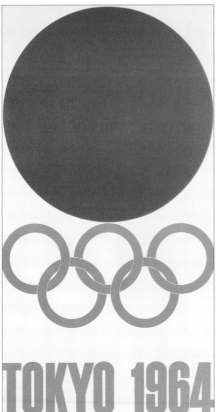

1964
Yusaku Kamekura
**1964 Olympic Games,
Tokyo**
Poster

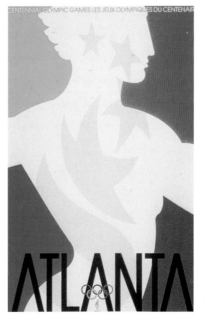

1996
Primo Angeli
Atlanta Centennial Olympic Games
Poster

Out of the Shadows

There is nothing mysterious about dimensional letterforms, except that the shadows that give them mass add a cryptic level. Dimensionality adds a sculptural aura to the flat surface. These letters graphically explode off the page, while often serving as illustrative elements.

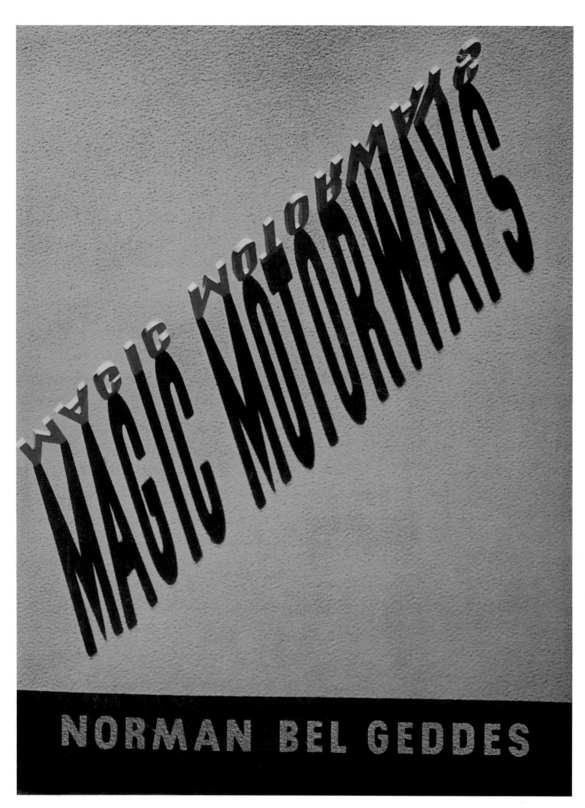

1940
Norman Bel Geddes
Magic Motorways
Book jacket

1940

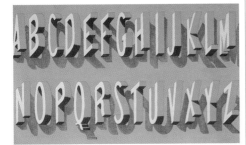

1884
Designer unknown
Novelty lettering
Typeface

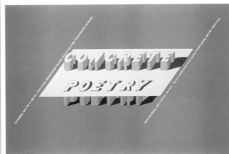

c. 1967
Milton Glaser
Concrete Poetry
Poster

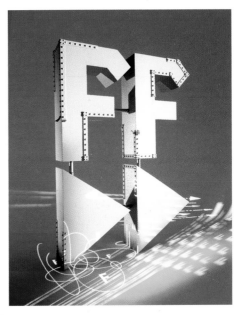

1990
Why Not Associates
Smirnoff
Advertisement

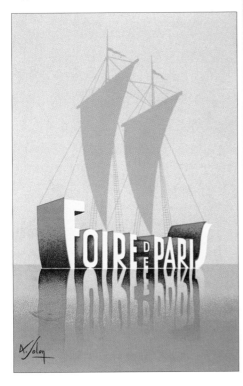

c. early 1900s
L. Solon
Foire de Paris
Postcard

1993
Krystyna Skalski, art director
Louise Fili, designer
The Thing Happens
Book jacket

1997
Stephen Doyle
The Stories of Vladimir Nabokov
Book jacket

1929
László Moholy-Nagy
14 Bauhaus Books
Book cover

Recording Devices

From sleeve to CD box, how records have been protected and promoted over the past century recalls the adage that necessity is the mother of invention. Without the need to protect the fragile material therein, the art would not have been necessary.

— 1941

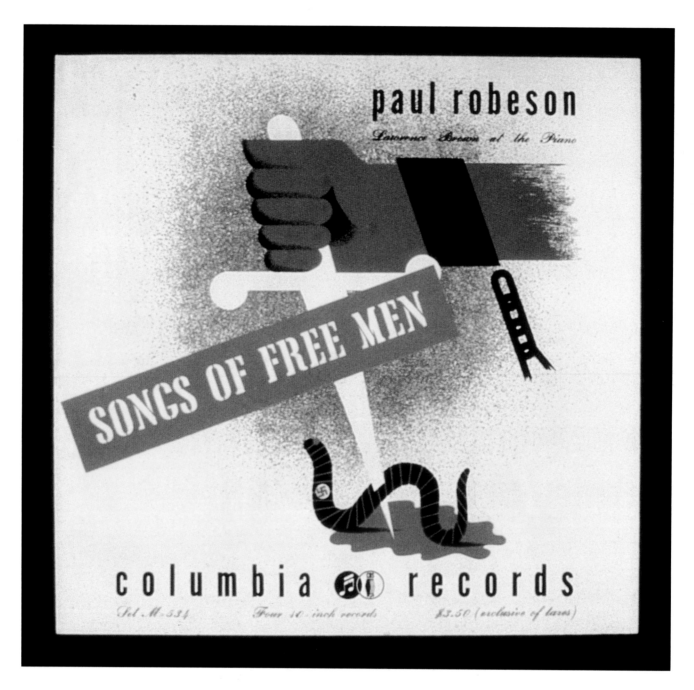

1941
Alex Steinweiss
Songs of Free Men
Album cover

1922
Chris Lebeau
Ultraphoon Huis
Record album sleeve
The Mitchell Wolfson Jr. Collection,
The Wolfsonian-Florida International
University, Miami Beach, Florida.
Photo by Bruce White.

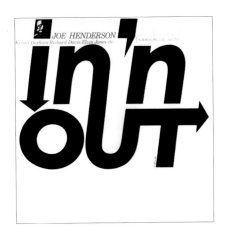

1964
Reid Miles
In 'n Out
Album cover

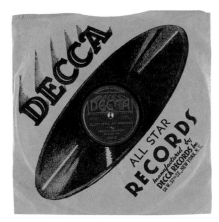

c. 1928
Designer unknown
Decca
Album sleeve

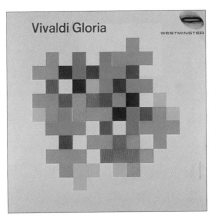

1961
Rudolph de Harak
Vivaldi/Gloria
Album cover

c. 1928
Designer unknown
Blue Bird
Album sleeve

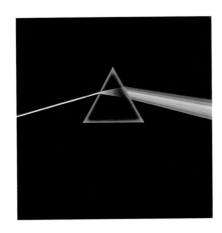

1973
Hipgnosis
***Dark Side of the Moon,
Pink Floyd***
Album cover

c. 1928
Designer unknown
Melotone
Album sleeve

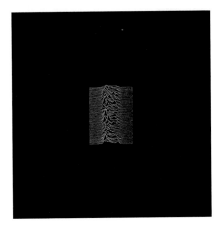

1979
Peter Saville
***Unknown Pleasures,
Joy Division***
Album cover

Hand in Glove

Designers cannot escape the grip of the hand. As a symbol of work, there are few more descriptive images. But some hands are more equal than others. The heavy-gloved iron-worker's hand has become the archetype of this genre.

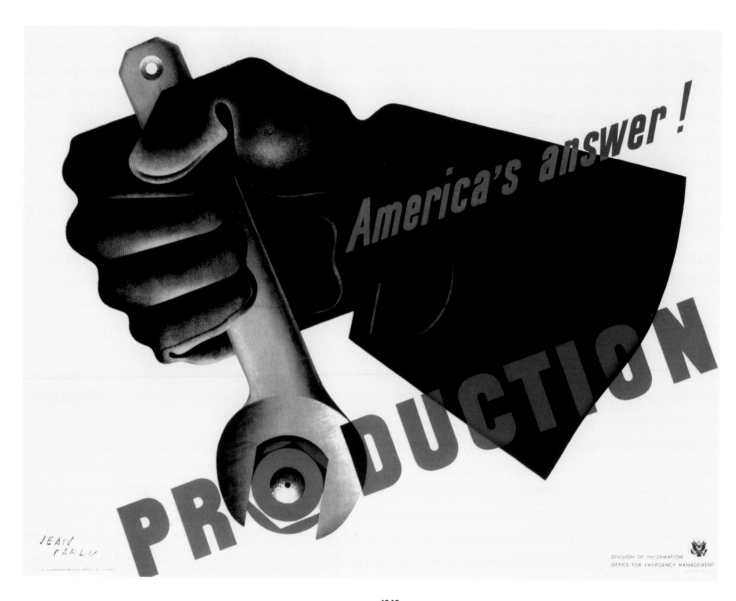

1942
Jean Carlu
America's answer: Production!
Poster

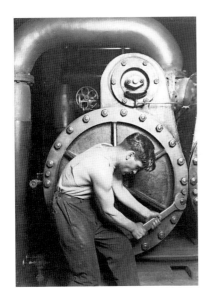

1925
Lewis Hine
Powerhouse Mechanic
Photograph
Courtesy George Eastman House

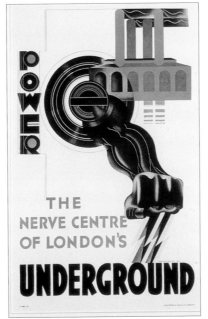

1930
E. McKnight Kauffer
Power, the Nerve Centre of London's Underground
Poster

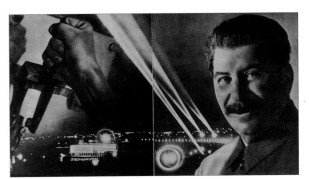

1932
L. Lissitzky
The Current Is Switched On
Photomontage

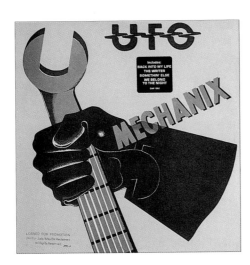

1982
John Pasche, designer
David Juniper, illustrator
***Mechanix*, UFO**
Album cover

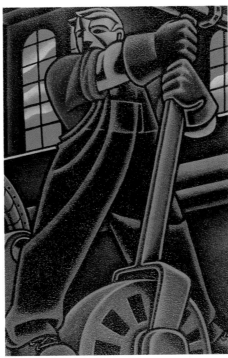

1989
Douglas Fraser
Powerhouse Murals
Mural

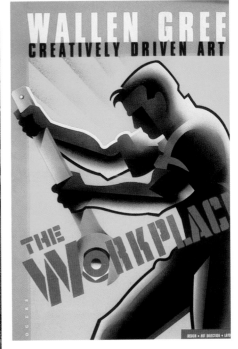

1991
Paul Rogers, illustrator
***The Workplace* by Wallen Green**
Advertisement

Integrated Campaign

The Container Corporation of America, founded in Chicago in 1934, launched various "institutional" advertising campaigns designed to inform rather than sell. This is not unique to CCA, but the company's exclusive reliance on art was unique to this special genre.

1943

AIM HIGH! Military production sights are set high — because quantities of metals, plastics, wood are released by new packaging in paper.

CONTAINER CORPORATION OF AMERICA

1943
Herbert Bayer
Aim high!
Advertisement

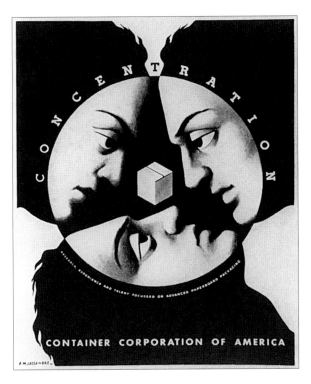

1938
A.M. Cassandre
Concentration
Advertisement

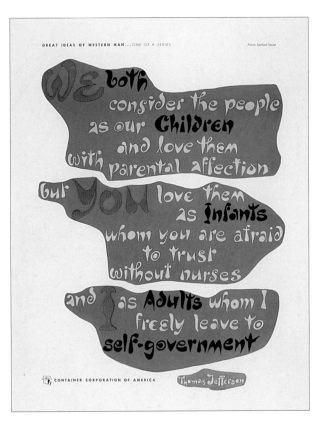

1951
Herbert Bayer
Great Ideas of Western Man: Thomas Jefferson
Advertisement

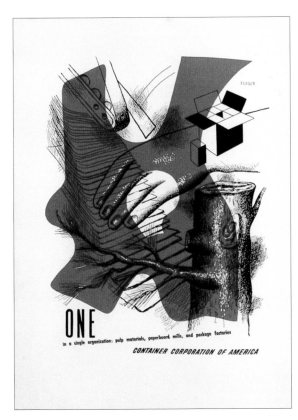

1941
Fernand Léger
One in a single organization…
Advertisement

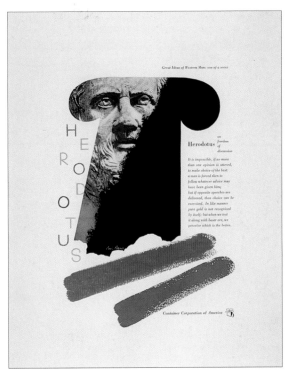

1957
Paul Rand
Great Ideas of Western Man: Herodotus
Advertisement

Fists and Starts

More hands? Yes, because there are few tools more versatile. Here the hand and forearm are symbolic of a nation's strength, its hold on both enemies and patriots and the power that it exerts, alone or in concert.

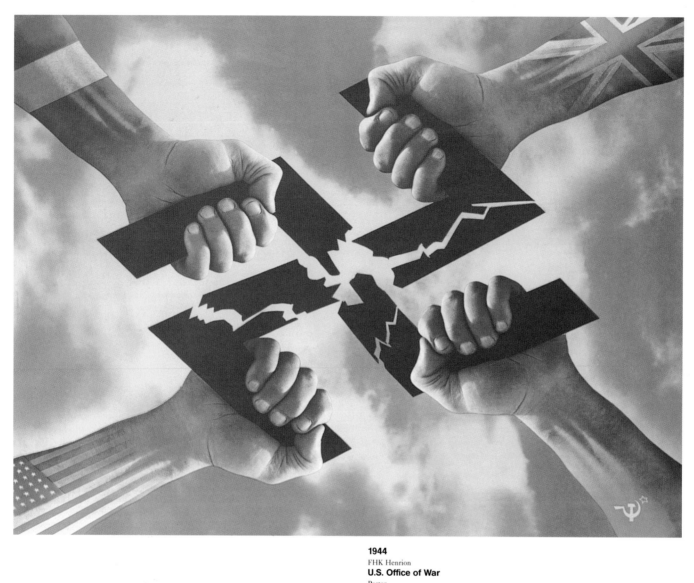

1944
FHK Henrion
U.S. Office of War
Poster
Courtesy Chisholm-Larsson Gallery, New York

1932
John Heartfield
Workers' Illustrated Newspaper
Cover

1990
Josh Gosfield
Censorship is un-American
Poster

1942
Kukriniksi
The Big Three will tie the enemy in knots
Poster

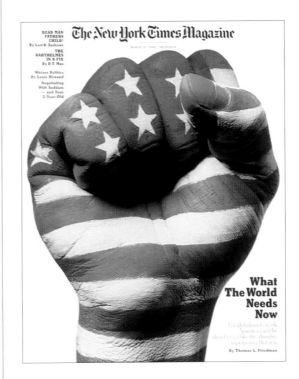

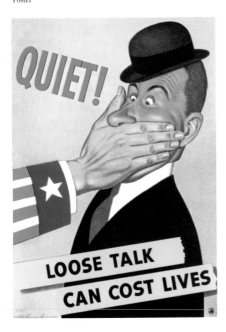

1942
D.B. Holcomb
**Quiet! Loose talk
can cost lives**
Poster

1999
Janet Froelich, art director, designer
Sarah Harbutt, photo editor
Craig Cutler, photographer
Melody Weir-Garren, hand painter
Ron Brownstein, hand model
The New York Times Magazine
Magazine cover

Modern Layout

The modern magazine page is something of a canvas on which type and image are applied like paint. The double page spread is akin to the classic diptych, separate components that equal a significant whole. Without one page, the other is weakened.

1945
Alexey Brodovitch
Henri Cartier-Bresson, photographer
Harper's Bazaar
Magazine spread

1930
John Heartfield
AIZ
Magazine spread

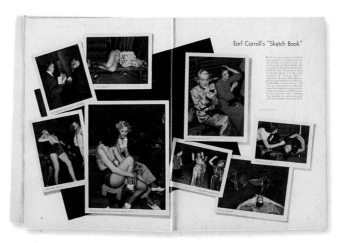

1936
Hehemed Fehmy Agha
Vanity Fair
Magazine spread

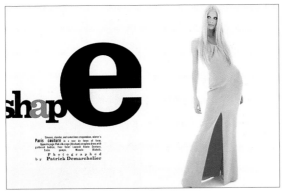

1995
Fabien Baron, designer
Patrick Demarchelier, photographer
Shape
Magazine spread

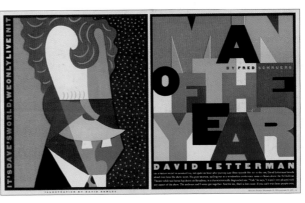

1994
Fred Woodward, art director
David Cowles, illustrator
Rolling Stone
Magazine spread

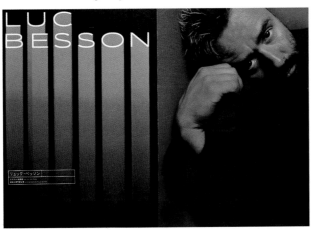

1997
Hideki Nakajima, designer
Fujio Saimon, photographer
Cut
Magazine spread

1998
Hans-Georg Pospischil, art director
Susan Lamèr, photographer
Frankfurter Allgemeine Magazin
Magazine spread

Cutout Figures

Reducing human forms to simple positive and negative shapes, both abstract and representational, is a common means of addressing the anonymity of groups and the specificity of the indescribable everyman. But even simple cutouts are not entirely without distinguishing characteristics.

— 1946

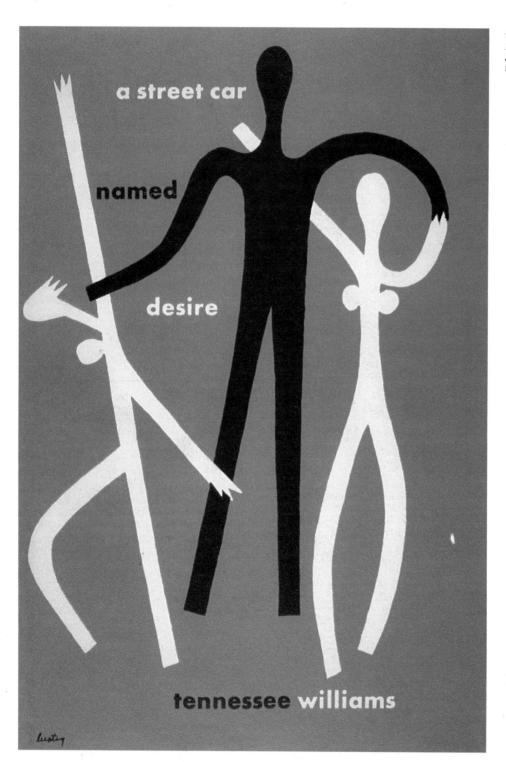

1927
Cleon
Blue Voyage
Book jacket

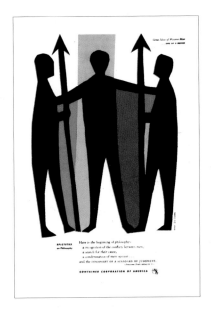

1952
Egbert Jacobson, art director
Leo Lionni, illustrator
Great Ideas of Western Man: Epictetus
Advertisement

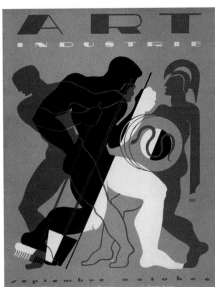

1933
Paule Max Ingrand
Art et Industrie
Magazine cover

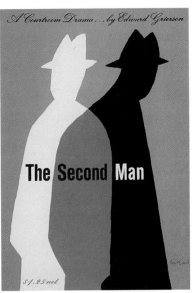

1956
Paul Rand
The Second Man
Book jacket

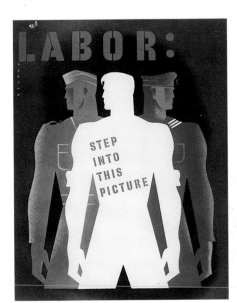

1943
Joseph Binder
Labor: Step into this picture
Poster

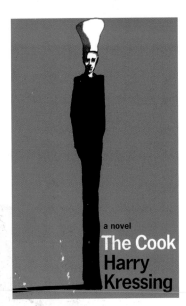

c. 1966
Milton Glaser
The Cook
Book jacket

Symbolizing Art

Art and design magazines are routinely faced with the vexing problem of conceptualizing the essence of art, which is often rooted in symbolism. While the vocabulary of art is infinite, the symbols to describe it are limited. The challenge of the designer is to transcend the cliché.

— 1947

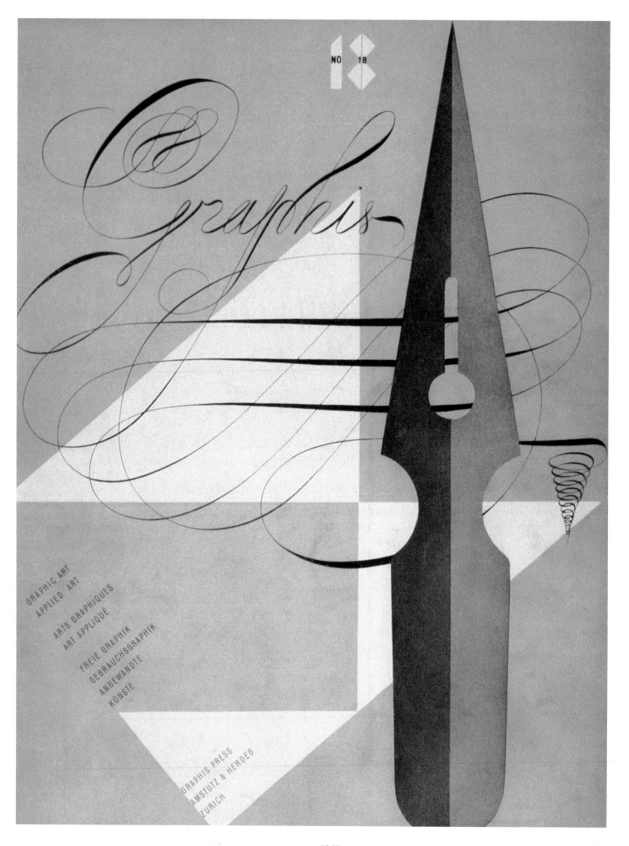

1947
Walter Herdeg
Graphis 18
Magazine cover

1957
Ben Shahn
Print
Magazine cover

1916
Carlo Egler
Das Plakat
Magazine cover

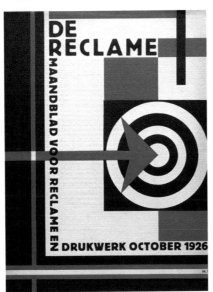

1926
M.W. (designer)
De Reclame
Magazine cover

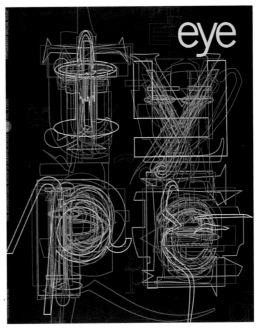

1993
Stephen Coates
Eye
Magazine cover

1938
Paul Rand
PM
Magazine cover

1999
Jonathan Barnbrook
Idea
Magazine cover

Transcendent White

Some say red, others black and even blue, but white is the most demonstrative (non)color when framed by any dark shade and hue. Like a light in the darkness, white glows, and thus leads the viewer's eye toward a message.

— 1948

1948
Giovanni Pintori
Olivetti
Poster

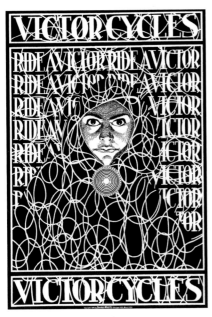

1898
Designer unknown
Victor Cycles
Poster

1986
Thomas Manss & Company
Laserbureau
Poster

1994
Stephen Coates, art director
Featuring fonts by Fuse and Jonathan Barnbrook
Eye
Magazine cover

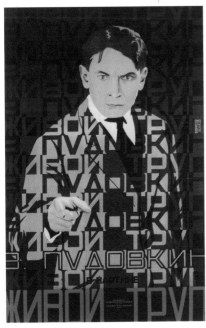

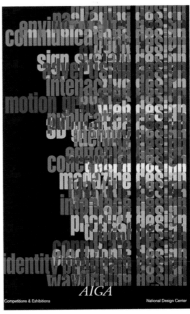

1929
Grigory Borisov and Pyotr Zhukov
The Living Corpse
Poster

1999
Chermayeff & Geismar Inc.
Steff Geissbuhler
**AIGA National Design Center, Competitions
and Exhibitions**
Poster

Title Pages

All books have title pages, mandated by convention. But some book designers use the title page as an opportunity to establish the visual character of the book. Whether ornate or economical, the title page sets the stage for the reading experience.

A

MERLE ARMITAGE

BOOK

Igor Stravinsky

EDITED BY EDWIN CORLE

WORKS OF ART BY:

Pablo Picasso • Russell Cowles
Edward John Stevens Jr. • Paul Klee
Cady Wells • Marc Chagall
Carlus Dyer • Antonio Frasconi
P. G. Napolitano • J. E. Blanche
Arnold Newman • Fred Plaut
Edward Weston • John Vachon

1949
Merle Armitage
Igor Stravinsky
Title spread

Before

1928
Karel Tiege
Break
(from book of a poem by Bieble)
Book title pages

1931
W.A. Dwiggins
The Time Machine
Book title pages

1940
Alvin Lustig
The Ghost in the Underblows
Book title pages

After

1951
Jacques Darche
Dora Providence
Book title pages

1968
Bradbury Thompson
The Red Badge of Courage
Book title pages

1990
Yolanda Cuomo, designer
Fran Bull, illustrator
Gwynne Truglio, woodtype handsetter
Mordant Rhymes for Modern Times
Book title pages

1996
Cyan
Scardanelli: Hautabziehn Gedichte
Book title pages

Nuts and Bolts

Trade and industrial catalogs are one of the most routine design jobs. However, the challenge of organizing disparate (and often visually mundane) materials and information has excited many designers. Ladislav Sutnar's *Catalog Design Progress*, a revolutionary approach to designing common data, provided a guide for creating sound informational hierarchies.

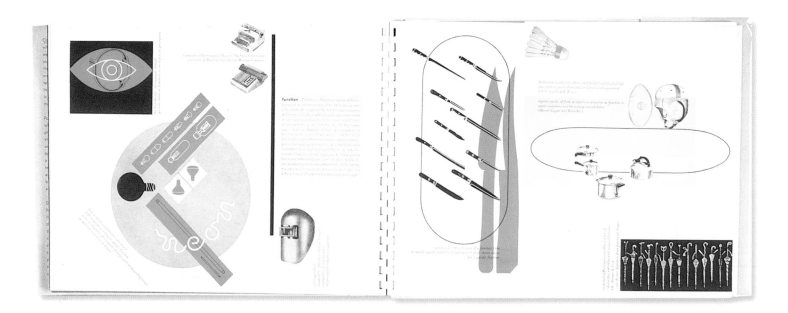

1950

1950
Ladislav Sutnar
Catalog Design Process
Catalog spread

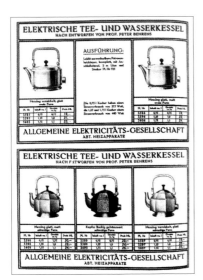

1908
Peter Behrens
Elektrische Tee- und Wasserkessel
Catalog page

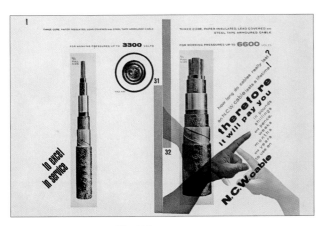

1926–1928
Piet Zwart
Dutch Cable Factory
Catalog spread

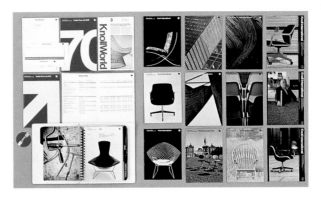

1966–1980
Massimo Vignelli
Knoll
Catalogs
Photo by Luca Vignelli

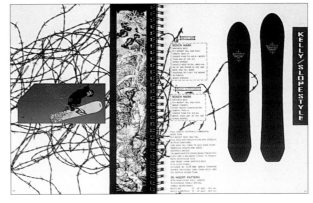

1991
Jager DiPaola Kemp Design
Burton Snowboards
Catalog spreads

1998
North
Jaqueline Rabun, Silver Book
Catalog spread

Magazine FX

Although most magazines conform to conventional shapes and sizes, some test the tolerance of printing in order to achieve a demonstrative effect. Die cuts, fold-outs, tip-ins and even string bindings are among the more unconventional methods of editorial packaging.

1951
Alexey Brodovitch
Portfolio
Magazine cover and pages

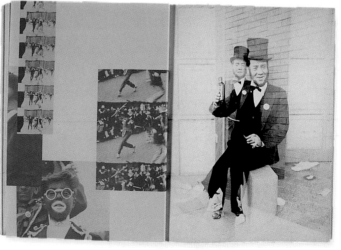

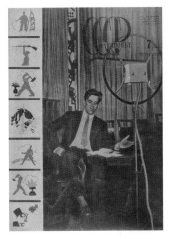

1935
Alexander Rodchenko
***USSR in Construction*, no. 7**
Magazine cover and spread

1950
Federico Pallavicini
Flair
Magazine cover and spread

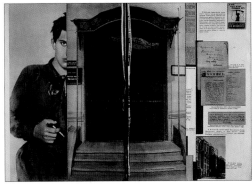

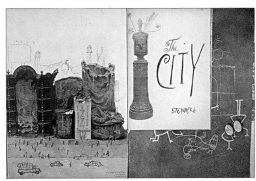

1959
Willem Sandberg
Nu
Magazine cover and spread
Courtesy Oaklander Books, New York

1999
Joseph Holtzman, art director
Nest
Magazine cover and spread

Wit and Satire

Magazines have been wellsprings of visual wit and satire since the mid-nineteenth century. The emphasis here is not on design per se, although type is often part of the puzzle, but the illustrated joke which can be either drawn or photographed.

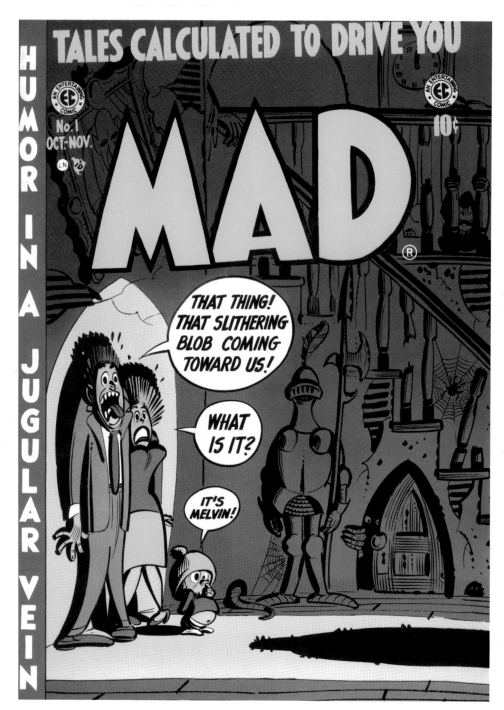

1952

1952
Harvey Kurtzman
MAD **magazine**
Magazine cover

1883
F.C. Burnand
Punch
Magazine cover

1971
Artist unknown
Private Eye
Magazine cover

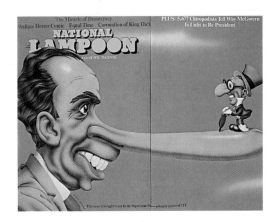

1972
Robert Grossman
National Lampoon
Magazine cover

1904
Roubille
Le Sourire
Magazine cover

1978
Designer unknown
Hara Kiri
Magazine cover

1915
Paul Iribe
Le Mot
Magazine cover

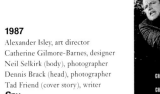

1987
Alexander Isley, art director
Catherine Gilmore-Barnes, designer
Neil Selkirk (body), photographer
Dennis Brack (head), photographer
Tad Friend (cover story), writer
Spy
Magazine cover

The Os Have It

One of the most frequently used visual puns is achieved by substituting a picture for a letter. Perhaps the most versatile letter is the ubiquitous vowel *O*. The possibilities are endless, including mouths, eyeglasses, inner tubes and breasts.

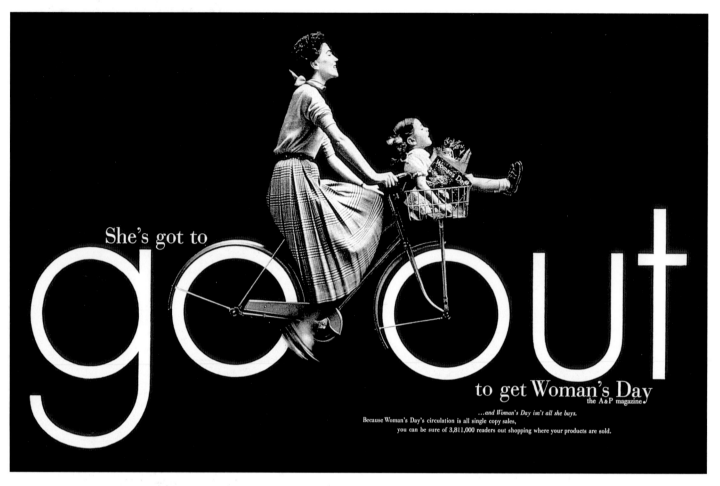

She's got to **go out** to get Woman's Day
the A&P magazine

...and Woman's Day isn't all she buys.
Because Woman's Day's circulation is all single copy sales,
you can be sure of 3,811,000 readers out shopping where your products are sold.

1953

1953
Gene Federico
Go out
Advertisement

c. 1918
Willrab
Problem Cigarettes
Poster

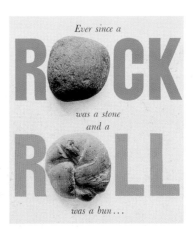

1957
Herb Lubalin
"Ever Since a Rock Was a Stone and a Roll Was a Bun…"
Brochure cover

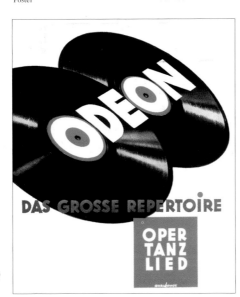

c. 1928
René Ahrlé, photographer
Odéon: Das Grosse Repertoire (Opertanzlied)
Advertisement

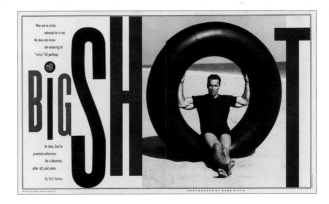

1989
Pentagram
Paula Scher, designer
Houghton-Mifflin, publisher
Goodbye, Columbus
Book jacket

1991
Fred Woodward, art director
Debra Bishop, designer
"Big Shot"
(from *Rolling Stone* magazine)
Magazine spread

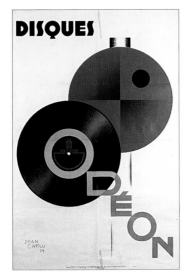

1929
Jean Carlu
Disques Odéon
Poster

1992
John Fontana, art director
Henry Sene Yee, designer
Elton John: The Biography
Book jacket

Mimetic Mnemonics

Logos trigger visual recognition as they impart a certain ethos. These ancestors of the medieval tradesman's mark, have evolved from illustrative pictographs to abstract shapes pregnant with symbolism. But for every original mark, scores of copies emerge to cash in on the power invested therein.

1954
Herbert Matter
New Haven Railroad
(for New Haven Railroad)
Logo

1882
Designer unknown
Procter & Gamble
Logo

c. 1890
A.L. Rich
General Electric
Logo

c. pre-1900
Gottlieb Daimler
Mercedes-Benz
Logo

1907
Peter Behrens
AEG
Logo

1924
László Moholy-Nagy
**Kreis Der Freunde Des
Bauhaus (Circle of Friends
of the Bauhaus)**
Logo

1951
William Golden
CBS
Logo

1962
Paul Rand
**International Business
Machines (IBM)**
Logo

1965
Francesco Sargolia
International Wool Secretariat
Logo

1974
Jean Widmer
Centre Georges Pompidou
Logo

1984
Saul Bass
AT&T
Logo

1989
Pentagram
Lowell Williams
The Herman Trust
Logo

1990
Chermayeff & Geismar Inc., New York
Steff Geissbuhler
Time Warner
Logo

Round and Round

The draftsperson's compass made drawing concentric circles incredibly easy. The hypnotic quality of circles makes them a common component of graphic decoration. In addition to their pure form, concentric circles appear to be in motion, which can serve as a metaphor for progress in the industrial and information ages.

— 1955

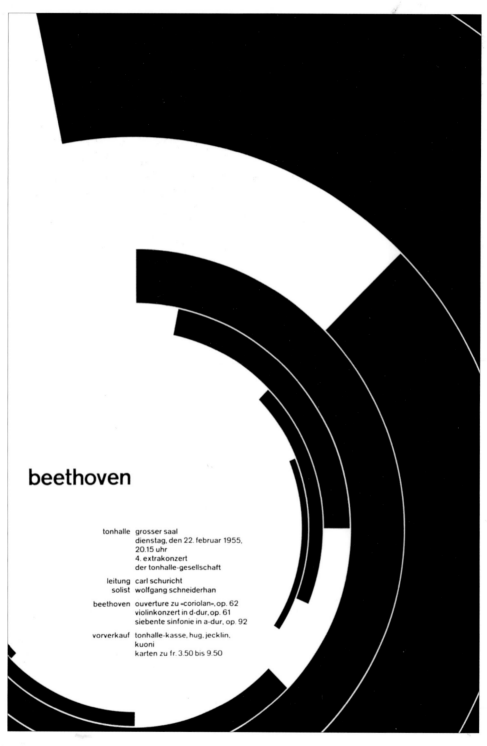

1955
Josef Müller-Brockmann
Beethoven
Poster

Before

After

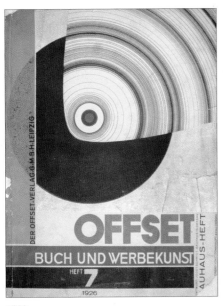

1926
Herbert Bayer
***Offset Buch und Werbekunst*, no. 7**
Magazine cover

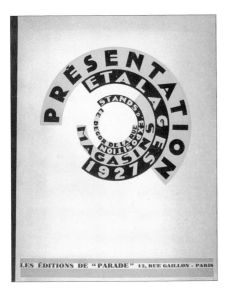

1927
Designer unknown
Présentation etalages
Catalog cover

1973
Yusaku Kamekura
ICSID '73 Kyoto
Poster

1978
Cream
Concept: Queen
***Jazz*, Queen**
Album cover

1994
The Designers Republic Ltd.
***Aaah! Extended Player*, Pop Will Eat Itself**
Album cover

c. 1998
BDDP Corporate
***7ème Édition, la Cité
de la Réussite***
Advertisement

1999
Viva Dolan Communication and Design, Toronto
Frank Viva, art director
Nathalie Cusson, designer
**Curious Paper Collection, Arjo Wiggins
Fine Papers**
Advertisement

Protest Symbols

Every cause needs a symbol as a mnemonic and rallying point. The world's most memorable symbols are inextricably linked to the events or ideas they represent. Like any logo or trademark, a bad ideology equals a bad symbol, no matter how pleasing the graphic form may be.

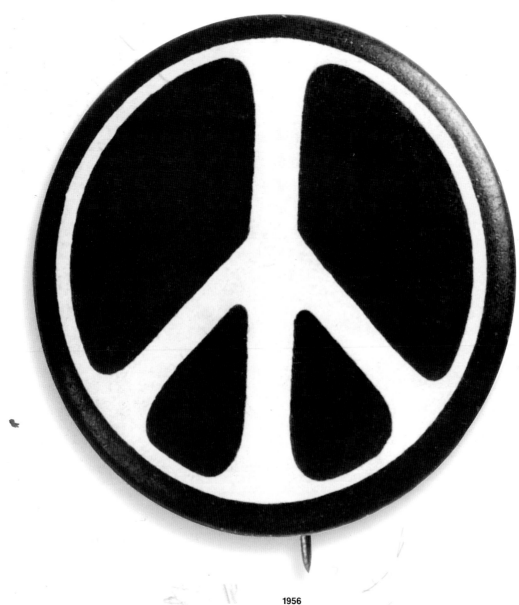

1956

1956
Gerald Holtom
Nuclear disarmament
Symbol

Date unknown
Artist unknown
Christian symbol
Symbol

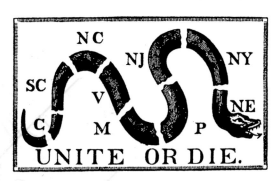

c. 1776
Benjamin Franklin
Unite or die!
Symbol

c. 1967
Designer unknown
Black Panther Party
Logo

c. 1970
Designer unknown
Hippie hand-sign for peace
Embroidered patch

c. 1970
Designer unknown
Anarchy
Symbol

c. 1970
Designer unknown
Women's Liberation Movement
Symbol

1974
Valerie Pettis
The UN Decade for Women
Symbol

1980
Jerzy Janiszewski
Solidarity—Poland '80
Logo

1992
Designer unknown
Malcolm X
Symbol

Flying Type

To increase the boundaries of the printed page, typographers have routinely used letters and words in kinetic compositions. Whether hitting letters over a grandstand or throwing words, like a volleyball, over a net (which is also made of a word or words), this kind of visual pun adds new dimension to tried and true form.

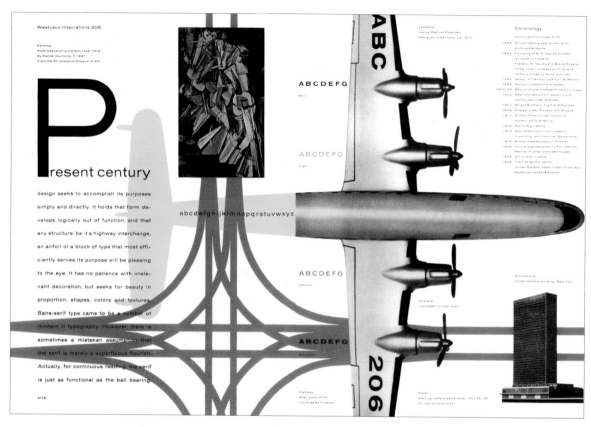

1957
Bradbury Thompson
Present century design…
(from *Westvaco Inspirations*)
Magazine spread

1930
Paul Schuitema
**Actual size of
a clock face**
Brochure spread

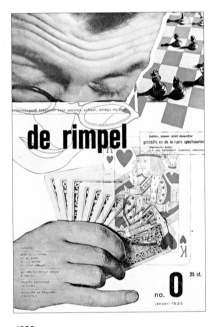

1933
Dick Elffers
De Rimpel
Magazine cover

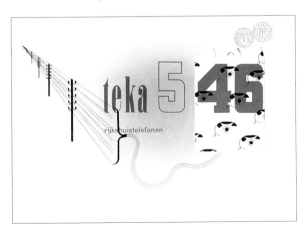

1938
Henny Cahn
Teka 546
Brochure cover

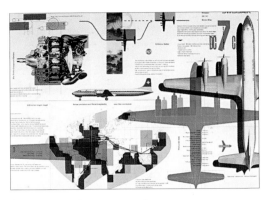

c. 1959
Designer unknown
Swiss Air (introducing the Douglas 7C-7)
Brochure spread

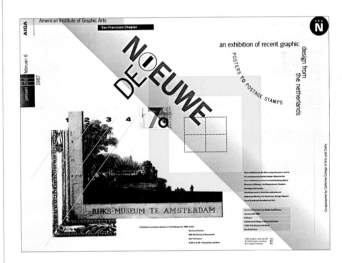

1987
Lucille Tenazas
**AIGA Exhibition of
Deutsch Graphic Design**
Poster

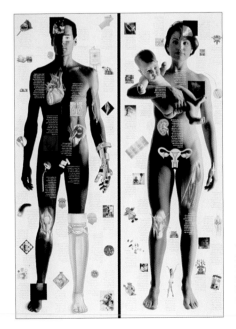

1988
Pentagram
Kit Hinrichs, designer
**National Medical
Enterprises: Everybody's
Body**
Annual report fold-out

Prism Colors

A designer's earliest experience with color theory comes in the form of the rainbow. It is the most elementary usage. The application of prismatic colors is based more on individual preference than any specific chromatic rules. But using gradations of color in pleasing or jarring juxtaposition always enlivens a page.

— 1958

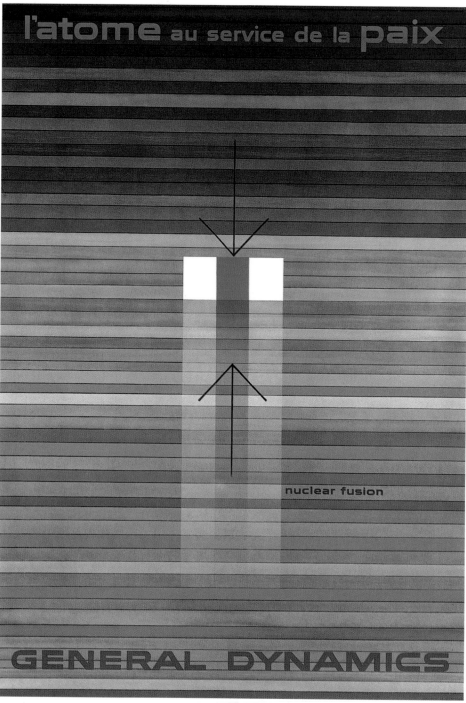

1958
Erik Nitsche
Exploring the universe: General Dynamics (nuclear fusion)
Poster

Before

1918
Kasimir Malevich
The Advance of the Red Cavalry
Painting
Scala/Art Resource, NY. Russian State Museum, St. Petersburg, Russia

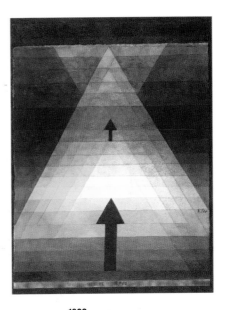

1922
Paul Klee
Separation in the Evening
Painting
© 2000 Artist Rights Society (ARS), New York, VG Bild-Kunst, Bonn

After

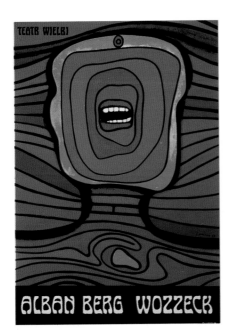

1964
Jan Lenica
Wozzeck
Poster
Courtesy Dydo Poster Collection, Crzysztof
Dydo, Postery Gallery Cracow, Ul. Stoiarska
8–10, 31–043 Krakow, Poland

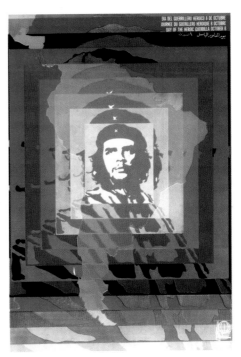

1968
Elena Serrano
Day of the Heroic Guerrilla
Offset lithograph

1983
Kiyoshi Awazu
Six Artists' Exhibition
Poster

Emotive Motion

Animating otherwise static images brings decided tension to the silver or cathode ray screens. Title sequences, which began as only type, evolved during the 1950s into graphic stories that introduced the plot of a film or TV show. These mini films within films further condense narratives into symbolic icons.

1959

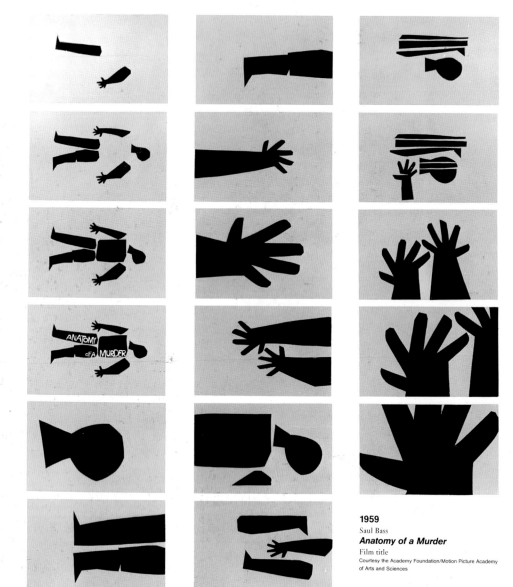

1959
Saul Bass
Anatomy of a Murder
Film title
Courtesy the Academy Foundation/Motion Picture Academy of Arts and Sciences

1933
Pacific Title
King Kong
Film title

1947
Designer unknown
Produced by Richard Wallace
Sinbad the Sailor
Film title

1964
Robert Brownjohn
Goldfinger
Film title

1968
United Artists
Norman Jewison, director
Pablo Ferro, designer
The Thomas Crown Affair
Film title

1995
Imaginary Forces
Kyle Cooper
Seven
Film title

Primal Screams

What is the most vivid emotion that can be expressed on a static page? The desperate scream takes the prize. Few facial expressions, whether drawn or photographed, reveal as much about the message being communicated. Few images attract the viewer as immediately and efficiently.

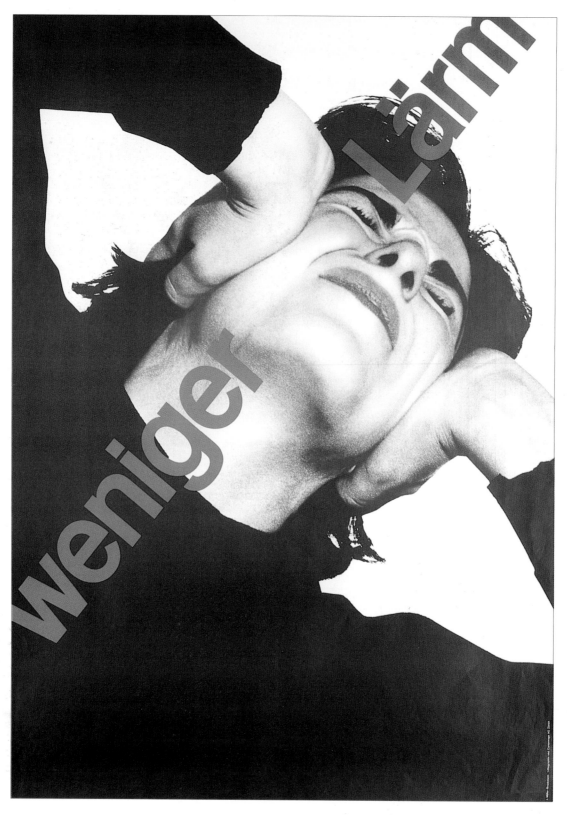

1960
Josef Müller-Brockmann
Less noise
Poster

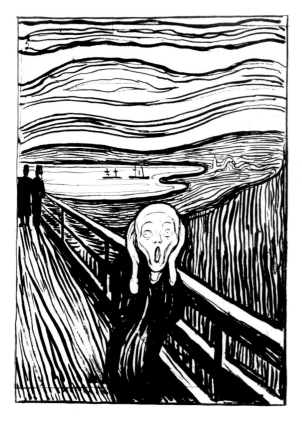

1895
Edvard Munch
The Scream
Woodcut print
Foto Marburg/Art Resource, NY

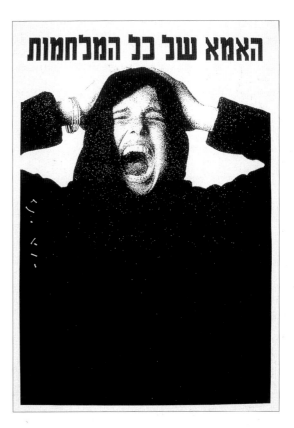

1991
Gali Hos
The mother of all wars
Poster

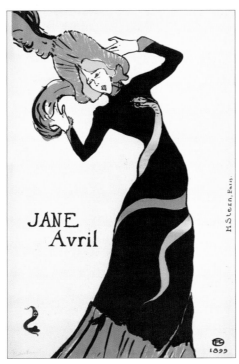

1899
Henri de Toulouse-Lautrec
Jane Avril
Poster
© Museum of Modern Art

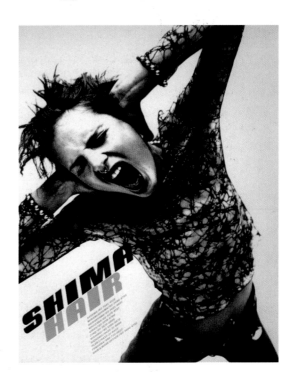

1995
Tsuguya Inoue
Shima Hair
Advertisement

Lingua Franca

Without type there is no graphic design. Type is a vessel for most ideas. But without variety in typographic style there are simply words. Type is as symbolic as it is functional. Even the most neutral of all typefaces, Helvetica, represents the clarity, economy and universality of an interdependent age.

ABCDEFGHIKLMN
OPQRSTUVWXYZ
abcdefghiklmn
opqrstuvwxyz

1961
Max Miedinger and Edouard Hoffman
Helvetica
Typeface

— 1961

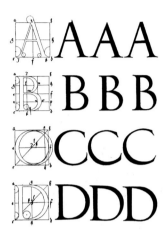

1525
Albrecht Dürer
**From Underweisung
der Messung**
Drawing

1985
Zuzana Licko
Oakland
Typeface

W CASLON JUNR LETTERFOUNDER

1816
William Caslon IV
"W CASLON JUNR LETTERFOUNDER"
Typeface

ABCDEFGHIJKLM
NOPQRSTUVWXYZ
abcdefghijklm
nopqrstuvwxyz

1985–1994
Erik Spiekermann
Meta
Typeface

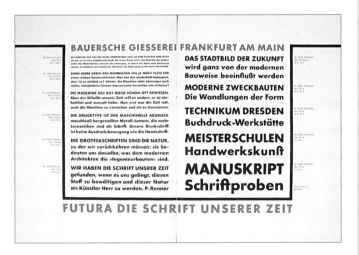

1927 (released in 1930)
Paul Renner
Futura
Typeface

ABCDEFGHIJKLM
NOPQRSTUVWXYZ
abcdefghijklm
nopqrstuvwxyz

1990
Barry Deck
Template Gothic
Typeface

Optic Nerves

Not all typography is designed to be scanned immediately or easily by the reader. Often the more neutral the composition, the less likely it will be read. Letterforms with built-in impediments, including tight settings and optical ticks, slow the reader down and demand levels of interactivity.

1962
Joshua Reichert
Typographic interpretation of a poem by Ludwig Greve
Print

Before

After

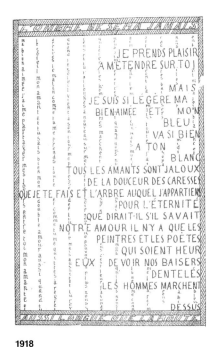

1918
Albert-Birot
L'ombre ne Sera Jamais
Calligram

1963
Franz Mon
Untitled
Collage

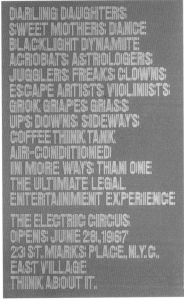

1967
Chermayeff & Geismar Inc., New York
The Electric Circus
Poster

1989
Pentagram
John Rushworth, designer
MDC Prints Ltd. have moved
Poster

1929
A.M. Cassandre
Bifur
Type specimen

1994
Lars Müller
See Saw
Book cover

133

Tag Lines

The slogan is the *sine qua non* of the advertising industry. Without a memorable tag, a product or idea could easily fade into obscurity. The true test is when, decades after the original coinage the slogan still resonates. For then it has become part of the culture and imbedded in the mind.

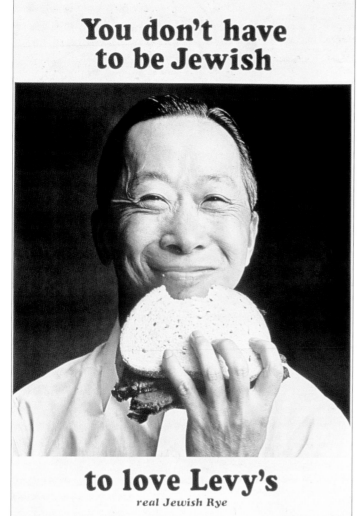

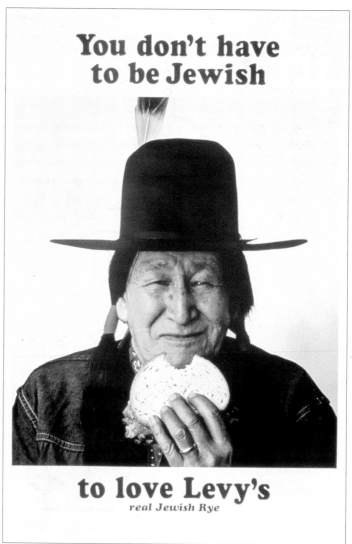

— 1963

1963
William Taubin, art director
Howard Zieff, photographer
You don't have to be Jewish to love Levy's
Advertisement

Before

After

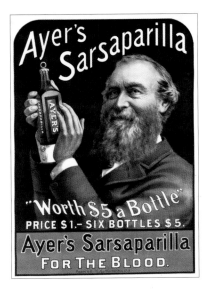

c. 1895
Anonymous
Ayer's Sarsparilla
Poster

1996
TBWA Chiat/Day, New York
Geoff Hayes, art director
Graham Turner, copywriter
Steve Bronstein, photographer
Absolut (Perfection)
Advertisement

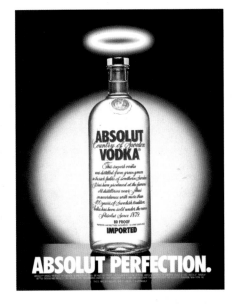

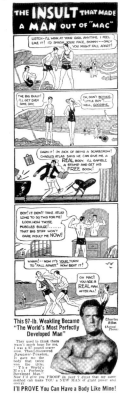

c. 1938
Artist unknown
The insult that made a man out of "Mac"
Advertisement

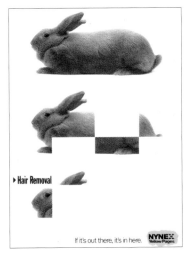

1996
TBWA Chiat/Day, New York
Rick Dublin
**Nynex Yellow Pages
(Hair Removal)**
Advertisement campaign

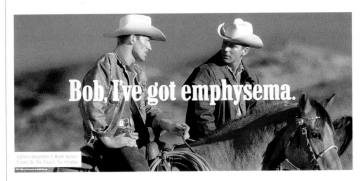

1960
Helmut Krone
Volkswagen (Lemon)
Advertisement campaign

1997
Asher & Partners
Nancy Steinman, art director
Bruce Dundore, creative director
Jeff Bossin, copywriter
Myron Beck, photographer
Nels Dielman, typographer
Bob, I've Got Emphysema
Billboard image
© 1997 California Department of Health Services

Pictorial Narratives

Few things are more engaging in print than comic strips. Likewise, graphic narratives of any kind engage the reader in sequential journeys. This kind of pictorial storytelling can be traditional or abstract as long as the plot advances at a gratifying clip.

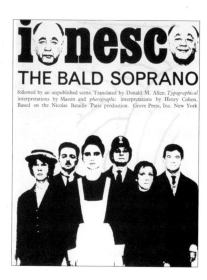

1964

1964
Robert Massin
The Bald Soprano
Book cover and spread

— 1964

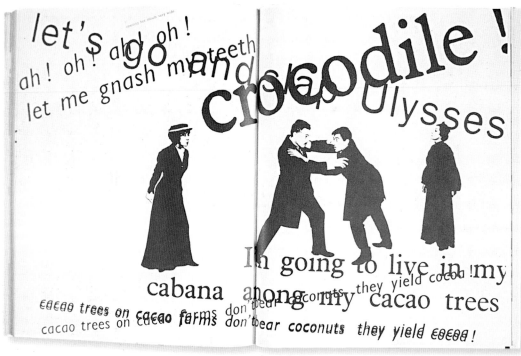

1940
Alexey Brodovitch
Saks Fifth Avenue Advertising
Magazine spread

1968
Lawrence Levy
Willie Masters'
Lonesome Wife
Book cover and spread

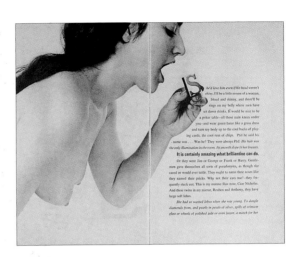

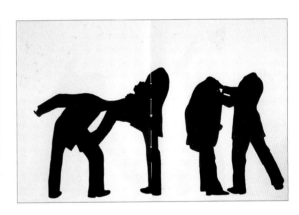

1974
Roman Cieslewicz
A Book for Children
Book cover and spread

1960
Harold Lang and Kenneth Tynan
The Quest for Corbett
Book cover and spread

1984
Dennis Bernstein
Warren Lehrer
French Fries: A New Play
Book cover and spread

Radiation Fallout

Lines emanating from a ground plane, as if rays emanating from the sun, suggest a powerful blast of energy. And energy equals strength in graphic design. Radiating lines have the power to illuminate and propel a message.

— 1965

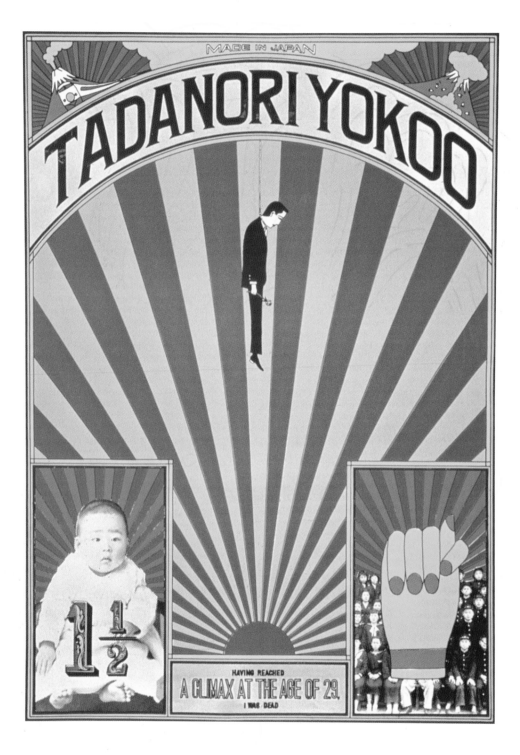

1965
Tandanori Yokoo
Tadanori Yokoo
Silk screen

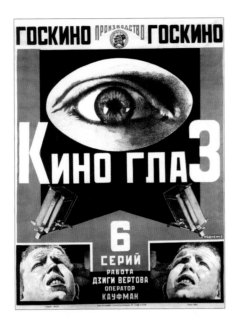

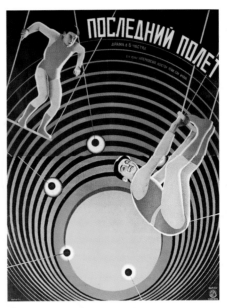

1924
Alexander Rodchenko
Film Eye
Poster

1929
Stenberg Brothers
The Last Flight
Poster

1982
Kazumasa Nagai
The First Contemporary Art Festival
(exhibition for Shyuzo Takiguchi and the
Postwar Art)
Poster

1995
Me Company
Paul White, art director
Wieden and Kennedy (Amsterdam), client
Michael Prieve, creative director for W+K
Erik Kessels and Johan Kramer, creatives for W+K
Image created by Me Company
Nike: Kluivert
Advertisement

1996
Katsunori Aoki, creative director, art director, designer
Ichiro Tanida, creative director, 3-D Illustrator
Yasuhiko Sakura, copywriter
New Laforet
Poster

Flow Chart

Art Nouveau—the upstart, *fin-de-siecle* design style—was rooted in curvilinear form. At the time it was introduced, the replication of organic form was a stark contrast to stiff academic rendering. The curvilinear ultimately gave way to Modernism's right angle, but the application's sensual, flowing curves continue to suggest mystery.

1966
Milton Glaser
Bob Dylan
Poster

1966

1897
C.A. Lion Cachet
Sigaren
Poster

1900
Koloman Moser
Illustrierte Zeitung
Poster

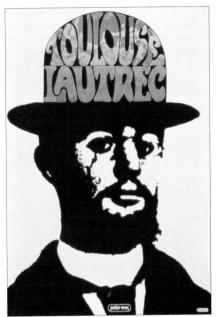

1967
Peter Max
Portrait of Toulouse-Lautrec
Poster
© Peter Max

1976
Andrew Kner, art director
Sheldon Seidler, designer
Print magazine
Magazine cover

1984
Dietrich Ebert
IBM 4361
Poster

About Faces

In polemic illustration, the head is used as a target. Heads and faces provide the artist with a bullseye. Whether as a specific individual or generic symbol, this anatomy underscores an offending or offended person or group. Few other images make the case as convincingly.

1967
Tomi Ungerer
Eat
Poster

1854
Gustave Doré
**"You've been mumbling 1812 under your breath
long enough…"**
(from *The History of Holy Russia*)
Pen and ink

1967
Seymour Chwast
End bad breath
Poster

1878
Andre Gill
L'Eclipse
Magazine cover

1992
Grapus
Pierre Bernard
Apartheid Racisme
Poster

1989
István Orosz
Comrades, adieu!
Poster

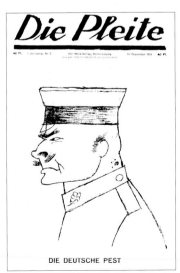

1919
George Grosz
Die Pleite
Magazine cover

1991
Robbie Conal
Gag me with a coat hanger
Poster

Comic Panels

The comic strip is the most kinetic form of the otherwise static graphic arts. On a single page, time and space move as fast or faster than real (or reel) time. But the comic has another dimension. This is the birthplace of surrealism, where fantasy and reality often collide.

1968
Robert Crumb
Cheap Thrills, Big Brother and the Holding Company
Album cover

Before

After

1897
Richard F. Outcault
Yellow Kid
Comic strip

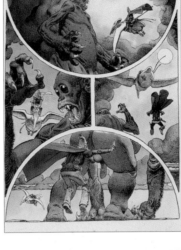

1976–1978
Moebius (Jean Gireaud)
Arzach
Graphic novel

1907
George Herriman
Krazy Kat
Comic strip
Reprinted with special permission of
King Feature Syndicate

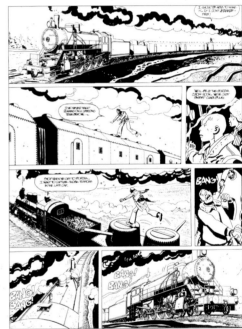

1979
Translated 1988
Hugo Pratt
*Corto Maltese
in Siberia*
Comic book

1938
Joe Shuster, artist
Jerry Siegel, writer
Superman from
Action Comics #1
Comic book
Courtesy DC Comics

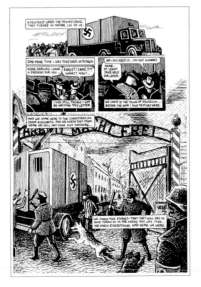

1986
Art Spiegelman
Maus
Graphic memoir

Photographically Surreal

The photomontage made it possible for designers to vividly present the inconceivable. Sandwiching disparate, though realistic, images together to form an impossible truth forces the viewer to seriously consider what is real in the unreal.

1969

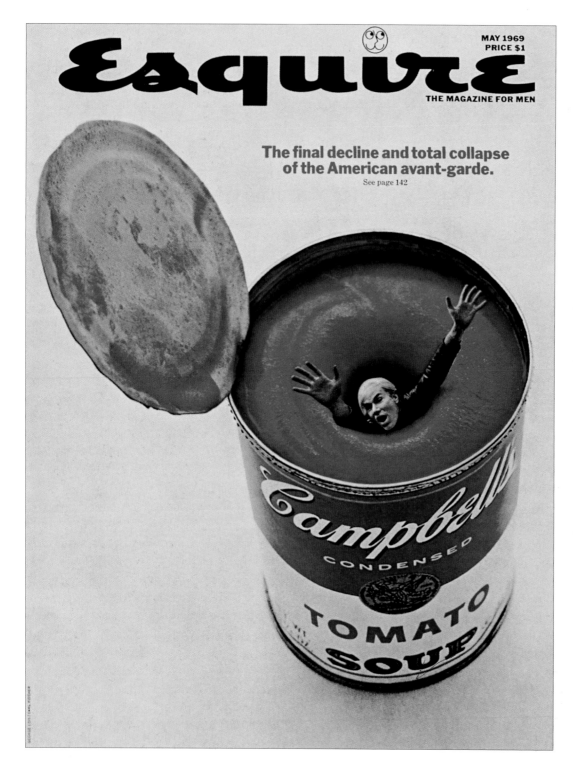

1969
George Lois
Carl Fischer
Esquire
Magazine cover

146

Before

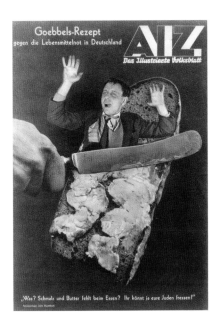

1935
John Heartfield
AIZ
Magazine cover

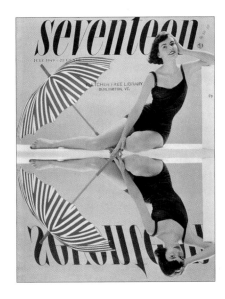

1949
Cipe Pineles
Seventeen
Magazine cover

1962
Henry Wolf
Show
Magazine cover

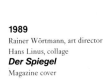

After

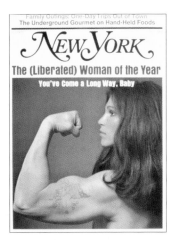

1969
Walter Bernard, art director
Milton Glaser, design director
New York magazine
Magazine cover

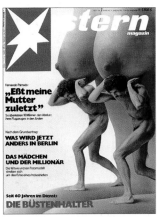

1973
Wollfang Benkhen, art director
Christa Peters, photographer
Stern
Magazine cover
Courtesy Stern Syndication
© Christa Peters/STERN

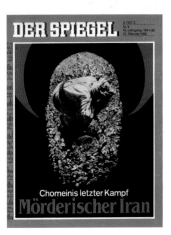

1989
Rainer Wörtmann, art director
Hans Linus, collage
Der Spiegel
Magazine cover

1997
Andrew Eccles, photographer
Janet Froelich, art director
Joele Cuyler, designer
Kathy Ryan, photo editor
The New York Times magazine
Courtesy The New York Times Company

147

Navigational Aid

Little else about graphic design is more functional, indeed more necessary, than way-finding aids (for the road, in the airport and even throughout the corporate hierarchy). The tools include signs, maps, charts and diagrams. Economy is essential in making complexity more accessible.

— 1970

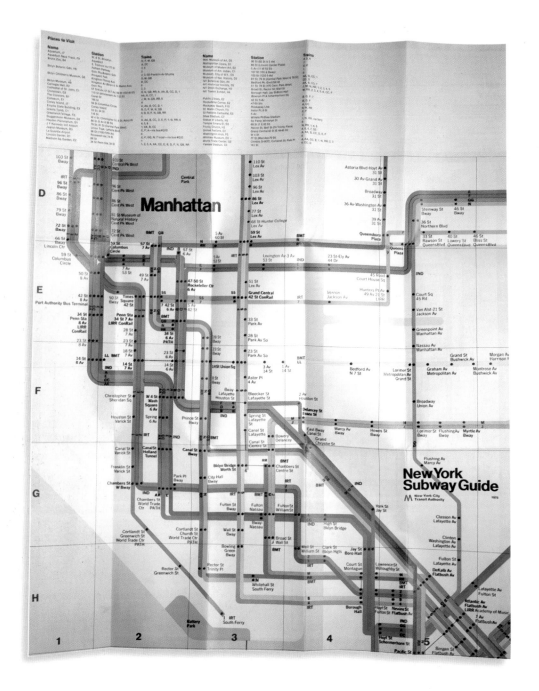

1970
Massimo Vignelli
**New York Metropolitan Transport
Authority Subway Transportation**
Graphic standards program

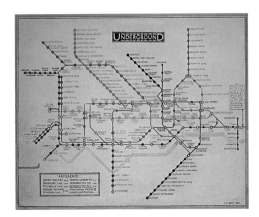

1931
Harry Beck
Proposal for the London Underground
Presentation sketch
The London Transport Museum

1991
Nigel Holmes
**"The Dirtiest Bank
of All"**
(from *Time* magazine)
Magazine spread

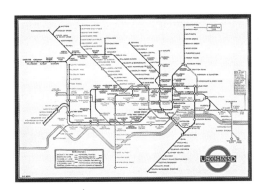

1933
Harry Beck
London Underground
Diagram
The London Transport Museum

1991
USA Today
Sam Ward, artist
**"How an Aircraft
Carrier Works"**
Diagram

1953
Herbert Bayer
World Geographic Atlas
Map

1964
Jock Kinneir
Maidenhead
Highway signage

1996
Studio Archetype
Clement Mok
24 Hours in Cyberspace
Site map

Book Type

The book is a temple of typography where designers pay homage to classical methods of composition and production. It is also a hothouse where experiments are carried out, directly challenging the past. The book may seem like a confining medium, but its many altered states prove otherwise.

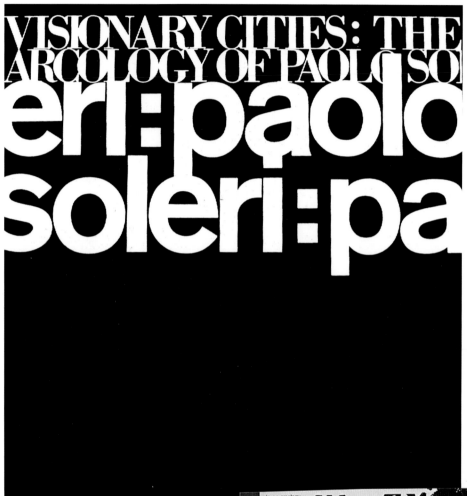

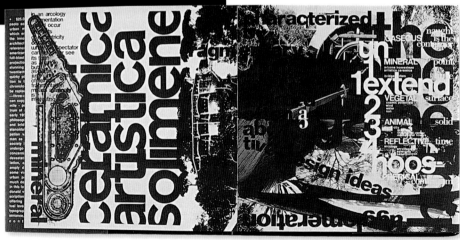

1971
Donald Wall
Visionary Cities: The Arcology of Paolo Soleri
Book cover and spread

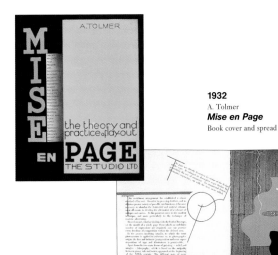

1932
A. Tolmer
Mise en Page
Book cover and spread

1995
Bruce Mau
Kevin Sugden
Nigel Smith
Greg Van Alstyne
Alison Hahn
Chris Rowat
Hans Werlemann, photographer
S,M,L,XL
Book cover and spread

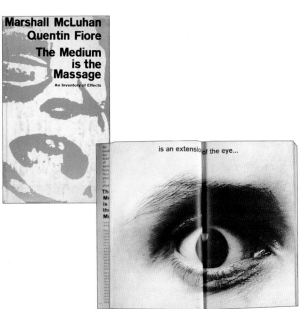

1967
Marshall McLuhan
Quentin Fiore
The Medium Is the Massage
Book cover and spread

1997
Aufuldish & Warinner
Icons: Magnets of Meaning
Book cover and spread

1967
Jož̌e Brumen
Batič
Book cover and spread

Graphic Commentary

Illustrators bear witness to events through drawings that satirize and criticize. The artist's role is not to vividly recreate but, in fact, to filter the facts through the mind's eye into iconic symbols. Objectivity is left to photographers, while graphic commentary exists to rile and excite the viewer's passions.

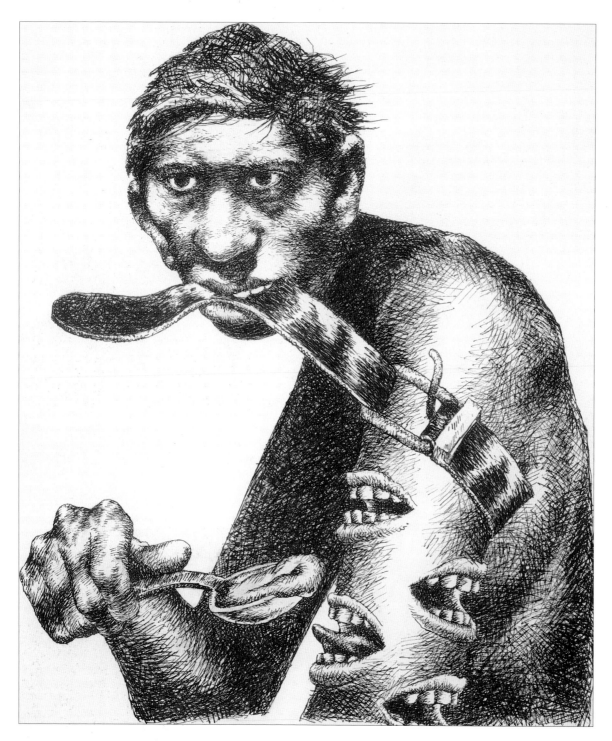

1972

1972
Brad Holland
Junkie
Drawing

Before

After

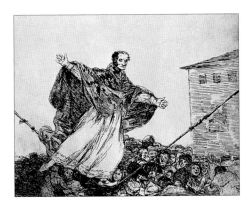

c. 1810
Francesco de Goya
Que se Rompe
la Cuerda
Etching

1977
Marshall Arisman
Mr. Death
Drawing

1854
Gustave Doré
"The Soldiers of Peace"
(from *The History of Holy Russia*)
Drawing

1982
Alan E. Cober, illustrator
Don Owens, art director
Why People in Dallas Are
Arming Themselves
Drawing

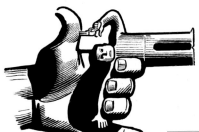

1984
David Suter
The Equalizer
Drawing

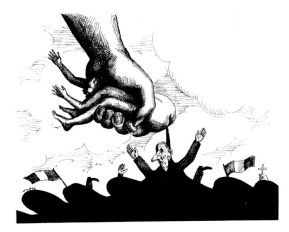

1968
Roland Topor
Illustration for *Le Pavé*
Drawing

1991
Sue Coe
"Thank You America"
Lithograph

Design for Designers

How a designer chooses to present him- or herself through the cover of a monograph speaks directly to how personalized design can be. Some designers reprise that work which is most distinctly identifiable. Others employ their signature styles to underscore who they are and what they do.

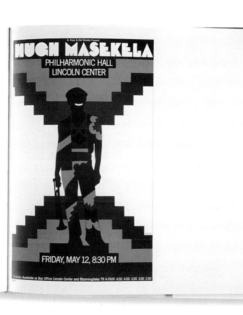

1973
Milton Glaser
Milton Glaser: Graphic Design
Book cover and spread

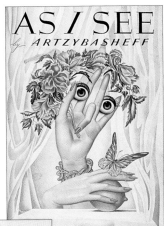

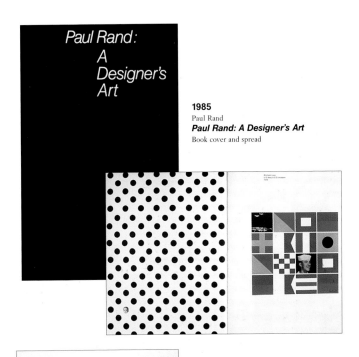

1985
Paul Rand
Paul Rand: A Designer's Art
Book cover and spread

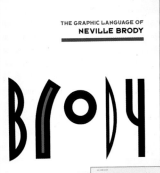

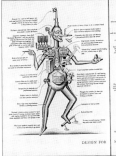
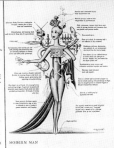

1950
Boris Artzybasheff
As I See
Book cover and spread

1988
Neville Brody
The Graphic Language of Neville Brody
Book cover and spread

1971
Tadanori Yokoo
The Complete Tadanori Yokoo
Book cover and spread

1995
David Carson
The End of Print
Book cover and spread

Alphabet As Metaphor

Morphing objects into letters, transforming letters into objects, and otherwise creating alphabetic metaphors is probably as old as letterforms themselves. In this practice, the letter becomes a picture of the thing expressed in words, and thus increases the meaning of (or at least the interest in) the particular message.

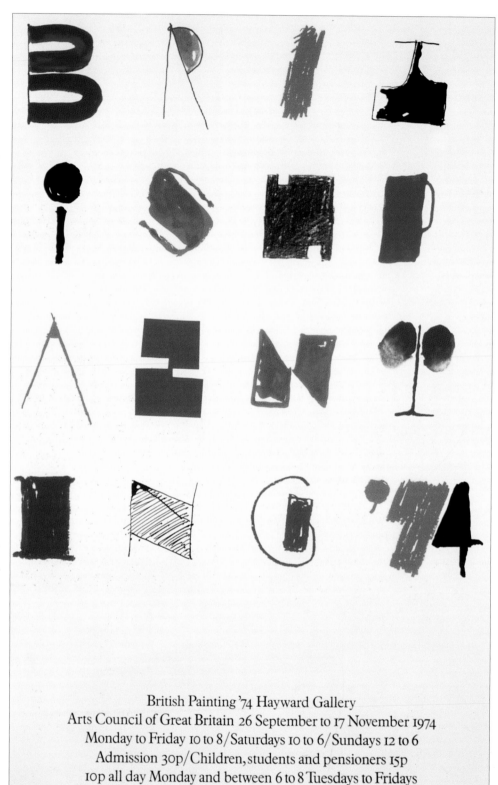

British Painting '74 Hayward Gallery
Arts Council of Great Britain 26 September to 17 November 1974
Monday to Friday 10 to 8/Saturdays 10 to 6/Sundays 12 to 6
Admission 30p/Children, students and pensioners 15p
10p all day Monday and between 6 to 8 Tuesdays to Fridays

1974

1974
Pentagram
Alan Fletcher, designer
British Painting '74
Poster

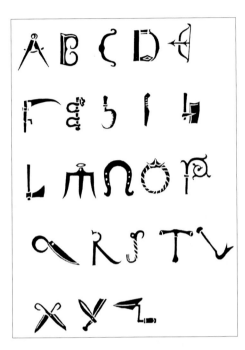

**1523 (reproduced in
1529)**
Abraham de Balmes
Alphabet from
Grammatica Hebraea
Drawing

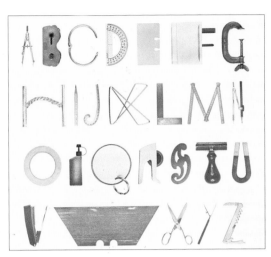

1977
Pentagram
Mervyn Kurlansky, designer
Alphabet With Tools
Typeface

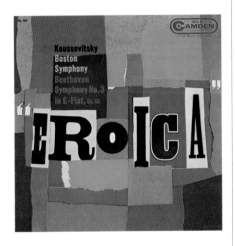

1957
Chermayeff & Geismar Inc.,
New York
Ivan Chermayeff
Eroica
Album cover

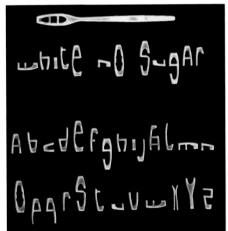

1995
Anna-Lisa Schönecker
White No Sugar
Typeface based on coffee stirrers

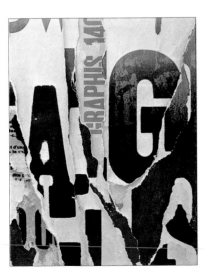

1964
Robert Weaver
Graphis 140
Magazine cover

1999
Talent Factory
**Wired Plan XXOO
Publikum's Calendar**
FeO2 (Ferro Oxid-Rust)
Typeface

Shouts and Murmurs

Like the primal scream, showing a mouth wide open as if to shout is a startling visual. By freezing this stark facial expression, the designer focuses the viewer's attention on a key action. In addition, this state of suspended animation is akin to a voice on the page.

— 1975

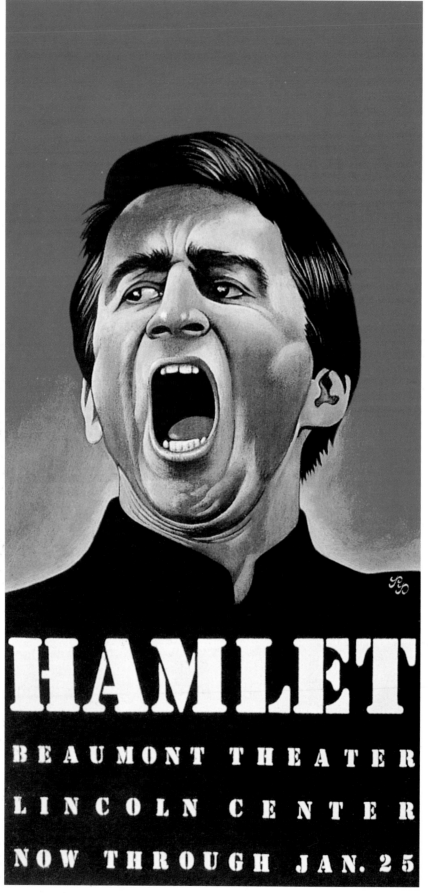

1975
Paul Davis
Hamlet
Poster

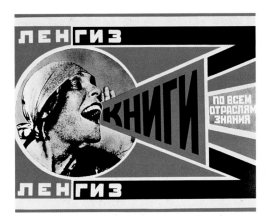

1925
Alexander Rodchenko
Leningrad Publishing House
Poster

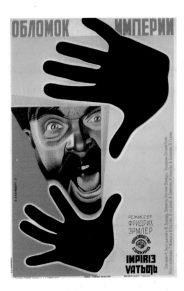

1929
Stenberg Brothers
Fragment of an Empire
Poster

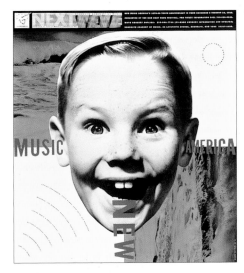

1989
Alexander Isley Inc.
Alexander Isley, art director
Alexander Knowlton, designer
New Music America
Poster

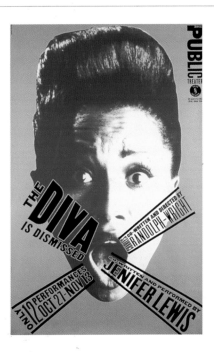

1994
Pentagram
Paula Scher, designer
Ron Louie, designer
Lisa Mazur, designer
Jane Mella, designer
Teresa Lizotte, photographer
Amassador Arts, printer
The Diva Is Dismissed
Poster

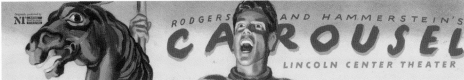

1994
James McMullan
Carousel
Poster

1998
Mires Design, Inc.
John Ball, art director
Deborah Hom, designer
Nike McEnroe Megaphone
Logo

Making Book

The book can be a container of or metaphor for other objects—among them a human behind, cigar box, doors and windows, even an X-ray screen. In fact, it is surprising how much can be accomplished within such strict confines. In the current milieu, books must compete with new interactive media, but the book as object is by no means merely a novel idea.

1976

John Gorham
The Parent's Schoolbook
Book cover

1929
Designer unknown
John D.: A Portrait in Oils
Book cover

1959
Designer unknown
The History of Surrealist Painting
Book cover

1969
Mendell & Oberer
Pierre Mendell, designer
Claus Oberer, photographer
Notes of a Dirty Old Man
Front and back book cover

1967
The Push Pin Studio
The Connoisseur's Book of the Cigar
Book cover

1988
Chip Kidd
Naked
Book covers

1994
Barbara de Wilde
Mapping the Farm
Book jacket/poster

1997
Jeffrey Keyton, designer
Stacy Drummond, designer
Tracy Boychuk, designer
VMA Book: Fetish & Fame
Book

Cut-up Letters

The Punks of the mid-1970s did not invent the ransom note, although they used this typographic trope often. The fact is, it is hard to determine who originally cut up individual letters and reordered them to give a somewhat anonymous, untutored look to communications. The Cubists are credited with being the first to introduce this to canvas, and from there it became a frequent code for counter-culture design.

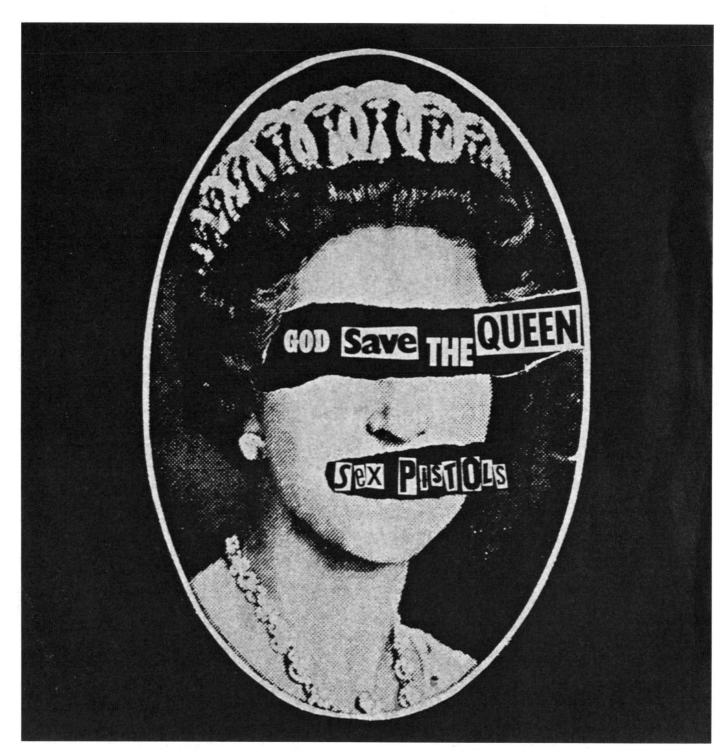

1977

1977
Jamie Reid
***God Save the Queen*, Sex Pistols**
Record cover

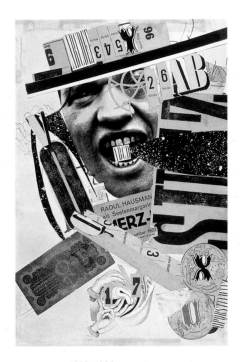

1923–1924
Raoul Hausmann
ABCD
Collage
Collections Mnam/Cci–Centre Georges Pompidou
Photo: Photothèque des collections du Mnam/Cci

1989
Art Chantry
Treepeople
Record cover

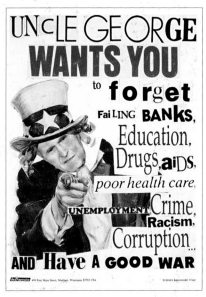

1991
Steven Kroninger
Uncle George wants you
Poster

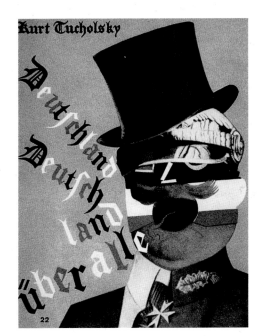

1929
John Heartfield
Deutschland, Deutschland, Über Alles
Book jacket

1993
NBBJ Graphic Design, Seattle
Klindt Parker, printing
Reprographics Northwest, camera
Seattle ImageSetting, output
Mandragola, Unchained
Poster

Envisioned Environments

Collage and montage allow designers and artists to create nonexistent environments. The process allows for dramatic juxtapositions and shifts in scale. But additionally, for purposes of propaganda, it facilitates the creation of deceptive realities.

1978
Jayme Odgers, photographer
April Greiman, typography
CalArts
Folded poster

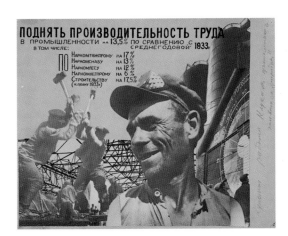

1933
Gustav Klutsis
Raise the productivity of labor
Poster

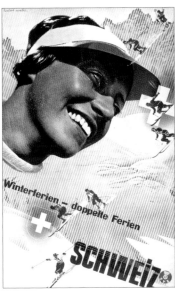

1934
Herbert Matter
Schweiz
Poster

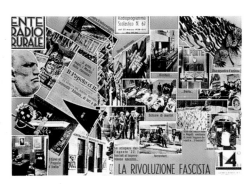

1938
Oreste Gasperini, designer
Printed by Tumminelli & Co., Rome
Published by Ente Radio Rurale, Società Anonima Istituto, Rome
**Rural Radio Corporation. Scholastic Radio Program
N. 67, The Fascist Revolution, no. 14**
Commercial color photo-lithograph
The Mitchell Wolfson Jr. Collection, The Wolfsonian-Florida International University, Miami Beach,
Florida. Photo by Bruce White.

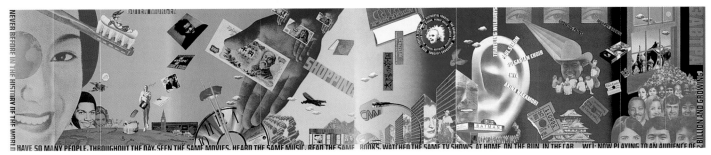

1988
Pentagram
Peter Harrison, partner
Harold Burch, associate, designer
John Berendt, writer
Gene Greif, illustrator
Carol Friedman, photographer
Cromwell Typographers, typographer
George Rice & Sons, printer
Reflections/Passport, paper
Warner Communications 1988
Annual report

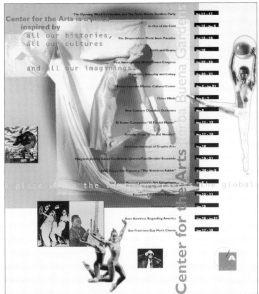

1993
Lucille Tenazas
Center for the Arts, Yerba Buena Gardens
Poster

1995–1996
Why Not Associates
Technology
Kobe Fashion Museum, Japan
(still from *Synapse*)
Audiovisual installation

Valuable Paper

Designing paper currency is like designing a flag. Money embodies the nation that it represents, and it also represents the wealth (or lack thereof) of its citizenry. A bill must be official, have roots in tradition and yet still be so well-designed that it is worth the paper it is printed on.

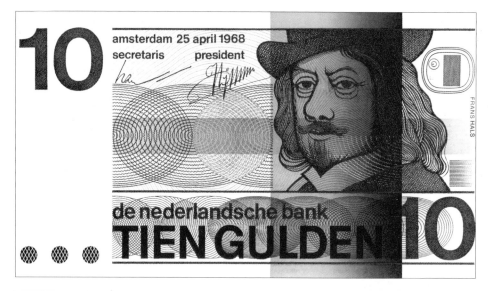

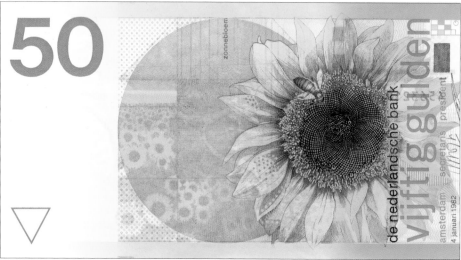

1968–1982
R.D.E. Oxenaar
10, 50 gulden bills (Dutch)
Paper currency

1923
Herbert Bayer
1,000,000 Mark bill (Thuringian)
Paper currency
Courtesy Oaklander Books, New York

1993
D. Andrić, designer
D. Matić, designer
500,000,000,000 Dinara bill (Yugoslavian)
Paper currency

c. 1929
Artist unknown
Untitled
Notgeld (ersatz currency)
Courtesy Oaklander Books, New York

c. 1970
Designer unknown
20 franc bill (Swiss)
Paper currency

c. 1929
Artist unknown
Untitled
Notgeld (ersatz currency)
Courtesy Oaklander Books, New York

1998
Designer unknown
$100 bill (U.S.)
Paper currency

Angular Composition

In the 1920s, back in the days of hot-metal composition, designing type on an angle was no easy task, which is one reason why it was so startling. The other is that any variation on familiar central axis symmetry disrupted reading patterns. Asymmetry of this kind is inherently more dynamic than traditional layout.

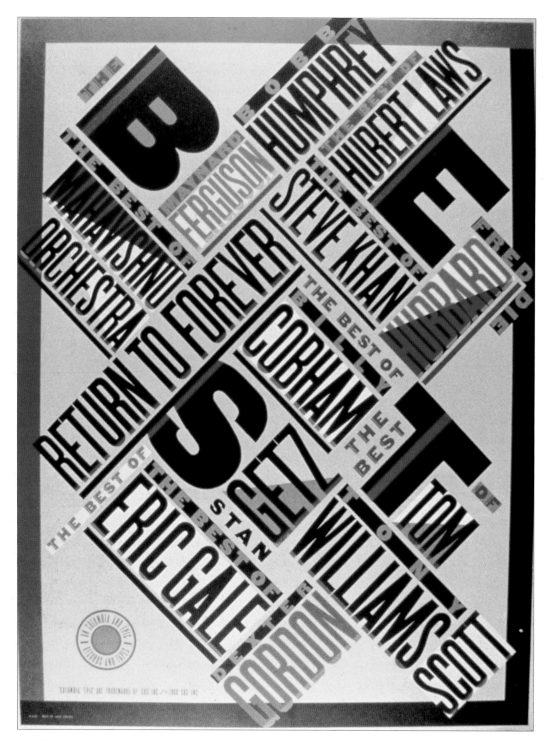

1980
Pentagram
Paula Scher, designer
CBS Records, *Best of Jazz*
Poster

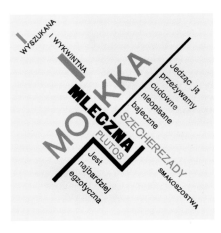

1924
Henryk Berlewi
Mokka Mleczna
Advertisement

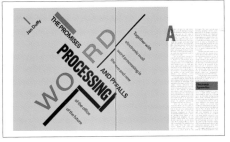

1983–1985
Pentagram
David Hillman, designer
"Information Resource Management"
Magazine spread

1927
Fortunato Depero
Depero: Futurista, Architetto, Pittore, Scultore, Decoratore, Fama Mondiale…
(from *Dinamo-Azari*)
Advertisement

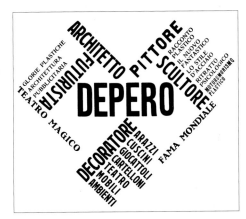

1994
Fred Woodward, art director
Fred Woodward and Gail Anderson, designers
John Collier, illustrator
"Tonya Harding: The Hard Fall"
(from *Rolling Stone*)
Magazine page

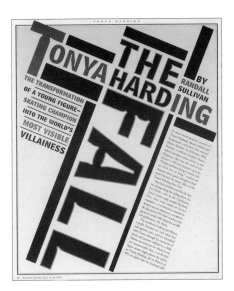

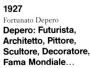

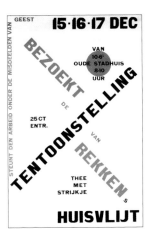

c. 1927
Sybold van Ravesteyn
Crafts Exhibition, Rekken
Poster

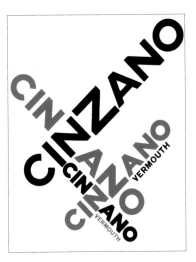

1961
Monnerat
Cinzano Vermouth
Poster

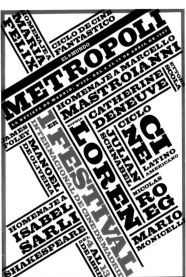

1997
Carmelo Caderot, design director
Rodrigo Sanchez, art director
Maria González, designer
***Metrólpoli: La Revista de Madrid*, no. 358**
Magazine cover

1999
Steven Baillie, creative director
Matthew Brooke, art director
Yooni Suh, senior designer
Garland Lyn, designer
Tim McIntyre, designer
Helen Niland, designer
Sean Ellis, photographer
***Arena* magazine**
Magazine cover

Youth Culture

Starting in the late 1960s, design codes that emanated from and were used to communicate with youth culture became dominant throughout the broader visual culture. In publication design, these codes involve visual ideas that address direct concerns (i.e., politics or sex) or captured the stylistic zeitgeist.

1981
Terry Jones
i-D
Magazine cover

1981

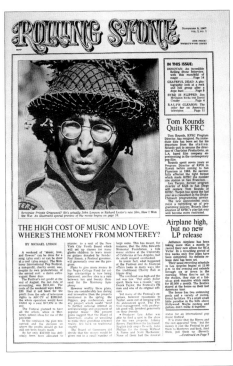

1967
Robert Kingsbury, art director
Rolling Stone
Magazine cover

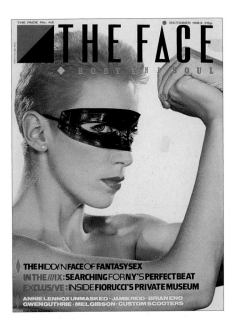

1983
Neville Brody, designer
Peter Ashworth, photographer
The Face, no. 42
Magazine cover

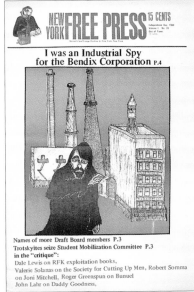

1968
J.C. Suares, art director
Steven Heller, illustrator
New York Free Press
Newspaper cover

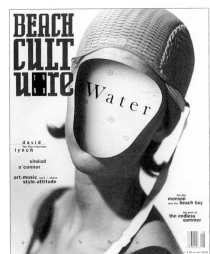

1990
David Carson
Beach Culture
Magazine cover

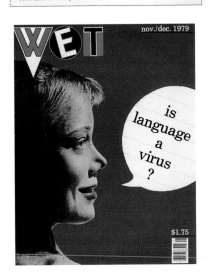

1979
Designer unknown
Wet
Magazine cover

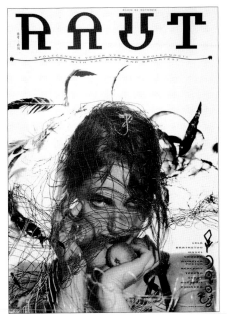

1992
Ales" Najbrt, designer
Tono Stano, photographer
Raut, no. 2
Magazine cover

Rebus Writing

The substitution of signs and symbols for letters to make words—and shape ideas—is as old as the earliest children's word games. But it is also one of the most successful graphic design tools because it stimulates interactivity. Forcing the viewer to decipher a simple word or phrase adds to its memorability.

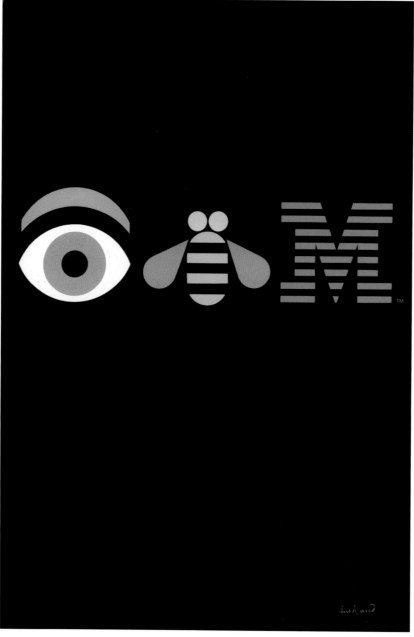

1982
Paul Rand
IBM
Poster

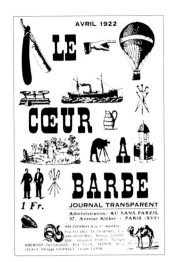

1922
Ilya Zdanevitch
Le Coeur a Barbe
Advertisement

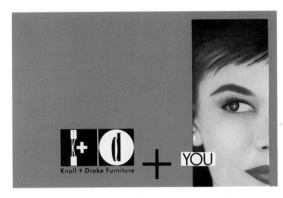

1954
Ladislav Sutnar
Knoll + Drake Furniture
Advertisement

1975
Mihajlo Arsovski
R & G = † (*Rosencrantz and Guildenstern Are Dead*)
Poster
Courtesy Luka Mjeda

1975
Milton Glaser
I Love NY
Logo

1984
Neville Brody
Style(s)
(from *The Face*)
Magazine department titles

1993–1995
David Carson
"Bryan Ferry"
(from *Raygun* magazine)
Magazine spread

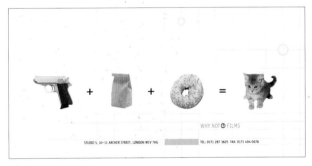

1996
Why Not Associates
Why Not Films, music video production company
Corporate identity

1998
Stefan Sagmeister
***Imaginary Day*, Pat Metheny**
CD package

Anthropomorphic Frolic

The transformation of animal (and animal characteristics) into human form dates back to antiquity. In Egypt these "animorphs" represented gods. In contemporary graphics the symbolism varies, based on the meanings that humans give to the animals used.

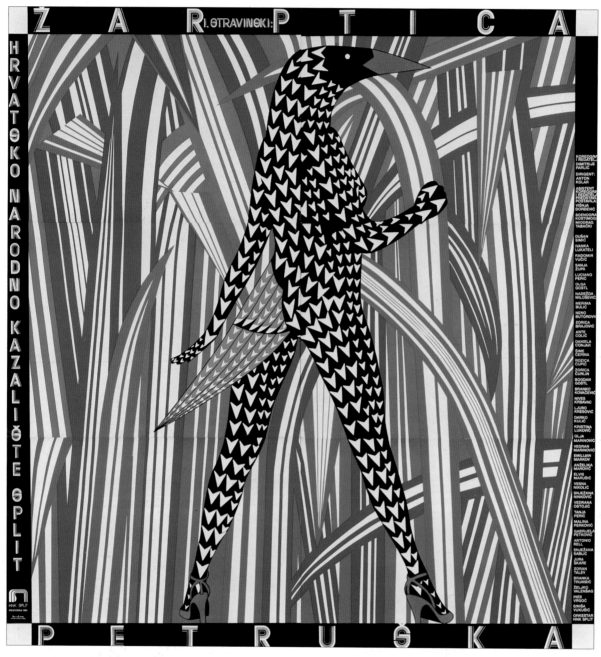

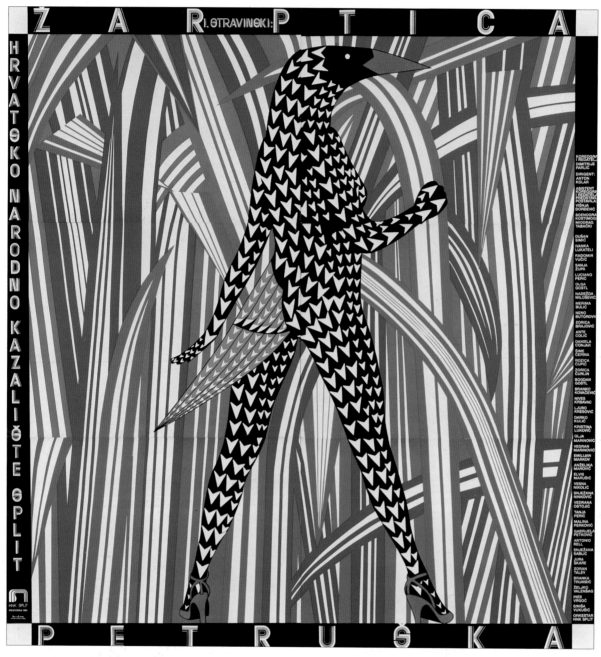

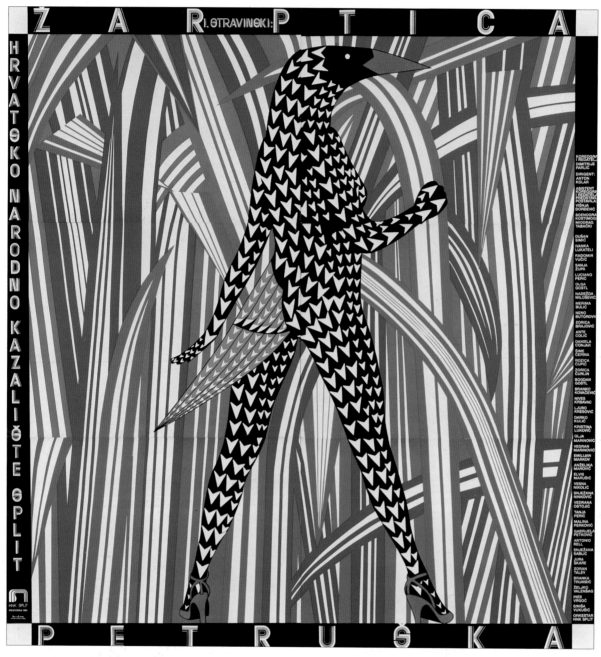

1983
Boris Bucan
The Firebird and ***Petruska***
Color screen-print
Poster Photo Archives, Posters Please, Inc., New York City

— 1983

174

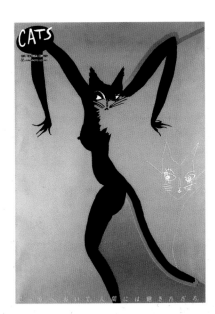

c. 950–730 B.C.
XXII Dynasty
Ancient Egyptian
***Stele of Ofenmut*, from Thebes**
Painted wood
© Metropolitan Museum of Art

1984
Yutaka Takada, art director
Yutaka Murakami, illustrator
Cats
Poster

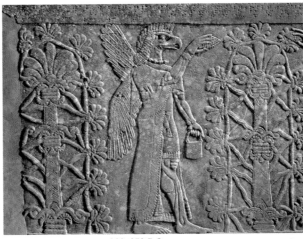

c. 883–859 B.C.
Middle Assyrian
Eagle-Headed Winged Being Watering Sacred Tree
Stone
© Metropolitan Museum of Art

1984
Günther Kieser
Ballet Woche
Poster

1934
Max Ernst
Une Semaine de Bonté
Collage

1997
Michael Ian Kaye, creative director
Paul Sahre, designer
Omon Ra
Book jacket

Sensual Stare

The eyes have it. And what they have is hypnotic power. The come-hither look of staring pupils draws attention, but does not overpower the viewer. It seduces rather than attacks. It promises rather than demands.

— 1984

1984
Louise Fili
The Lover
Book jacket

1927
Irving Politzer
Georgie May
Book jacket

1990
Jackie Merri Meyer, designer
Mel Odom, illustrator
Max Lakeman and the
Beautiful Stranger
Book jacket

1992
Chip Kidd, designer
Carol Devine Carson,
art director
Dreaming in Cuban
Book jacket

1930
Designer unknown
Gallows Orchard
Book jacket

1998
Paul Buckley
Giovanni's Gift
Book jacket

Spreading Out

One can tell a magazine (like a book) from its cover. But the interior spreads of books and magazines frame the all-important content. The designer's need to burst off the confines of the page is something of a primal urge. Yet to what lengths type and image are combined to be read (or experienced) is a challenge that tests the tolerance of the reader and designer.

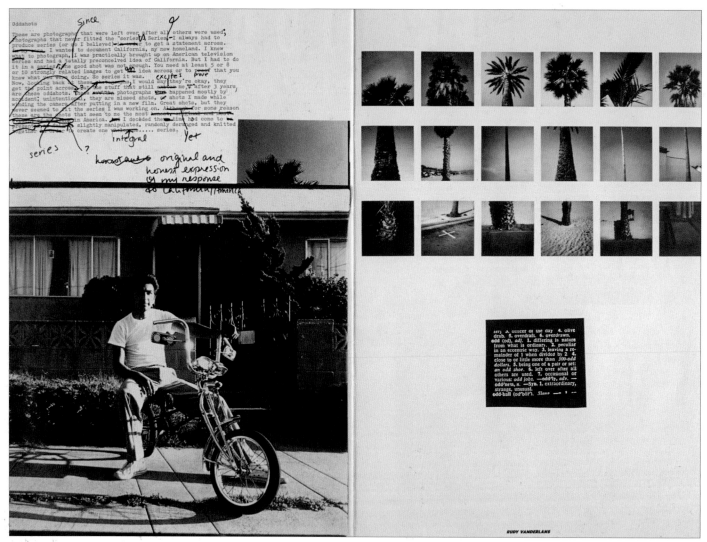

1985
Rudy VanderLans
Émigré 2
Magazine spread

1917
John Heartfield
Neue Jugend
Magazine page

1983
Neville Brody, designer
Peter Ashworth, photographer
***The Face**, no. 42*
Magazine spread

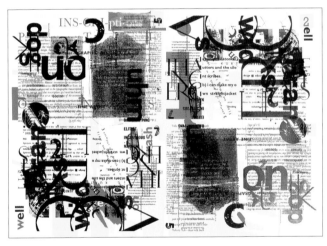

1987
Why Not Associates with Phil Baines
Yak
Magazine spread

1991
David Carson
"Hanging Out at Carmine Street"
(from *Beach Culture*)
Magazine spread

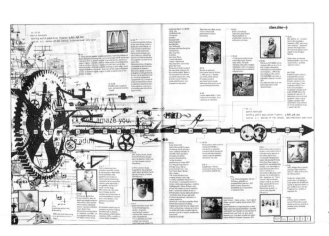

1997
Dejan Dragosavac, designer
Rutta and Dejan Krsic, designers
Fonts by Ermin Medjedovic + Platelet, Émigré and FF
***Arkzin**, no. 3*
Magazine spread

Cautionary Words

A few simple words writ large and designed strong can have a striking impact on anyone's consciousness. Some slogans are simply obvious: "No More War," "Let My People Go" and "Silence = Death." Each can easily stand alone without graphic accompaniment. But when framed in a stark manner or combined with the perfect visual pun, the result is incalculable.

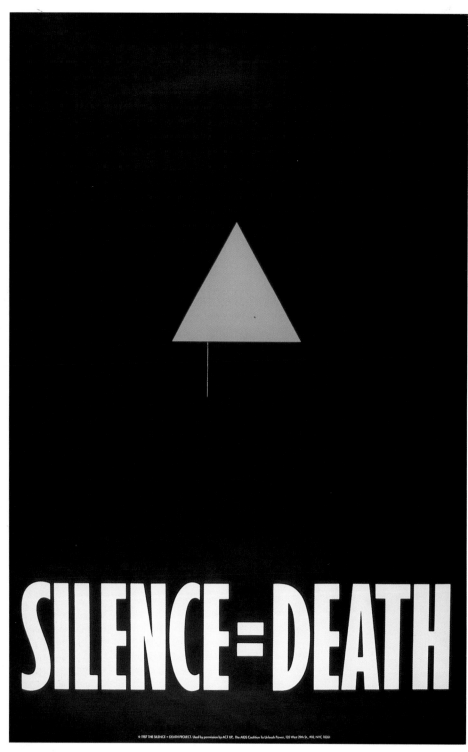

1986
Act Up, New York
Silence = Death
Poster

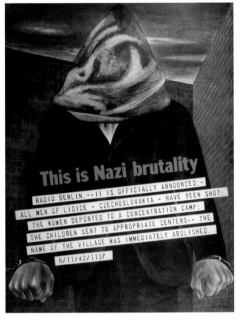

1943
Ben Shahn
This is Nazi brutality
Poster

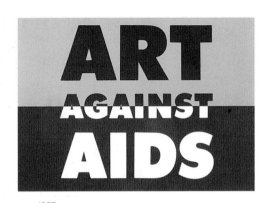

1987
Friedman
Art Against AIDS
Poster

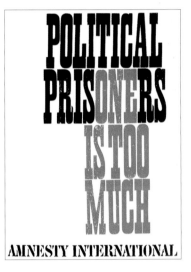

1967
Prins
**One political prisoners
[sic] is too much**
Poster

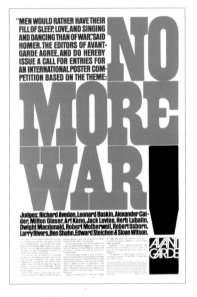

1968
Herb Lubalin
No more war!
Poster

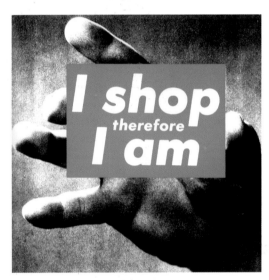

1987
Barbara Kruger
Untitled (I Shop, Therefore I Am)
Photographic silkscreen on vinyl
Courtesy the artist

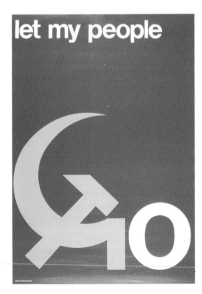

1970
Dan Reisinger
Let my people go
Poster

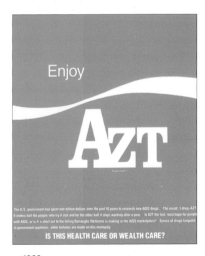

1989
Vincent Gagliostro and Avram Finkelstein
Enjoy AZT
Poster

Multiple Layers

One explanation for the 1980s and 1990s trend in layering type and image is the convergence of media. There is validity to this, but layering is also used without pretense to condense information into a single frame. The challenge is to transform clutter into an aesthetic whole.

1987
Katherine McCoy
Cranbrook Ceramics
Poster

1987

Before

After

1936
Paul Schuitema
Scheveningen
Brochure spread

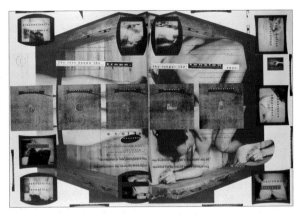

1989
Allen Hori
Émigré Graphics
It Feels Like a Bad Play
Poster

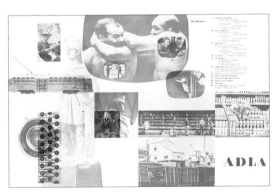

1952
Louis Danzinger
ADLA Call for Entries
Poster

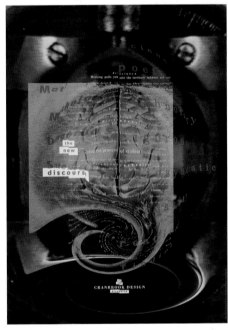

1990
P. Scott Makela
**The New Discourse:
Cranbrook Design**
Poster

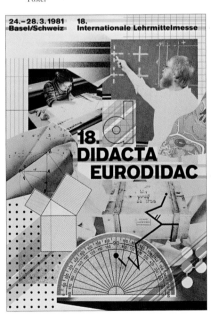

1981
Wolfgang Weingart
18 Didacta Eurodidac
Poster

1998
Charles Spencer Anderson
Design Company
Urban Outfitters
Advertisement

Kinetic Overprints

Words printed over images are akin to captions under them. They help move the narrative along while imparting valuable information. When used with film or video, words must also gallop in concert with the picture. Sometimes the type is also used to illustrate the idea in place of the image.

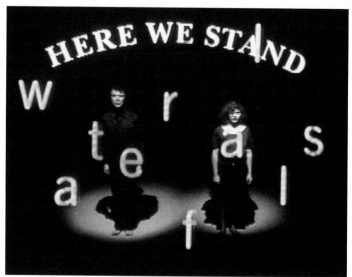

1988
M & Co.
Index Video
(Nothing But) Flowers
Music video
Courtesy Maira Kalman, M & Co.

1959
Norman McLaren
Jack Paar
Title sequence
Courtesy The National Film Board of Canada

1964
Pablo Ferro
Dr. Strangelove
Film title
Courtesy Pablo Ferro

1993
Why Not Associates
Tobacco free
Television commercial

1998
P. Scott Makela
Scream
Music video

Object Photography

In the 1920s the photograph replaced the painted or drawn image as the primary source of visual stimulus and information. In addition, the photograph became the basis for a hybrid form of painting. Object photographs are collages, montages and still-lives of people and things—illustrative devices—wed to words and letters to form a unique entity.

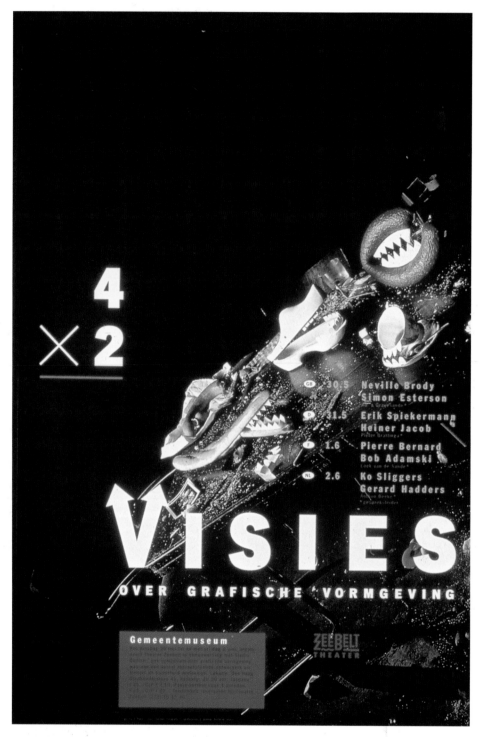

1989

1989
Gert Dumbar, designer
Robert Nakata, typographer
Lex van Pieterson, photographer
4 x 2 Visies
(for Zeebelt Theater)
Poster

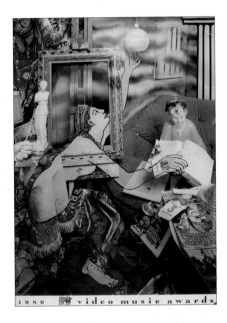

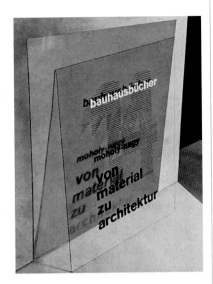

1929
László Moholy-Nagy
***Von Material zu
Architektur***
(***Bauhaus Book 14***)
Book cover

1989
Stacy Drummond
Steven Byram
Colin Calvin
**MTV Video Music
Awards**
Brochure cover

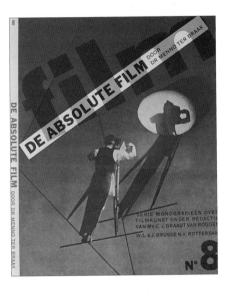

1931
Piet Zwart
***Film: De Absolute Film,
no. 8***
Magazine cover

1990
Vaughan Oliver
Bossanova, Pixies
CD cover

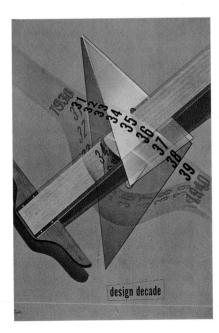

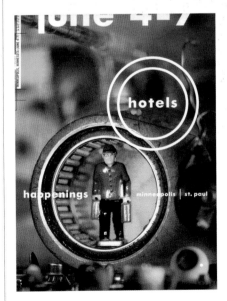

1942
Wil Burtin
A-D
Magazine cover

1997
Charles Spencer Anderson
Design Co.
HOW Design Conference
Brochure

Clips and Fragments

The single image has the virtue of a single focus, but the fragmented composition enables the viewer to decide where to look (more or less) at his or her own pace. Multiple fragments ultimately add up to a whole, so depending on the skill of the designer the message will always be conveyed in the end.

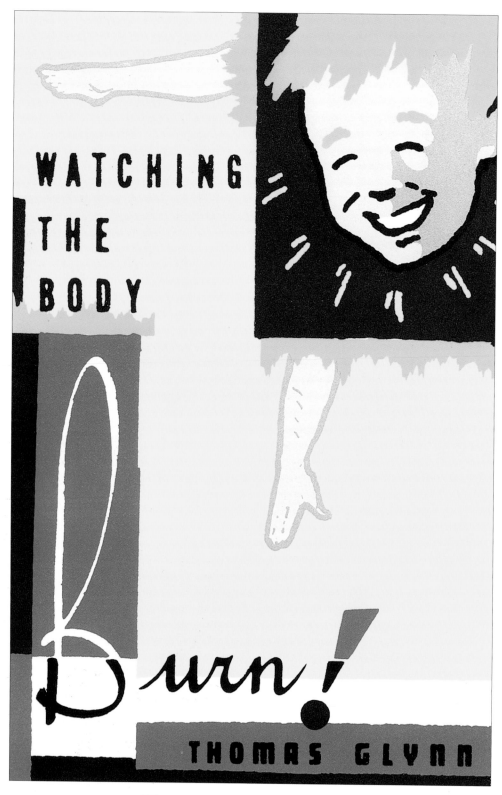

1990
Chip Kidd, designer
Charles Burns, illustrator
Watching the Body Burn!
Book jacket

1931
Designer unknown
Tiger Valley
Book jacket

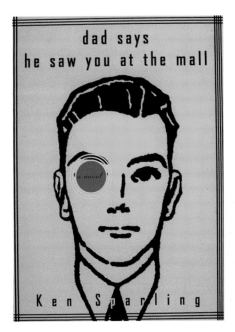

1994–1995
Carol Devine Carson, art director, creative director
Archie Ferguson, designer
Dad Says He Saw You at the Mall
Book jacket

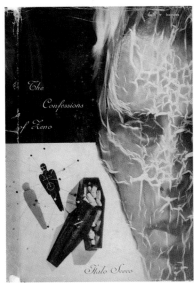

1947
Alvin Lustig
The Confessions of Zeno
Book jacket

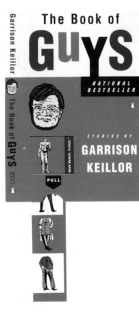

1995
Paul Buckley
The Book of Guys
Book jacket

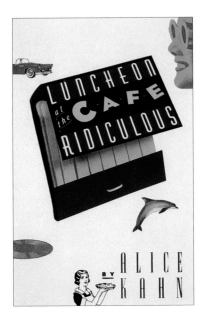

1988
Frank Metz, art director
Carin Goldberg, designer
Gene Greif, illustrator
Luncheon at the Cafe Ridiculous
Book jacket

1995
The Senate
David Eldridge
Stuart Brill
***D Case or the Truth About
the Mystery of Edwin Drood***
Book jacket

Text Blocks

Columns of text usually come in two sizes, wide or narrow. But contoured and constructed columns of body text, either as pure design or metaphor, are on the rise, especially given the computer's facility. Nonetheless, composing text blocks to radically conform to particular images began long before the computer made it so common, and will continue long after.

1991
Cyan
Form & Zweck, no. 2/3
Magazine spread

1934
Alexey Brodovitch
"Paris, 1935"
(from *Harpers Bazaar*)
Magazine spread

1992
Aleš Najbrt, designer
Raut **magazine**
Magazine spread

1964
Peter Knapp, art director
"Votre Demarche '64"
(from *Elle*)
Magazine spread

1995
Martin Vanesky
Speak
Magazine spread

1987
Tibor Kalman
"The World in a Bottle"
(from *Artforum* magazine)
Magazine spread
Courtesy Maira Kalman, M & Co.

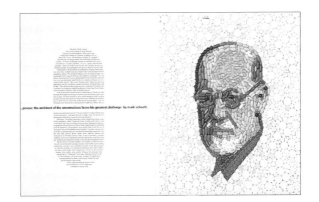

1998
Ted Keller, design director
Keith Campbell, art director
Minh Uong, art director
Jen Graffam Wink, designer
Jason Mecier, illustrator
VV Publishing Group, publisher
"Freud vs. Prozac"
(from *The Village Voice*)
Newspaper spread

Distort and Distress

Perhaps the original idea to distress and distort visual elements was influenced by printers' make-ready sheets, where words, pictures and inks are accidentally (on purpose) printed together to test the efficiency of the press. Or perhaps it derives from the early modern artist's desire to disrupt the stasis of academic art.

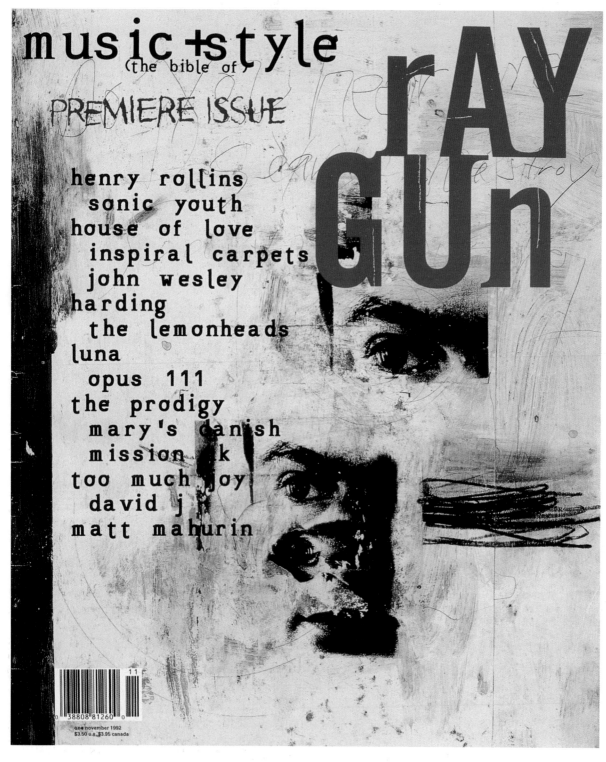

music +style
(the bible of)

PREMIERE ISSUE

rAY Gun

henry rollins
sonic youth
house of love
inspiral carpets
john wesley
harding
the lemonheads
luna
opus 111
the prodigy
mary's danish
mission k
too much joy
david j
matt mahurin

one november 1992
$3.50 u.s. $3.95 canada

1992
David Carson
Raygun **magazine**
Magazine cover

Before

1921
Francis Picabia
L'Oeil Cacodylate
Painting
Giraudon/Art Resource, NY Musee National d'Art Moderne, Centre Georges
Pompidou, Paris, France. ©ARS, NY Collections Mnam/Cci–Centre Georges
Pompidou. Photo: Photothèque des collections du Mnam/Cci

1991
Steven Byram
Slammin' Watusis
Album cover

After

1994
M/M
Eye magazine
Magazine cover

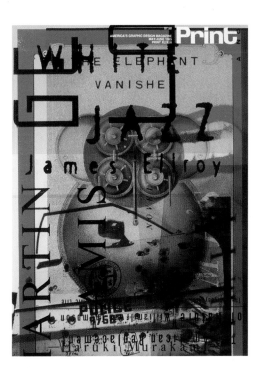

1995
Andrew Kner, art director
Chip Kidd, designer
Print magazine
Magazine cover

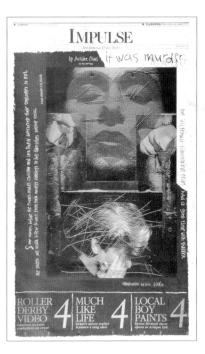

1995
Galie Jean-Louis, creative director, art director
Dee Boyles, designer
Eric Dinyer, illustrator
Anchorage Daily News
Newspaper page

Designing Character

The visionary magazines—those that refuse to follow dominant fashions—have unique visual characteristics (that is, as long as they are not co-opted by copycats). But character is determined by more than a typeface or aesthetic. It is an honest exploration of its chosen theme, expressed textually and graphically.

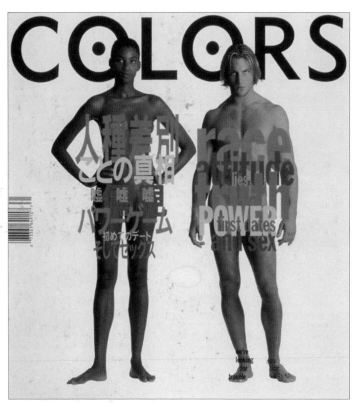

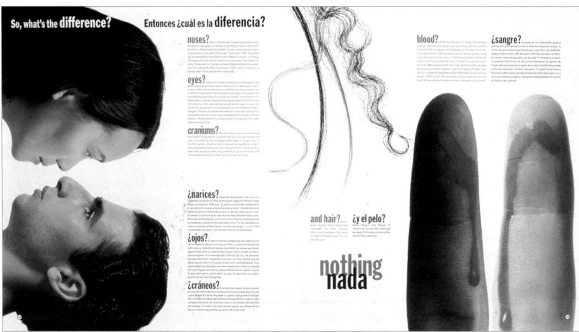

1993
M & Co.
Tibor Kalman
"So, What's the Difference?"
(from *Colors* magazine)
Magazine cover and spread

Before

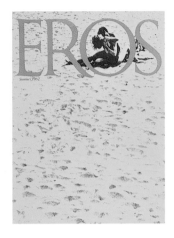

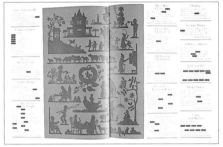

1962
Herb Lubalin, designer
Donald Snyder, photographer
Eros **magazine**
Magazine cover and spread

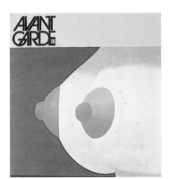

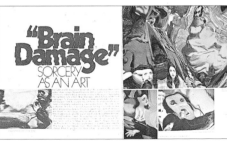

1968
Herb Lubalin
Avant Garde **magazine**
Magazine cover and spread

After

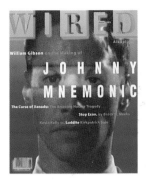

1995
John Plunkett
Wired **magazine**
Magazine cover and spread

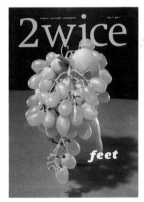

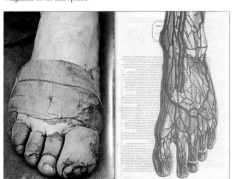

1997
J. Abbott Miller, art director
2wice **magazine**
Magazine cover and spread

1998
Tycoon Graphics
Big **magazine**
Magazine cover and spread

Sky Writing

Designers address many recurring themes, but one of the most common, because of its modernity and monumentality, is the skyscraper. Using type and picture to simulate an upward motion, designers have interpreted the thrusting cityscape in a variety of abstract ways.

1994
Tomato
John Warwicker
Karl Hyde
Mmm…Skyscraper I Love You
Book spread
© Booth-Clibborn Editions

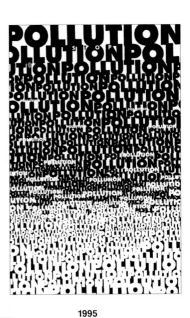

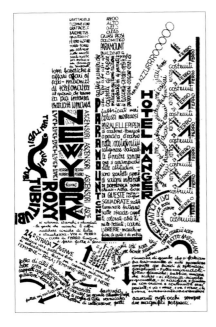

1995
Lanny Sommese, art director
Marina Garza, designer
Stop pollution
Poster

1929
Fortunato Depero
New York
Postcard

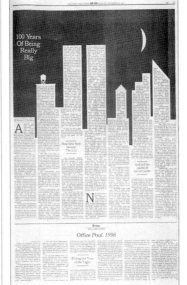

1964
John Furnival
**The fall of the tower of Babel
(Peace for the world)**
Poster

Office Pool, 1998

1997
Nicholas Blechman, art director
"100 Years of Being Really Big"
(from *The New York Times* Op-Ed page)
Newspaper page

c. 1991
Peter Saville, Pentagram London
Yohji Yamamoto
Magazine spread

1997
Shinnoske Sugisaki, art director, designer
Jun Itadani, designer
Shiho Sugisaki, copywriter
Yasunori Saito, photographer
Morisawa font
Poster

Visualizing Music

The LP and CD have offered designers an opportunity to build stories around logos. The record album must be a logo for the music, but when synchronicity is clicking, the two become one—the album art substitutes for the recording artist's name and image.

1995
Stefan Sagmeister, art director, designer
Veronica Oh, designer
Mountains of Madness, **H.P. Zinker**
CD package

1970
Zacron
Led Zeppelin III
Album cover

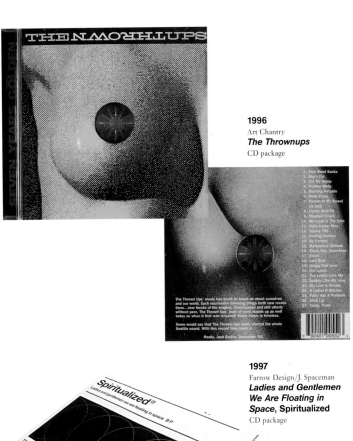

1996
Art Chantry
The Thrownups
CD package

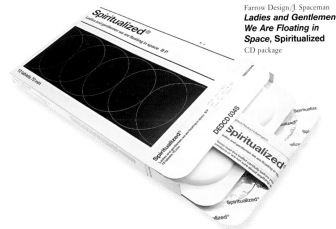

1997
Farrow Design/J. Spaceman
*Ladies and Gentlemen
We Are Floating in
Space*, Spiritualized
CD package

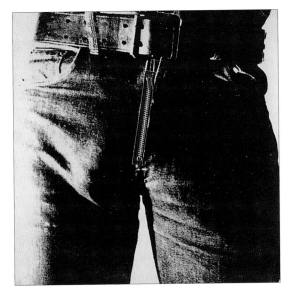

1971
Andy Warhol
Sticky Fingers, Rolling Stones
Album cover

1997
Keiko Hirano
Dogs
CD package

Chicken Scratching

Type is official language, handwriting is informal. So why do designers decide to make untutored scrawls instead of proper letters? The answer is "individuality." In a sea of conventional letterforms, the chicken scratch stands out, and expresses more immediacy—which could indeed be more memorable.

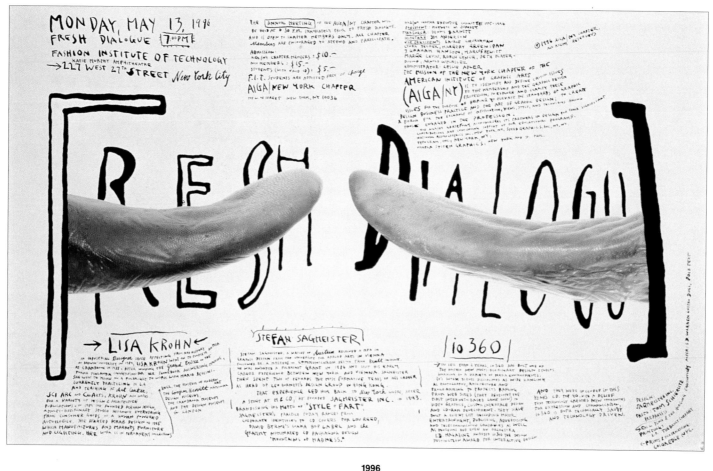

1996
Stefan Sagmeister
Tom Schierlitz, photographer
Fresh Dialogue
Poster

— **1996**

c. 1915
F.T. Marinetti
Manicure Faire Les
Ongles; *L'Italie*
Book

1996
Cahan & Associates
Bill Cahan, art director
Bob Dinetz, designer, illustrator
Stefanie Marlis, copywriter
GVO Book #1 (Chances
That There Is Life…)
Annual report

1971
Josef Müller-Brockmann
Jim Knopf und Lukas der
Lokomotivführer
Poster

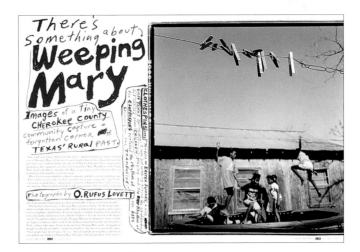

1998
D.J. Stout, art director, designer, typographer
Nancy McMillen, designer
O. Rufus Lovett, photographer
"There's Something About
Weeping Mary"
(from *Texas Monthly*)
Magazine spread

1992
Pentagram
Michael Bierut, designer
Elizabeth Bierut, handletterer
Meehan Tooker, printer
Cross Pointe Paper Corp., paper
What Is Good Design?
Call for Entries
15th Annual American
Center for Design
One Hundred Show
Poster

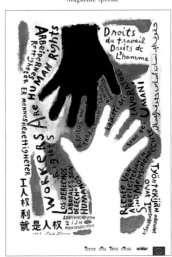

1998
Paul Davis
Workers' rights are
human rights
Poster

More Book Tricks

One expects children's books to be filled with games and gimmicks to attract and inspire. But is there a need to invest the same novelty into adult offerings? Stimulation is welcome at any age, and in any medium. The pop-ups, inserts, and foldouts that define these books expand their essential function of books.

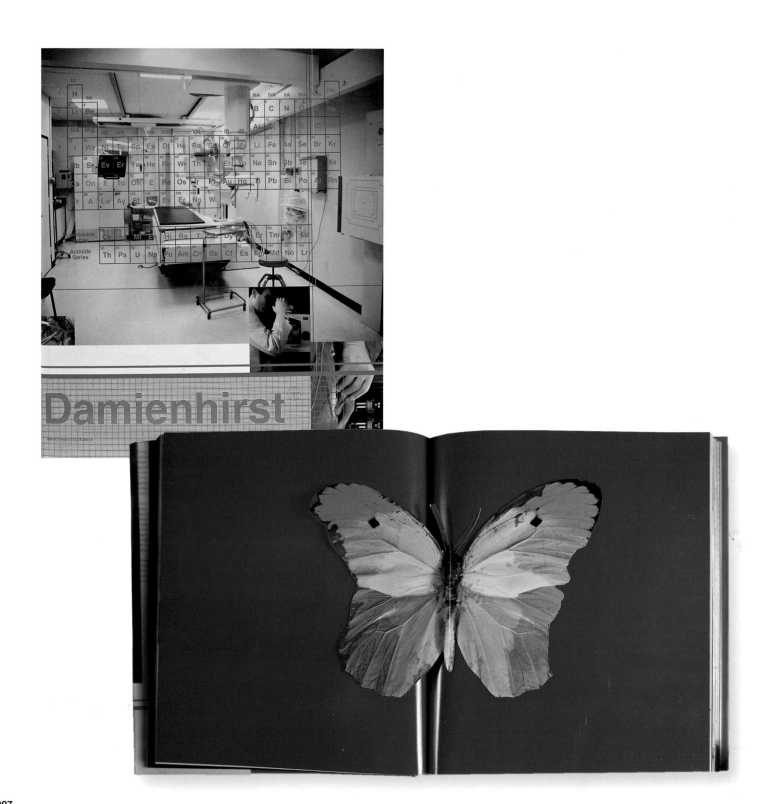

1997
Jonathan Barnbrook
I Want to Spend the Rest of My Life Everywhere, With Everyone, One to One, Always, Forever
Book cover and spread

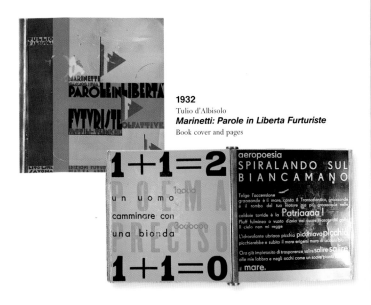

1932
Tulio d'Albisolo
Marinetti: Parole in Liberta Furturiste
Book cover and pages

1999
David Byrne, author
Stefan Sagmeister, designer
*Your Action World: Winners Are Losers
With a New Attitude*
Book cover and spread

1988
Seymour Chwast
Design & Style
(for Mohawk Paper)
Paper promotion

1994
Jeffrey Keyton
Stacy Drummond
Tracy Boychuk
MTV Video Music Awards
Book cover and spread

1999
April Greiman
*Design Process at SCI-ARC,
Southern California Institute
of Architecture*
Book cover and spread

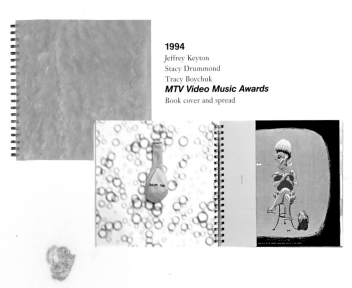

Stock Stories

The typical corporate annual report gives stockholders a peek at a business's inner workings, as well as the stock-holders' investments. It is invariably a happy face on the year's numbers (good or bad). Hence these are the most difficult business communications to design. The challenge is to inform, inspire and instill confidence, and, oh yes, to entertain.

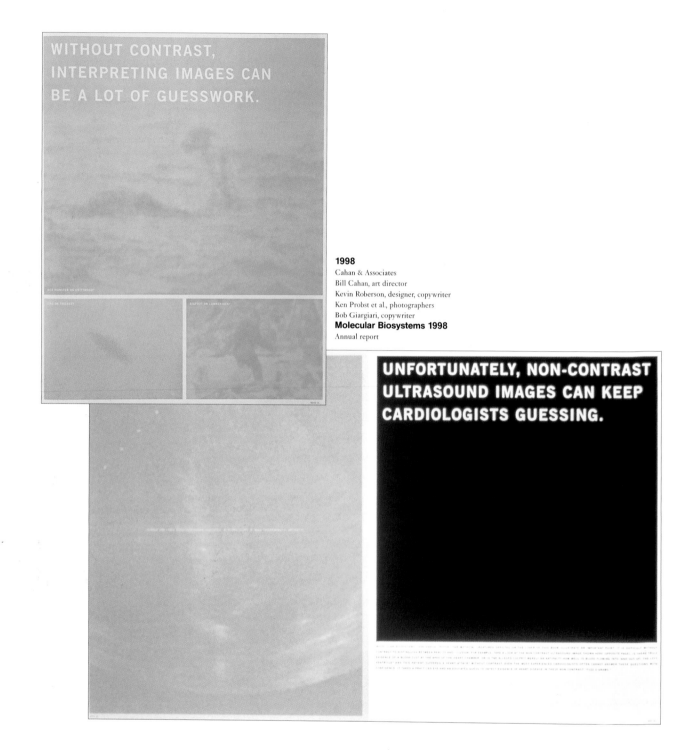

1998
Cahan & Associates
Bill Cahan, art director
Kevin Roberson, designer, copywriter
Ken Probst et al., photographers
Bob Giargiari, copywriter
Molecular Biosystems 1998
Annual report

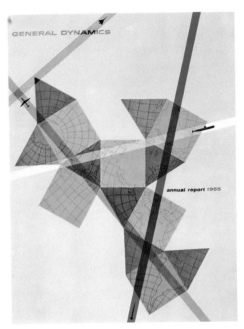

1956
Erik Nitsche
General Dynamics
Annual report

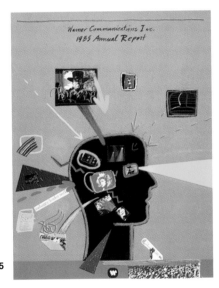

1985
Pentagram
Peter Harrison
Susan Hochbaum, designer
Sue Huntly, illustrator
Donna Muir, illustrator
National Bickford Foremost, printer
Warner Communications 1985
Annual report

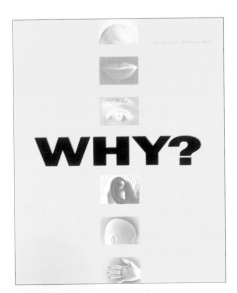

1990
Frankfurt Gips Balkind
Kent Hunter
Ricki Sethiadi
Time Warner 1989
Annual report

1999
Bielenberg Design
Eric Cox, designer
David Guarnieri, designer
ITG, Inc.
Annual report

1999
SamataMason
Greg Samata, creative director
Beth May, designer
R.R. Donnelley & Sons Company
Annual report

1999
VSA Partners
James Kovac, creative director, designer
Thom Wolfe, designer
Andrew Reeves, designer
Interface, Inc.
Annual report

Hyperactive Interactivity

Interaction is not new, but from this time forward all design must in some form relate mutually with the audience. With new media in the forefront of communications, designers must draw upon old, simple methods to inspire new, complex navigational ideas.

1999
John Maeda
Tap Type Write
Book and mini-CD-ROM
© Copyright 1998 John Maeda

1514–1517
Arñao Guillen de Brocar
Polyglot Bible
Book page

1923
L. Lissitzky, designer
Lutze & Vogt, Berlin, printer
Soviet Russian State Publishing House, Berlin, publisher
For the Voice
(by Vladimir Mayakovsky)
Book spread
The Mitchell Wolfson Jr. Collection, The Wolfsonian-Florida International University,
Miami Beach, Florida. Photo by Bruce White.

1940
Jam Handy Organization
Traffic
Filmstrip graphics

1984
Susan Kare, designer
Bill Atkinson, programmer
Apple Lisa
Computer interface

207

supplier	Cypher
catalogue	29.10.01
process	✓
tag	✓
spine	
cover	
memo	
barcode	R 54378
final check	